SCIENCE, REASON,
AND ANTHROPOLOGY

SCIENCE, REASON, AND ANTHROPOLOGY
The Principles of Rational Inquiry

James Lett

ROWMAN & LITTLEFIELD PUBLISHERS, INC.
Lanham • New York • Boulder • Oxford

ROWMAN & LITTLEFIELD PUBLISHERS, INC.

Published in the United States of America
by Rowman & Littlefield Publishers, Inc.
4720 Boston Way, Lanham, Maryland 20706

12 Hid's Copse Road
Cummor Hill, Oxford OX2 9JJ, England

British Library Cataloguing in Publication Information Available

Library of Congress Cataloging-in-Publication Data

Lett, James William, 1955-
 Science, reason, and anthropology : the principles of rational inquiry / James Lett.
 p. cm.
 Includes bibliographical references and index.
 ISBN 0-8476-8592-6 (cloth : alk. paper). ISBN 0-8476-8593-4 (pbk. : alk. paper)
 1. Anthropology—Philosophy. 2. Anthropology—Methodology. 3. Social
epistemology. 4. Humanism. I. Title.
GN33.L39 1997
301'.01—dc21 97-28198
 CIP

ISBN 0-8476-8592-6 (cloth : alk. paper)
ISBN 0-8476-8593-4 (pbk. : alk. paper)

Printed in the United States of America

⊖™ The paper used in this publication meets the minimum requirements of American
National Standard for Information Sciences—Permanence of Paper for Printed Library
Materials, ANSI Z39.48–1984.

*This book is
for Teresa,
as promised*

It is quite true that the facts do not speak for themselves, but a conclusion that therefore there are no facts is a crashing *non sequitur*.
—Albert C. Spaulding
"Archeology and Anthropology"

Contents

Preface

This is a book about anthropological theory, but it is neither a history of anthropological thought, such as *The Rise of Anthropological Theory* (Harris 1968) or *A Century of Controversy* (Service 1985), nor is it a catalogue of anthropological paradigms, such as *High Points in Anthropology* (Bohannon and Glazer 1973) or *Perspectives in Cultural Anthropology* (Applebaum 1987). At the same time, this is neither a prospectus for a particular theoretical perspective, such as *Cultural Materialism* (Harris 1979) or *Anthropology as Cultural Critique* (Marcus and Fischer 1986), nor a treatise on research methodology, such as *A Handbook of Method in Cultural Anthropology* (Naroll and Cohen 1970) or *Research Methods in Cultural Anthropology* (Bernard 1995).

This is a much more basic and fundamental book: it is about the epistemological foundations of anthropological theory, or the essential nature and ultimate source of anthropological knowledge. My primary concern here is to identify the means or method by which anthropological knowledge can best be achieved. H. Russell Bernard, whose textbook on research methodology is justly celebrated for its cogency and comprehensiveness, has observed that the word "method" has at least three meanings:

> First, method refers to *epistemology*, to sets of assumptions about how we acquire knowledge. . . . Second, method refers to *strategic approaches* to the accumulation of actual data [e.g., the experimental approach or the natural history approach]. . . . And third, method refers to *techniques* or sets of techniques for collecting and analyzing data [such as participant observation and componential analysis]. (Bernard 1994:168)

In the same way, the word "theory" has at least three meanings. First, it refers to *epistemology*, to questions about the nature and source of knowledge, just as "method" does. Second, theory refers to *paradigmatic approaches* to understanding (e.g., cultural materialism or structuralism). And third, theory refers to specific *explanations* of particular phenomena (such as the materialist explanation of Aztec cannibalism or the structuralist explanation of Bororo mythology).

Here, I will be concerned primarily with theory in the first sense, as a set of assumptions underlying the acquisition of knowledge. More than anything else, this is a how-to book: how to think critically, how to draw logical inferences, how to appraise the quality of evidence. In short, this is a book about how to acquire reliable knowledge. My principal aim here is to elucidate as clearly and as comprehensively as possible the essential principles of rational inquiry. If I have succeeded in that goal, I do not deserve any particular credit for having done so. I did not invent the rules of rational inquiry, and I am not responsible for their timeless value.

Nevertheless, I believe that this book addresses issues of major importance to contemporary anthropology. While much of what I have to say here will be familiar to students of philosophy, logic, or epistemology, much of it, I am afraid, is unappreciated or unrecognized by a significant number of anthropologists. In my judgment, that alone is reason enough for a book such as this. Anthropological training all too frequently lacks formal instruction in the fundamentals of critical thinking, and that is a lacuna this book is intended to fill.

The impetus for this book can be easily identified. Since the mid-1980s, numerous anthropologists have seriously questioned the very foundations of traditional anthropological knowledge. Much of that criticism has been cogent and constructive. It is undeniably true, as many anthropologists have argued, that the epistemological assumptions of ethnographic research deserve careful scrutiny, just as it is undeniably true, again as many have argued, that the rhetorical conventions of ethnographic writing merit thorough analysis. At the same time, much of the recent criticism has gone too far in rejecting rational approaches to anthropological knowledge. One of the principal motivations behind this book is the desire to correct that imbalance.

I am convinced that our discipline faces a significant threat to its intellectual integrity from those within its ranks who advocate irrational approaches to knowledge, and I am not content to allow their arguments to go unchallenged. Many, if not most, of those arguments rejecting the fundamental principles of rational inquiry can be traced to interpretive anthropology. Since my primary purpose in this book is to identify the fundamental principles of rational inquiry, and since, in my judgment, the interpretive approach often violates those principles, many of my illustrations will necessarily involve interpretive anthropology. I would like to make two things clear at the outset, however.

First, this book is not a critique of the interpretive approach per se; it makes no attempt to offer a comprehensive analysis of the paradigm of interpretive anthropology. Informed readers will note that most of my

examples involve the more extreme and outlandish positions taken by interpretive anthropologists and that I rarely refer to the more subtle and balanced products of the interpretive approach. The omission is deliberate. My focus here is on the nature of reason, not the nature of interpretive anthropology, and the most obvious errors in reasoning provide the clearest examples. Nor is my analysis restricted to interpretive anthropology. I find examples of theoretical shortcomings in other contemporary paradigms, including cultural materialism, and I will refer to those examples as well when appropriate. Furthermore, this book does not advocate any particular paradigmatic approach to anthropological investigation. Instead, it attempts to identify the essential principles of rational inquiry that underlie all responsible and conscientious approaches to knowledge. Adherents of any and all anthropological paradigms should be able to find common ground in the basic axioms of logical analysis outlined here.

Second, I would like to make it clear that I am not approaching the paradigm of interpretive anthropology with a negative prejudice. In fact, I have long maintained a sympathetic appreciation for many of the goals and insights of the interpretive approach. In 1987, in a text on anthropological theory entitled *The Human Enterprise*, I offered a generally favorable assessment of interpretive anthropology (Lett 1987:110–26), even though I called attention to several of the paradigm's shortcomings. I admitted that the research strategy had "so far produced disappointingly few theoretical principles to explain the universal characteristics of human nature and symbolic processes," and I argued that "the most significant deficiency of symbolic [i.e., interpretive] anthropology is its lack of explicit theoretical and methodological guidelines" (Lett 1987:112, 117). Nevertheless, I suggested that the interpretive and scientific approaches within anthropology could and should be complementary and that interpretive approaches should be used to address a set of anthropological issues that I collectively referred to as "the maintenance of human identity" (Lett 1987:48–53). I concluded my discussion of interpretive anthropology by declaring that I was "appreciative of the paradigm's contributions, attracted by its aesthetics, impressed by its potential, and concerned about its lack of rigor" (Lett 1987:119).

I continue to see much of value in the interpretive approach, as I will discuss in greater detail later. Interpretive anthropologists have focused legitimate and important scrutiny on the genre conventions of ethnographic writing and the implicit assumptions of ethnographic research. In addition, interpretive anthropologists have made notable contributions to the ethnographic record, producing ethnographies that are imaginatively evocative, factually rich, and intellectually provocative. Nevertheless, in

the years since I published my first text on anthropological theory, I have become increasingly disillusioned with the interpretive approach, despite its laudable features. On the whole, I believe the paradigm of interpretive anthropology has betrayed its promise and is moving distinctly in the wrong direction. In the pages that follow, I will attempt to explain in detail the reasoning behind these conclusions.

Chapter 1 reviews the historical context of the contemporary debate between the scientific and humanistic approaches in anthropology and introduces the central task of the book: to define the nature of reason and to defend its logical and moral preeminence. What are the differences between the scientific and humanistic approaches to knowledge? How have those differences come to be expressed in anthropology?

Chapter 2 examines the basics of epistemological analysis and identifies the acquisition of reliable knowledge as the essential goal of reason. What is knowledge? What is a fact? How can facts be distinguished from values? How can reliable claims to knowledge be distinguished from unreliable ones?

Chapter 3 identifies the fundamental features of the scientific approach to knowledge and describes science as the systematic application of reason. What is science? What are its assumptions, and what are its essential elements? In what sense can science be said to be objective, logical, and systematic?

Chapter 4 applies the fundamental principles of reason to an analysis of contemporary anthropological theory and discusses the epistemological and ethical errors of various contemporary approaches, especially interpretive anthropology. What are the strengths and weaknesses of the interpretive approach? What are its logical and moral shortcomings, and what contributions can it make to anthropological inquiry?

Chapter 5 concludes by suggesting a reconciliation between science and humanism founded upon reason and identifies some promising approaches in anthropology that are successfully applying the fundamental principles of rational inquiry. What is the true nature of humanism? In what sense is anthropology a humanistic science? What contemporary approaches within anthropology exemplify the consistent application of rational inquiry? What future direction should anthropology take?

Let me offer one last word of caution before we begin. I hold several strong convictions about anthropological theory, and my personal tendency is to express those convictions in strong, unequivocal language. It is not, however, my intention to provoke an emotional response from those who may not be predisposed to agree with me. The central premise of this book is that virtually all differences of opinion can ultimately be

resolved by appeal to the fundamental principles of logic and reason. The fact that I express my convictions in emphatic language does not mean that I fail to recognize the possibility that I could be mistaken. Indeed, I think it is virtually certain that this book will contain errors in analysis that I will eventually discover and regret. If critical readers can demonstrate those errors to me, using the principles of logic and reason outlined here, I will willingly admit my mistake and modify my position. I am convinced that substantive debate between people who share a commitment to the fundamental principles of rational inquiry is always constructive and that such debate among anthropologists can only lead to the expansion of anthropological knowledge. For that reason, I believe that even those who ultimately disagree with me should find this book useful and instructive, because it will provide the context for them to frame their counterarguments. If those counterarguments are effective, I can say sincerely that I will gladly embrace them, because I am much more interested in coming to a correct understanding than I am in winning a debate. If I can persuade readers to approach this book in that spirit, I think they will find it provocative in the best sense of the term.

I would like to express my gratitude to Paul Shankman of the University of Colorado at Boulder, who reviewed the first draft of this book at the request of the publisher. Professor Shankman shares many of my convictions about the value of the scientific perspective in anthropology, but the approach of this book is not one he would have taken himself. As a result, he should not be identified with any particular position or argument in these pages. Nevertheless, I have benefited considerably from his insightful appraisal of the original manuscript, and this final version incorporates many of his astute suggestions.

I would like to acknowledge as well the invaluable assistance of Tim O'Meara of the University of Melbourne, who provided me with a remarkably thoughtful and thought-provoking critique of the penultimate draft of this book. In addition to being an exceptionally original and creative thinker, Professor O'Meara is also a highly capable editor, and this book clearly bears the influence of his talents and skills. I alone am responsible for any errors, however; although he found much to endorse in these pages, Professor O'Meara also found much to challenge, and I look forward to future discussions with him on those issues.

Finally, I would like to express my appreciation to my editor at Rowman & Littlefield, Dean Birkenkamp. This book has benefited significantly from his substantial anthropological knowledge and his keen editorial skills, and I am especially grateful to him for allowing me to write the book that I wanted to write.

I

Introduction: Art, Science,
and the Discipline of Anthropology

Since its inception, the discipline of anthropology has been plagued by an unresolved identity crisis, uncertain whether to emulate the humanities or the natural sciences in its definition of itself (see Kroeber 1935; Benedict 1948; Redfield 1953). Richard Lee (1992:32) astutely observes that "anthropology has never declared itself unequivocally on the matter of whether it is a particularizing, historical discipline interested in understanding unit cultures, or whether it is a generalizing, nomothetic [i.e., lawgiving] science searching for the broadest possible explanatory frameworks." Within the discipline, there have always been strong partisans for one side or the other; a thoroughly humanistic approach is clearly illustrated in Ruth Benedict's (1934) *Patterns of Culture,* while a consistently scientific perspective is obviously reflected in Leslie White's (1949) *Science of Culture.* Among contemporary anthropologists, Stephen Tyler (1986a; 1986b) is notable for his strong advocacy of humanistic approaches to ethnographic knowledge, Marvin Harris (1979; 1991) for his impassioned defense of the scientific method.

It is probably fair to say, however, that most anthropologists (at least most cultural anthropologists) have refused to side exclusively with either the humanists or the scientists. Eric Wolf's (1964:88) oft-quoted observation that "anthropology is both the most scientific of the humanities and the most humanistic of the sciences" continues to be widely appreciated; I would suspect that it represents the majority opinion within contemporary anthropology (particularly within contemporary *cultural* anthropology). Shore (1990:750), for example, maintains that "cultural anthropology necessarily and properly straddles the humanities and the sciences"; Wilk (1991:36) agrees, claiming that "anthropology as science is only part of a larger anthropological tradition, anthropology as humanism." Scholte (1974:431) argues, similarly, that "anthropological activity is

never only scientific"; Brady (1991:5) concurs, insisting that "there is more than one way to say anthropology."

The Incommensurability of Science and Humanism

While anthropology has always combined the humanistic and scientific perspectives, however, it has not always done so successfully. The two approaches are not necessarily incompatible (as I will discuss later), but they are fundamentally different. The problems they specify and the methods they employ to solve those problems are divergent; in Kuhn's (1970) term, the humanistic and scientific approaches are largely "incommensurable" (see Lett 1987:31–38). The consequence, for anthropology, has often been confusion. Because anthropologists tend to vacillate between the humanistic and scientific "forms of thought," as Service (1985:287) explains, they "are likely to misunderstand one another when addressing an issue or, frequently, to not even be interested in the same kind of issue." All too often, as a result, debates in anthropology become pointless exercises in miscommunication:

> Mostly, the controversies seem to come down to mutual incomprehension because of divergent aims and interests. Often, therefore, controversy is also a matter of different questions being asked, which itself results in a lack of any confrontation whatsoever between important ethnologists. Not only do they sometimes talk right past one another, often they are not talking toward one another at all. (Service 1985:287–88)

The Two Meanings of "Humanistic"

Among anthropologists, the incommensurability of the humanistic and scientific perspectives is further complicated by the fact that the term "humanistic" can be understood in various ways. In the first place, "humanistic" is the adjectival form of two different nouns, the "humanities" and "humanism." "The humanities" refers to a particular set of disciplines, including literature, art, and philosophy, that are devoted to the collection, preservation, analysis, and appreciation of the intellectual achievements of humanity. "Humanism" refers to a particular set of philosophical convictions dealing with ethics (the question of morality), aesthetics (the question of beauty), and epistemology (the question of knowledge). There is considerable overlap between the two terms, since the disciplines that constitute the humanities generally adhere to the ethical, aesthetic, and epistemological principles of humanism. The problem

arises when the adjective "humanistic" is used, because it is not always clear whether it refers to the content and methods of the humanities or to the values and principles of humanism (or to both at the same time).

Most often, however, the term "humanistic" can be understood in one of two ways, in either a *moral-aesthetic* sense or in an *epistemological* sense. In the moral-aesthetic sense of the term, "humanistic" refers to a wide range of aesthetic and ethical values. It can suggest a predilection for the artistic temperament, encompassing an appreciation of fiction, poetry, drama, dance, music, painting, and sculpture, or it can suggest a penchant for sensuality, embracing an affection for fine wine, savory cuisine, enticing fragrances, beautiful landscapes, or sexual pleasures. In some instances, the term "humanistic" can be understood to refer to qualities of sensitivity, affection, kindness, sympathy, or tenderness; at other times, it can denote particular ethical propositions, such as the values for individual liberty or human dignity. The term "humanistic" is often contrasted with the term "scientific" in contexts that suggest that the former includes everything that is playful, colorful, exciting, concrete, particular, personal, and qualitative, while the latter includes everything that is toilsome, mundane, dull, abstract, general, impersonal, and quantitative.

In the epistemological sense of the term, "humanistic" refers to a set of assumptions about the nature and source of knowledge. The epistemological principles of humanism assume that knowledge is unavoidably both subjective and relative, that it is best achieved through a combination of intuitive insight and empathic imagination, and that the relative merit of competing accounts depends upon their inherent persuasiveness. In evaluating the relative persuasiveness of competing claims, humanists consider a variety of variables, including logical consistency, moral authority, rhetorical style, aesthetic appeal, and emotional satisfaction. The goal of humanistic inquiry is to produce contextual interpretations that are illuminating. In contrast, the epistemological principles of science assume that knowledge can aspire to be both objective and absolute, that it is best achieved through a combination of logical analysis and empirical investigation, and that the relative merit of competing accounts depends upon their evidential support. In evaluating the relative degree of evidential support associated with competing claims, scientists rely upon a number of guidelines, including the rules of operationalism, comprehensiveness, replicability, intersubjectivity, and testability. The goal of scientific inquiry is to produce causal explanations that are predictive.

Humanism in Contemporary Anthropology

Humanistic approaches, in all of their various formulations, are very much alive and well in anthropology today. In the moral-aesthetic sense, the humanistic perspective is especially apparent in the works of contemporary ethnographers. According to Wilk (1991:37), for example, "to teach anthropology humanistically is to teach with feeling, to teach with the integrity of personal example." Pandian (1985:117) declares that he believes "it is the humanist component which provides anthropology and history with their holistic philosophy, relevance, and meaning." Shore (1990:750), objecting to what he perceives to be the sterility of scientific anthropology, explains that in embracing humanistic perspectives, he has "opted for the tastes that positivistic approaches have left behind." Stoller (1989) takes Shore's metaphor literally; he urges anthropologists to enrich their ethnographies with the actual gustatory details of "the taste of ethnographic things." Wanting his colleagues to adopt a livelier, more literary writing style, Stoller (1986:69) has issued a "call for a humanistic anthropology," by which he means an anthropology capable of producing "meaningful descriptions" and "fine ethnographies."

In the epistemological sense, the humanistic perspective presents a much more significant challenge to traditional anthropology, because it explicitly rejects the goals and assumptions of the scientific method. Stephen Tyler (1984:328), who perceives a widespread and fundamental shift from scientific to humanistic perspectives in the discipline today, observes that "this turn to poetics is also a 'turning away' from formal linguistics and modern logic as the dominant models of discourse." For Tyler (1984:329), the "poetic" approach of contemporary anthropology is explicitly humanistic in the epistemological sense of the term: "the discourse of postmodern anthropology does not demonstrate by logical proof alone; it reveals by paradox, myth, and enigma, and it persuades by showing, reminding, hinting, and evoking." Jackson (1989:13), too, argues that humanistic anthropologists (he calls them "radical empiricists") are "inclined to judge the value of an idea, not just against antecedent experiences or the logical standards of scientific inquiry but also against the practical, ethical, emotional, and aesthetic demands of life." Rabinow and Sullivan (1979:6) claim that anthropology has no choice but to be humanistic, because "the exactitude that is open to the human sciences is quite different from that available to the natural sciences." They therefore reject scientific objectivity, embracing instead humanistic subjectivity, on the grounds that "there is no privileged position, no absolute perspective, no final recounting."

Frequently, of course, the two senses of "humanistic" are commingled, and it is often argued that they are not only compatible but interdependent. Shweder (1991:49), for instance, believes scientific anthropology errs twice when it denies the existence of "gods, ghosts, souls, witches, and demons:" first, because the epistemological principles that deny the existence of the supernatural realm are not necessarily superior to the epistemological principles that affirm its existence, and second, because denying the existence of supernatural beings has as its consequence "the degrading of other peoples" who believe in such entities. In other words, from Shweder's point of view, if one decides (on the basis of scientific principles of knowledge acquisition) that particular people are ignorant, superstitious, or deluded, it then becomes impossible to respect their moral worth or human dignity. Shweder is hardly alone in this perspective; in fact, many anthropologists reject the scientific approach on both moral/aesthetic and epistemological grounds. Nowhere is this more true than in the contemporary paradigm of interpretive anthropology.

Interpretive Anthropology

The phrase "interpretive anthropology" is a broad covering label for a diverse but interrelated set of epistemological, aesthetic, and theoretical perspectives that have been variously labeled "interpretive" (Geertz 1973; Rabinow and Sullivan 1979), "hermeneutic" (Geertz 1986; Bruner 1986a); "symbolic" (Doglin, Kemnitzer, and Schneider 1977; Boon 1982), "postmodern" (Tyler 1986a; Rabinow 1986), "deconstructionist" (Marcus 1988; Crapanzano 1992), "critical" (Marcus and Fisher 1986), "reflexive" (Scholte 1974), "postprocessual" (Hodder 1982a; 1986), "poststructural" (Tilley 1990), and "literary" (Reyna 1994). Despite varying concerns and emphases, all these perspectives have a common denominator. All, as Carrithers (1990:263) observes, share the conviction that "anthropological knowledge is interpretive and hermeneutic rather than positive, tentative rather than conclusive, relative to time, place, and author rather than universal."

Interpretive anthropology is explicitly humanistic in its origins, interests, methods, and goals. As Shankman (1984:261) notes, the interpretive approach represents "an attempt to refocus anthropology—indeed all of social science—away from the emulation of the natural sciences and toward a reintegration with the humanities." Interpretive anthropologists make no secret of the fact that they draw their "inspiration from the arts and the humanities rather than the natural sciences proper" (Scholte 1984:542). Philosophers and literary critics such as Jacques Derrida (1976;

1978) and Michel Foucault (1976) figure prominently in the intellectual heritage of interpretive anthropology; within the discipline today, there is a clearly discernible trend toward "a coalescence of anthropology and . . . literary theory" (Manganaro 1990:3; see also Ashley 1990). Interpretive anthropologists regard cultures as texts to be read and interpreted, just as a critic reads and interprets works of literature. The accounts produced by interpretive anthropologists are therefore liberally sprinkled with such literary terms as "rhetoric," "genre," "discourse," "poetics," "allegory," "diction," "authority," "dialogue," "voice," "trope," "irony," "synecdoche," "metaphor," and the like. Interpretive anthropologists are more likely to allude to James Joyce or Jean-Paul Sartre than they are to Franz Boas or Alfred Kroeber, and references to Hermes or Hamlet generally outnumber those to Nanook or Ishi (see, for example, Jackson 1989; Crapanzano 1992).

The Origins of Interpretive Anthropology

The paradigm of interpretive anthropology owes its origins and much of its popularity to the work of a single anthropologist, Clifford Geertz, whose humanistic interests and inclinations have always been apparent. Geertz began his academic career as an English major with the ambition of becoming a novelist; eventually he completed his undergraduate degree in philosophy before turning to anthropology (Handler 1991). Geertz admits that it has always been his desire "to make anthropology a more broadly intellectual discipline," one that would be cognizant of the works of "philosophers and other intellectuals" (quoted in Handler 1991:611). Geertz's admiration for humanistic erudition is reminiscent of Victor Turner's (1974:17) call for a more literary anthropology: "I would plead with my colleagues to acquire the humanistic skills that would enable them to live more comfortably in those territories where the masters of human thought and art have long been dwelling."

The cornerstone of interpretive anthropology can be found in *The Interpretation of Cultures*, which Geertz published in 1973. In sonorous prose, redolent with insight and imagination, Geertz articulates his image of an explicitly interpretive approach to anthropological knowledge. "The essential vocation of interpretive anthropology," he argues, "is not to answer our deepest questions, but to make available to us answers that others . . . have given, and thus to include them in the consultable record of what man has said" (Geertz 1973:30). In *The Interpretation of Cultures*, Geertz addresses a number of traditional anthropological topics (including culture, religion, politics, and ritual), but he does so in a way that

redefines traditional anthropological goals. The analysis of culture, he declares, is "not an experimental science in search of law but an interpretive one in search of meaning" (Geertz 1973:5). Because "culture" consists of a "pattern of meanings embodied in symbols" (Geertz 1973:89), the interpretation of culture entails "the elucidation of its symbolic meanings" via the application of "the ethnographer's empathy, *Verstehen*, insight, imagination, understanding, and the like" (Spiro 1986:263).

Geertz's classic article "Deep Play: Notes on a Balinese Cockfight" provides an excellent example of the character and appeal of interpretive anthropology. In the article, which appears as chapter 15 of *The Interpretation of Cultures*, Geertz describes a cockfight he observed while conducting fieldwork in Indonesia and then muses on the cultural significance of cockfighting for the Balinese. The writing is personal, evocative, and captivating. Geertz and his wife narrowly escape a police raid while watching a cockfight, and the story is told with great aplomb. Geertz skillfully conveys the drama and passion of the cockfight along with the fear and excitement of the flight from captivity. Interspersed throughout are fascinating tidbits of Balinese cultural symbolism, such as these:

> A pompous man whose behavior presumes above his station is compared to a tailless cock who struts about as though he had a large, spectacular one. A desperate man who makes a last, irrational effort to extricate himself from an impossible situation is likened to a dying cock who makes one final lunge at his tormentor to drag him along to a common destruction. A stingy man, who promises much, gives little, and begrudges that, is compared to a cock which, held by the tail, leaps at another without in fact engaging him. A marriageable young man still shy with the opposite sex or someone in a new job anxious to make a good impression is called 'a fighting cock caged for the first time.' (Geertz 1973:418)

Geertz does not stop at providing rich ethnographic detail, however. He moves beyond that to an abstract sociological conclusion, namely that the cockfight "is fundamentally a dramatization of status concerns" (Geertz 1973:437). He then proceeds to tease a number of interesting generalizations from that conclusion. "The more a match is...between near status equals . . . and/or . . . high status individuals," Geertz (1973:441) observes, "the deeper the match"; and the deeper the match, "the closer the identification of cock and man" and the "greater the emotion that will be involved," among other things.

Following that richly supported analysis, Geertz (1973:434) moves to yet a higher level of abstraction: "the imposition of meaning on life is the major end and primary condition of human existence," he maintains.

Therefore it follows that "the culture of a people is an ensemble of texts, themselves ensembles, which the anthropologist strains to read over the shoulders of those to whom they properly belong" (Geertz 1973:452). The task may be difficult, Geertz admits, but he is certain it can be done, because "societies, like lives, contain their own interpretations. One has only to learn how to gain access to them" (Geertz 1973:453). The article is written in Geertz's distinctively eloquent, sophisticated prose style, and it is replete with allusions to Aristotle, Auden, Bentham, Dostoyevsky, Freud, Hogarth, Schoenberg, Shakespeare, Weber, and Yeats, among others. Whatever one thinks ultimately about interpretive anthropology, one must admit that "Notes on a Balinese Cockfight" is grand intellectual fun.

Potential Shortcomings of Interpretive Anthropology

Intellectual fun and intellectual significance are not necessarily the same thing, however. Critics of interpretive anthropology have pointed out that the paradigm's methodology raises serious concerns about verification and replicability (see Lett 1987:117). "There appear to be two problems with thick description," as Reyna (1994:572–73) puts it: "the first has to do with its vagueness," and the second "has to do with the validity of its attributions of meaning." Ironically, however, Geertz himself was among the first to identify those problems. In *The Interpretation of Cultures*, he observes that "the besetting sin of interpretive approaches . . . is that they tend to resist, or to be permitted to resist, conceptual articulation and thus to escape systematic modes of assessment," and he argues that "there is no reason why the conceptual structure of a cultural interpretation should be any less . . . susceptible to explicit canons of appraisal" (Geertz 1973:24). From the beginning, Geertz (1973:30) recognized that "nothing will discredit a semiotic approach to culture more quickly than allowing it to drift into . . . intuitionism . . . no matter how elegantly the intuitions are expressed." A decade later, however, when Geertz published his next collection of essays, he still had not solved the problem of methodological replicability; he could only suggest that the successful practice of interpretive anthropology is "one of those things like riding a bicycle that is easier done than said" (Geertz 1983:11).

The Goals of Interpretive Anthropology

Nevertheless, Geertz has been adamant in his assertion that interpretive anthropology is (or could be) empirical, verifiable, and essentially nomothetic. "Whatever, or wherever, symbolic systems . . . may be," he

states, "we gain empirical access to them by inspecting events" (Geertz 1973:17), and he expresses his desire to participate in the "generalized attack on privacy theories of meaning" (Geertz 1973:12). He claims further that particularistic interpretations of individual cultures are not the only goal of interpretive anthropology. In Geertz's formulation, the paradigm seeks generalizable frameworks as well. "Our double task is to uncover the conceptual structures that inform our subjects' acts . . . and to construct a system of analysis in whose terms what is generic to those structures . . . will stand out against the other determinants of human behavior" (Geertz 1973:27). More recently, Geertz (1990:274) has explicitly rejected the humanistic focus of interpretive anthropology: "I do not believe that anthropology is not or cannot be a science, that ethnographies are novels, poems, or visions, that the reliability of anthropological knowledge is of secondary interest, or that the value of anthropological works inheres solely in their persuasiveness."

It could be argued, of course, that there is a significant discrepancy between Geertz's stated logic and his logic-in-use (in other words, there could be a discernible difference between what Geertz says interpretive anthropology could accomplish and what it has actually accomplished). For most of Geertz's intellectual heirs, however, there is no such discrepancy, because most contemporary interpretive anthropologists make no claim to nomothetic explanations. (In fact, most of the paradigm's contemporary adherents explicitly reject the scientific canons of verifiability and replicability.) Moreover, most of them have relinquished the original raison d'etre of interpretive anthropology. The recent history of the paradigm suggests that many of its advocates have abandoned the interpretation of cultures in favor of the interpretation of ethnographies.

Interpretive Anthropology and Ethnographic Writing

As Johannsen (1992:74) remarks, contemporary interpretive anthropologists "are characterized by a distinctive fixation on self-criticism." Even the paradigm's proponents, such as Marcus and Fischer (1986:16), admit that interpretive anthropology has shifted its "emphasis from the attempt to construct a general theory of culture to a reflection on ethnographic fieldwork and writing." According to Marcus and Cushman (1982:25), the principal objective of interpretive anthropology is the analysis of "the genre conventions of ethnographic realism about which there has been a tacit and artificial consensus in Anglo-American anthropology." Since interpretive anthropologists view ethnography as an art (with "art" defined as "the skillful fashioning of useful artifacts" [Clifford 1986:6]), they regard

ethnography as "a genre of storytelling" (Bruner 1986b:139). Interpretive anthropologists conclude, therefore, that their task is to critique ethnographic stories, a task for which the techniques of literary criticism rather than the methods of scientific inquiry are obviously best suited.

As a result, interpretive anthropologists such as Marcus and Fischer (1986:165) have focused their "intense concerns" upon "the way social reality is to be presented" rather than upon social reality itself. In the process, according to critics such as Sangren (1988:412–13), interpretive anthropologists have turned anthropology into "meta-anthropology," since "the quantity of publication discussing the characteristics or ideals of postmodern ethnography seems to exceed the quantity of such ethnographic writing itself." Interpretive anthropologists, however, are convinced that their focus is well placed. Clifford, for example, contends "that ethnography is, from beginning to end, enmeshed in writing" (Clifford 1988:25) and that writing is properly regarded as "central to what anthropologists do both in the field and thereafter" (Clifford 1986:2). Geertz would seem to concur. "It is clear," he says, "that anthropology is pretty much entirely on the side of the 'literary' discourses rather than 'scientific' ones" and that "ethnographies tend to look as much like romances as they do like lab reports" (Geertz 1988:8).

It is certainly unarguable, as Marcus and Cushman (1982:29) contend, that the implicit genre conventions of ethnographic writing deserve explicit scrutiny, since "ethnographic description is by no means the straightforward, unproblematic task it is [sometimes] thought to be in the social sciences, but a complex effect, achieved through writing and dependent upon the strategic choice and construction of available detail." The specific changes that interpretive anthropologists have proposed in the ways ethnographies are traditionally written, however, may be somewhat more debatable. Stoller (1986:69), for instance, suggests that "we need to acknowledge in the text the presence of an ethnographer who engages in dialogue with his or her subjects." Whether such an acknowledgment would appreciably further the anthropological enterprise remains an open question. As Marcus and Cushman (1982:26) note, "whether ethnographies can . . . balance both *reflection on* understanding and *an* understanding itself in a single text is still largely unresolved by these [interpretive anthropological] experiments."

Postmodern Ethnography and Postprocessual Archeology

Within anthropology, the influence of the interpretive approach has not been restricted to ethnography and ethnographic writing. Contem-

porary archeology has felt the impact of interpretive critiques as well, and it is evident there that the goals of the interpretive program extend well beyond the analysis of writing conventions. Bruce Trigger (1991:551) observes that "archeologists [are] active participants in one of the major debates that is currently going on in the social sciences," namely the debate between scientific and humanistic approaches to knowledge. Archeologists who favor the scientific approach, generally called "processualists," see themselves as heirs to the New Archeology of the 1960s and "believe that a positivist approach provides the key to good archeology" (Trigger 1991:553). Archeologists who favor the humanistic approach, generally called "postprocessualists," see themselves as allies of contemporary postmodernists and "emphasize the relativistic nature of data . . . [and] the importance . . . of the present-past dialectic" (Redman 1991:299). The processualists are epitomized by Lewis Binford (1962; 1981; 1986; 1989), the postprocessualists by Ian Hodder (1982a; 1982b; 1986; 1987).

The premises and goals of postprocessual archeology are virtually identical with those of postmodern ethnography. Like postmodern ethnographers, postprocessual archeologists embrace humanistic epistemological assumptions. "The salient feature [of postprocessualism]," according to Spaulding (1988:269), "appears to be rejection of science and 'positivism,' including rejection of the possibility of objective observation." Like postmodern ethnographers, postprocessual archeologists draw attention to the imbalances of political power between professional researchers and the subjects of their research and to the implications that imbalance has for the legitimacy of the researchers' claim to knowledge. Shanks and Tilley (1987:186) maintain that "archaeology is to be situated in the present as discourse in a political field, and as a practice located in relation to structures of power." And like postmodern ethnographers, postprocessual archeologists affirm humanistic value positions. As Watson and Fotiadis (1990:621) explain, "the postprocessualists believe that the processualist approach took the soul out of archeology and out of the cultural past by denying, or at any rate ignoring, the basic humanity of those who created the archeological record."

In the final analysis, the central concern of postmodern ethnography and postprocessual archeology—of interpretive anthropology, in other words—is the concern with the question of epistemological authority. Interpretive anthropology poses some fundamental questions: "How well does ethnography [or archeology] portray other cultures? To what extent can ethnography [or archeology] be true?" (Birth 1990:550). The answers offered by interpretive anthropology are decidedly restrictive:

meaning is subjective, truth is contextual, knowledge is elusive. Clifford (1989:562) insists that "*any* claim to authenticity must always be tactical, politically and historically contingent." For interpretive anthropologists, as Birth (1990:550) explains, "a purely objective ethnography is impossible, because ethnography is determined by context, rhetoric, the institutions in which it is written, the limitations of the genre, politics, and its historical situation." Moreover, no ethnography could represent all the disparate voices that make up a culture, so every ethnography is necessarily incomplete. As a result, no ethnographer or archeologist can ever claim to speak with absolute authority about the subject of his or her research.

The Two Premises of Interpretive Anthropology

What follows, then, for anthropology? What should be its goals, and how should those goals be pursued? Interpretive anthropologists answer, of course, that the humanistic approach should be used to pursue the interpretation of cultures. Anthropology cannot aspire to attain objective knowledge, they maintain, but should content itself with achieving partial insights. Implicit in that answer are the two fundamental premises of the paradigm. Interpretive anthropology assumes, first, that the goal of anthropology should be the *evocation and interpretation* of cultural variability (in contrast with scientific anthropology, which assumes that the goal of anthropology should be the *description and explanation* of cultural variability); second, interpretive anthropology assumes that scientific knowledge of human affairs, which entails the description and explanation of objective fact, is unattainable. Each of these two premises deserves a few words of amplification.

Premise 1: The goal of anthropology should be the evocation and interpretation of cultural variability. Interpretive anthropologists, as we have seen, explicitly reject the goals of scientific anthropology. Evocation and interpretation, they argue, should supplant rather than supplement description and explanation. Tyler (1986b:130) asserts that "concepts such as 'facts,' 'description,' 'generalizations,' 'verification,' and 'truth' . . . have no parallels either in the experience of ethnographic fieldwork or in the writing of ethnographies." Geertz suggests that anthropological knowledge is much more closely linked to the intuitive insights of the humanities than to the analytical discoveries of the natural sciences. In his words, understanding in anthropology "is more like grasping a proverb, catching an allusion, [or] seeing a joke" (Geertz 1979:21). Jackson (1989:2), to cite

another example, also prefers to evoke and interpret rather than describe and explain: "it is the character of lived experience I want to explore," he writes, "not the nature of man."

However, while interpretive anthropologists agree that the goal of anthropology should be evocation and interpretation, they do not agree about the purpose of such evocation and interpretation. Clifford Geertz, as noted earlier, is virtually alone in his aspiration to have interpretive anthropology achieve nomothetic generalizations, but nowhere in his work does he claim significant success in that endeavor. Indeed, in the years since the publication of *The Interpretation of Cultures*, his ambitions for interpretive anthropology have become increasingly more modest. Geertz (1983:5) has characterized his career in its later stages as little more than "an effort . . . to understand how it is we understand understandings not our own," and most recently he has argued that "the job of ethnography, or one of them anyway, is indeed to provide, like the arts and history, narratives and scenarios to refocus our attention . . . [in order to] make us visible to ourselves" (Geertz 1994:463).

Other than Geertz, Marcus and Cushman (1982:66) are among the very few interpretive anthropologists who have pleaded with their colleagues not to "lose sight of the goal of constructing systematic knowledge of cultures." Their plea has gone largely unheeded, however. Tyler (1986a:135) is one of many interpretive anthropologists who have no such ambitions: "post-modern ethnography," he declares, "aims not to foster the growth of knowledge but to restructure experience." Elsewhere, Tyler (1986b:125) says that the purpose of interpretive anthropology is "to provoke an aesthetic integration that will have a therapeutic effect"; as far as he is concerned, the function of a postmodern ethnography is "to reintegrate the self in society and to restructure the conduct of everyday life" (Tyler 1986b:135). For Wilk (1991:3), the "goal of humanistic anthropology" is an "increased awareness of one's existence." Marcus and Fischer (1986:1) regard interpretive anthropology as a vehicle for "self-reflection and self-growth." Bruner (1986a:4) advocates an anthropology that would explore "how individuals actually experience their culture, that is, how events are received by consciousness."

Scientific anthropologists, not surprisingly, have been sharply critical of the goals of interpretive anthropology. Keesing (1987:161), for example, declares that "our task [as anthropologists] goes well beyond interpreting cultural meanings." There is nothing objectionable in evocation per se, he suggests, nor is there anything inherently wrong with contextual interpretations, but neither activity is sufficient justification for anthropological research. If interpretive anthropology "is not to be yet another passing

phase and fad," Keesing (1987:169) argues, "anthropology as interpretive quest will have to be situated within a wider theory of society." Jarvie expresses his agreement with a thorough condemnation of the goals of interpretive anthropology:

> Anthropology . . . is not general curiosity about exotics (including ourselves seen as exotics) the main methodological problem of which is then how we are to conduct the study, description, representation, satisfaction of this curiosity. . . . Anthropology is, rather, a continuous tradition of debate around certain problems concerning humankind. . . . The debate was initiated because its participants thought we might make some progress with the problems—get nearer to the truth—or, if you prefer, eliminate some of our worst errors. (Jarvie 1988:429)

Interpretive anthropologists are little swayed by such arguments, however. If scientific anthropologists think the goals of interpretive anthropology are trivial and unworthy, interpretive anthropologists think the goals of scientific anthropology are naive and unrealistic. From the point of view of interpretive anthropology, the discipline has no choice in the matter: evocation and interpretation are the only appropriate goals for anthropology because they are the only goals anthropology could ever possibly attain. That, obviously, brings us to the paradigm's second fundamental assumption.

Premise 2: Scientific knowledge of human affairs, which entails the description and explanation of objective fact, is unattainable. Two principal lines of argument are used by interpretive anthropologists to justify this conclusion. The first maintains that the epistemological procedures of science are the product of a particular cultural tradition and hence have no greater claim to authority than the epistemological procedures of any other cultural tradition. The second holds that the scientific quest for objective knowledge is unavoidably doomed, either because the subject matter of anthropology defies objective description or because all knowledge is by its nature subjective.

The first argument is quintessentially anthropological; its fundamental premise stems from the concept of cultural relativism. Interpretive anthropology, according to Tyler (1984:328), "denies that the discourse of one cultural tradition can analytically encompass the discourse of another cultural tradition." Clifford (1988:10) argues that "all authoritative collections, whether made in the name of art or science, are historically contingent and subject to local reappropriation." Scholte (1974:431) draws attention to the "obvious" point that all "intellectual paradigms, includ-

ing anthropological traditions, are culturally mediated." Pandian (1985:1) attempts to demonstrate "how anthropological concerns are linked with cultural concerns of the West and how anthropology has a social function in the West." Rabinow (1986:241) maintains that the Western "constitution of reality" is "exotic" and that scientific "claims to truth are linked to social practices."

The second argument in support of the premise that objective knowledge is unattainable is essentially philosophical; its roots can be found in the concept of epistemological relativism. In one of its principal formulations, this argument holds that the subject matter of the human sciences makes the application of the scientific method either impossible or impractical. This idea achieves one of its more authoritative articulations in the work of the philosopher Peter Winch (1958), but it is one that has been adopted by a number of anthropologists. Rabinow and Sullivan (1979:5–6), for example, contend that evocation and interpretation are the only possible approaches to the study of "the human world," since "the web of meaning constitutes human existence to such an extent that . . . there is no outside, detached standpoint from which to gather and present brute data." Similarly, Sperber (1985:9) argues that "it is impossible to describe a cultural phenomenon . . . without taking into account the ideas of the participants," and he maintains that ideas "cannot be described but only interpreted."

In another of its frequent formulations, the argument that scientific knowledge of human affairs is unattainable derives from the premise that all knowledge is by its nature subjective. James Clifford (1989:562), for example, maintains that "*any* claim to authenticity must always be tactical, politically and historically contingent" (emphasis in original). Among interpretive anthropologists, however, Stephen Tyler is the leading proponent of this view. He suggests that the scientific method, instead of achieving objective knowledge about the world, succeeds only in achieving consensus within the subculture of science. "[A]greement among scientists," Tyler (1986b:124) says, has become "more important than the nature of nature," and he openly declares that "scientific discourse, particularly in the social sciences, is deeply mendacious" (Tyler 1984:329). Interpretive anthropology, Tyler (1984:328–29) explains, necessarily "takes discourse itself as its object" of study, because "worlds beyond discourse [are] possible only inasmuch as they are implicated by a discourse."

Many interpretive anthropologists, in fact, dismiss the notion of objective reality as a chimera. Tyler (1986b:135) refers at one point to the "scientific illusion of reality," a viewpoint shared by Jackson (1989:13–14):

"the traditional empiricist's hankering after order and control is to be seen as just one of many consoling illusions, one stratagem for making sense of an unstable world, not as an 'accurate representation of reality' or a privileged insight in to the way the world 'really' works." The scientific method, according to Tyler, conveys no advantages in the search for knowledge. "Reason," he claims, is simply "the means by which we justify the lies we tell," and he insists that "no one has ever demonstrated the independence of reason, of logic and mathematics, from the discourses that constitute them" (Tyler 1986a:37).

The Errors of Interpretive Anthropology

Now to the crux of the matter. I am convinced that interpretive anthropology is fundamentally in error in both of its essential premises. The goal of anthropology *must* involve more than merely the evocation and interpretation of cultural variability, and anthropology *can* aspire to objective descriptions and explanations of human affairs. I have come to these conclusions despite the fact that I have long maintained a sympathetic appreciation for the efforts and insights of interpretive anthropologists, as I explained in *The Human Enterprise* (Lett 1987:110–26). Over the years, however, my admiration for interpretive anthropology has diminished as my impatience with its inadequacies has increased.

In 1991, I published a critique of interpretive anthropology in the *Journal of Anthropological Research* entitled "Interpretive Anthropology, Metaphysics, and the Paranormal" (Lett 1991b). In that article I attempted to demonstrate that "the epistemological dangers of the interpretive perspective are readily apparent when that perspective is applied to claims of paranormal phenomena" (Lett 1991b:309), and I argued, contra the claims of interpretive anthropology, that evocation and interpretation cannot be regarded as sufficient anthropological goals.

Instead, as I stated, "the goal of anthropology must include description of the objective context of the beliefs that are to be evoked and interpreted; otherwise evocation and interpretation become pointless exercises in fantasy" (Lett 1991b:314). I referred to several interpretive case studies to illustrate my argument, including Luhrmann's (1989:16) analysis of witchcraft in contemporary England in which she claims that whether "magical rituals can alter physical reality or not is beside the point." I countered that the truth about paranormal claims is always very much to the point, and I insisted that anthropologists are compelled by logical necessity to declare the falsity of paranormal beliefs.

The Epistemological Relativism of Interpretive Anthropology

Although I was not aware of it at the time, Ernest Gellner had used the same sort of illustration to make precisely the same argument three years previously in an article published in the *American Scholar*. Gellner (1988:26) cogently observed that "an anthropologist who would explain witchcraft beliefs and practices of a given society by saying, 'Well, as a matter of fact, in their country, witchcraft works, like what they say,' would simply not pass muster. . . . In fact, what the anthropologist does do is explain how witchcraft beliefs can function notwithstanding their falsity." Gellner went on to argue forcefully against the kind of "murky relativism" that is not uncommon in interpretive anthropology. He explicitly affirmed the objective superiority of the scientific approach and the privileged claim to knowledge that science makes:

> Cultures are not cognitively equal, and the one within which alone anthropology is possible cannot really be denied a special status. The nature and justification of that pre-eminence is a deep and difficult matter. But it springs from something far more important that the arrogance of an imperial class. It is linked to the very possibility of reason. (Gellner 1988:29)

I first became aware of Gellner's article when I read *Hermes' Dilemma and Hamlet's Desire*, by the interpretive anthropologist Vincent Crapanzano. In the introduction to his book, Crapanzano refers disparagingly to Gellner's article. Other than to fault Gellner for not "specifying what he [Gellner] means by 'reason,'" however, Crapanzano (1992:7–8) does not address the substance of Gellner's argument; he simply dismisses Gellner's essay as "a long polemic" founded on "shaky footing." After quoting the passage from Gellner's article that I have quoted above, Crapanzano comes to a sweeping conclusion:

> With these words Gellner wipes out the very possibility of anthropology, for an anthropologist has to begin his research with an openness—a bracketing off, however unsuccessfully, of his prejudices—and pre-understandings. Gellner even cuts himself off from other anthropologies, coming from other societies with other values. (Crapanzano 1992:7)

Crapanzano (1992:8) goes on to claim that "few anthropologists would of course publicly subscribe to Gellner's views." I am not sure that Crapanzano is correct on this point (to be honest, I hope that he is mistaken),

but in any event I wish to declare publicly that I, for one, could not possibly disagree with Crapanzano more drastically or concur with Gellner more completely. Crapanzano's contention that "reason" is simply a cultural prejudice that must be abandoned in order to pursue anthropological research is the most misguided and pernicious argument in our discipline today. The concept of "other anthropologies" is (or at least should be) as thoroughly absurd as the notion of "other physics" or "other chemistries" or "other biologies." I cannot state this point too emphatically: an anthropology that was *not* based on reason would be both intellectually indefensible and morally irresponsible.

Admittedly, these convictions are expressed in strong, unequivocal language, and I realize that I risk alienating those who do not already agree with my perspective. Many people are understandably uncomfortable with extreme positions, preferring instead to seek moderation in a compromise between opposing viewpoints. That is often the wisest course, but compromise is not always warranted, and extreme positions are not inevitably unjustified. It is possible for one side in a debate to be entirely right and the other entirely wrong, and any compromise in those circumstances will result in a position that is at best only partially correct. I am convinced that this is just such a case. The argument that reason is simply a cultural prejudice *is* pernicious, in the full sense of the word: it is fallacious, misleading, injurious, and potentially immoral. I will not ask you to accept such an extreme assertion at face value, however. Instead, I intend to explain, as thoroughly and carefully as I can, the entire chain of reasoning that leads to that conclusion. Gellner is certainly correct that justifying the "pre-eminence of reason" is a "deep and difficult matter," but he is equally correct in insisting that it can be done. If you will suspend your disbelief until the end of chapter 5, I think you will be persuaded to agree.

The Preeminence of Reason

Thus the task of this book is to delineate and defend the fundamental principles of rational inquiry. Crapanzano's challenge is one that must be answered: the precise meaning of the term "reason" should be specified, and that is what I intend to do in the chapters that follow. Contra Crapanzano and his ilk, reason *is* a preeminently valuable achievement of the human intellect. Cultural phenomena *are* amenable to rational inquiry, and objective knowledge *is* possible. It is most definitely not an unjustified prejudice of Western culture to claim a "privileged insight" for the scientific viewpoint. Science is more than ethnoscience, and scientific

knowledge is more than a "consoling illusion," much more than simply a "stratagem for making sense of an unstable world." Far from being "the means by which we justify the lies we tell," reason is the only reliable means we have of distinguishing between truth and falsity. Moreover, any legitimate set of humanistic values must be founded upon a bedrock of objective knowledge, because reason is also the only reliable means we have of distinguishing between right and wrong. The remainder of this book is devoted to a justification of these claims.

2

The Nature of Knowledge

What is reason? At first glance, the question seems needlessly abstruse, since the term is both ordinary and familiar. "Reason," as the dictionary defines it, refers simply to "sound judgment and good sense." "To reason" is "to think through logically," or "to employ the power of intelligent and dispassionate thought." But what exactly constitutes sound judgment? How is good sense distinguished from bad sense? What does it mean to think logically? What, for that matter, is knowledge? How should we seek to acquire it? Is it possible to achieve certainty? Even a passing familiarity with epistemology (the branch of philosophy that studies the nature and source of knowledge) reveals the surprising complexity of these questions.

Philosophical Analysis

Complex, yes, but intractable, no. There are well-established criteria that distinguish reasonable modes of thought from unreasonable ones, and they can be clearly specified. To do so, however, requires an extensive foray into philosophical analysis, and therein lies a potential difficulty. Many people regard the discipline of philosophy with understandable suspicion. To be "philosophical," it is often perceived, is to be abstract at best and addled at worst. (It was philosophers, after all, who pondered the question of how many angels could dance on the head of a pin.) The contemporary American philosopher Paul Kurtz (1986:3) considers much of professional philosophy to be "irrelevant"; he compares it to "an ingrown toenail, turned within itself, festering with sharp linguistic distinctions and painful sophistries." (To be fair, of course, the same criticism could be leveled with some degree of justification against anthropology and many other academic disciplines in the late twentieth century.)

At the same time, however, as Kurtz (1986:3) also observes, the study of philosophy can provide many practical benefits, including "intellectual wisdom, logical clarity, and moral excellence." The term "philosophy," after all, simply means "love of wisdom." As such, all philosophical activity is ultimately directed at two undeniably valuable goals: clarity of thought and precision of expression. In the words of another contemporary American philosopher, Reuben Abel (1976:xxiii), "philosophy is the kind of insight into fundamental questions that first requires that we make clear exactly what we are asking." The best philosophical analysis, then, is anything but esoteric and irrelevant. It is instead fundamental and indispensable for any form of intellectual inquiry, whether scientific or humanistic.

Accordingly, I intend to demonstrate the value of philosophical analysis by examining the epistemological issues that divide scientific anthropologists from their humanistic colleagues. Debates over epistemology invariably lie at the heart of paradigmatic conflicts in all disciplines (Lett 1987:9–38), and this is certainly true of the debate between the scientists and the humanists in anthropology. Unfortunately, much of the contemporary discourse coming from the two camps consists of partisan polemics devoid of any genuine philosophical insight (Crapanzano's critique of Gellner provides a clear example).

I think I can offer an alternative, and I think I can do so while avoiding the pitfalls of academic philosophy. My goal here is to outline, as clearly and as comprehensively as possible, the criteria inherent in a reasonable approach to knowledge. Since this is not intended as an original contribution to epistemological analysis, I will not be concerned with the esoteric subtleties that interest professional philosophers. I am interested instead in the basic insights that can be gleaned from the study of epistemology. It is my intention to explore a very fundamental and essential question: how can we achieve reliable knowledge? I must therefore begin at the beginning, and start with the most basic question of all: what is knowledge?

Analytic Propositions

The verb "to know" is used variously in English to refer to knowledge-by-acquaintance (I knew Charles Wagley), knowledge-by-ability (I know how to sail), and knowledge-by-description (I know that Indonesia is the fourth most populous country in the world). Of these three senses of knowing—knowing *who*, knowing *how*, and knowing *what*—epistemological analysis is primarily concerned with the third. When we speak of

knowing *what* (or, for that matter, of knowing where, or knowing when), we are talking about factual knowledge. A *factual* assertion is a statement that is either true or false. A claim to factual knowledge thus takes the form of the statement "I know that such and such is the case."

Such claims to knowledge are also called propositional statements. A *propositional* statement is an assertion that makes (i.e., proposes) a claim that is either true or false. There are two types of propositional statements: analytic and synthetic. An *analytic* proposition is either true or false on the basis of the meaning of its terms. If it is true (e.g., all unmarried men are bachelors), it is called a tautology. A *tautology* is true by definition, and it conveys information about the meaning of words only. A tautology conveys no information whatsoever about the world of experience. If the analytic proposition is false (e.g., all married women are single), it is called a contradiction. A *contradiction* is false by definition, and it conveys no information whatsoever. A contradiction is completely meaningless, even though its words may be familiar and its grammatical structure may be recognizable.

Analytic propositions are sometimes called *a priori* statements, because their truth or falsity is known prior to any appeal to experience. An analytic proposition that makes a true assertion is immune to revision on the basis of any evidence. Because it is known to be true in advance, regardless of whatever could happen, it is absolutely certain. That degree of certainty, however, means that a true analytic proposition gives no information whatsoever about the world of experience. For example, the proposition that "Either all anthropologists are rational, or at least some are not" is clearly true, but it tells us nothing at all about the discipline of anthropology or its practitioners; it simply shows us how the terms "all," "or," "some," and "not" are used in English.

Synthetic Propositions

In contrast, a *synthetic* proposition is either true or false on the basis of the evidence of experience. It purports to convey information about the world by telling us what evidence we will encounter if the statement is true and how that evidence will differ if the statement is false. Thus the proposition that "The American Anthropological Association has more than ten thousand members" is either true or false, and a review of the organization's records would determine which. A proposition need not be provable in order to be synthetic, however. For example, consider these two propositions: 1) "There is life in at least one of the ten thousand galaxies in the Hercules Cluster"; and 2) "A scientifically unrecognized

hominoid called Sasquatch (i.e., Bigfoot) lives in the Pacific Northwest." The first proposition is highly probable, the second enormously improbable, but neither can be absolutely demonstrated to be either true or false on the basis of presently available evidence. Nevertheless, both propositions are synthetic, because both are provable *in principle*; the evidence would matter in each case.

Synthetic propositions are sometimes called *a posteriori* statements, because their truth or falsity can be determined only after the examination of evidence obtained from experience. For example, anthropologists have offered the synthetic proposition that marriage is a cultural universal, with "marriage" defined as a culturally recognized union of two or more people whose purposes include socially sanctioned sexual activity and reproduction. The truth or falsity of that proposition cannot be known intuitively; it can be determined only by an exhaustive review of the ethnographic record. Similarly, anthropologists have claimed that mother-son incest is condemned in every culture in the world; again, the question of whether that claim is true or false can be resolved only by appeal to the ethnographic evidence.

The Nature of Synthetic Truth

I do not mean to suggest by these examples that the determination of the truth or falsity of a synthetic proposition is invariably a straightforward matter. Throughout the history of philosophy, a substantial portion of epistemological analysis has been devoted to the ticklish problems of perception and truth. Our knowledge of the external world is notoriously problematic. It is demonstrably true that human sensory perception is an intricate act of active inquiry, dependent upon context, experience, and predisposition, rather than a simple act of passive reception. The range of our perceptions is significantly restricted by the limits of our sensory organs and the instruments we have devised to extend those limits. Moreover, there is considerable disagreement among epistemologists about the nature of truth. At what point, using what criteria, do we decide that a given synthetic proposition is "true"?

These problems are very real, but they are not insoluble. I will return to these issues when I discuss the nature of science and the procedures essential for a reliable approach to knowledge. For the moment, however, I will say that I am persuaded by those philosophers who favor a pragmatic definition of truth. There is an inescapable human dimension to knowledge: a true proposition is one that consistently and reliably satisfies our human need to understand, predict, and control phenomena. If a

proposition is consistent with all available evidence, if it does not conflict with other propositions considered to be true, and if it is vulnerable to revision in the light of additional evidence, then it is true. Synthetic truth is thus tentative, although it is not arbitrary. Again, more on this later.

Analytic and Synthetic Propositions Summarized

Let me pause briefly to recapitulate the major points so far. Propositional statements, which make assertions that are either true or false depending on the evidence, come in two varieties: analytic and synthetic. The evidence that is used to determine the truth or falsity of an analytic proposition consists of the meaning of the terms used in the statement. The evidence that is used to determine the truth or falsity of a synthetic proposition consists of anything and everything that could be experienced through any perceptual means whatsoever (I will return later to the question of which kinds of experiences and perceptions are reliable and trustworthy and which are not). Analytic statements, such as the statement that all hominids are anthropoids, are either true or false by definition. Synthetic statements, such as the statement that the earliest hominids appeared in Africa, are either true or false on the basis of experience. Analytic propositions, remember, convey information only about the meaning of terms, while synthetic propositions convey information about the world of experience.

Emotive Statements

There is a third kind of statement that people can make when they claim to know something, however, one that is neither analytic nor synthetic. That third kind of statement is called an emotive statement. An *emotive* statement, as the term suggests, is one that communicates the speaker's feelings and nothing else. It might consist simply of an exclamation ("Oh my God!"), or it could be a declaration of emotion ("Woe is me"). The most common form of emotive statement, however, is one that ascribes value or disvalue to some particular entity, action, event, or activity. A *value* statement praises or blames, commends or condemns, prescribes what ought or ought not to be done. It can be recognized by the implicit or explicit use of such words as "good" or "bad," "better" or "worse," "right" or "wrong," "moral" or "immoral," "just" or "unjust."

By way of example, consider the following statements from the Revised Principles of Professional Responsibility adopted by the American Anthropological Association in 1990 (Fluehr-Lobban 1991:274–79):

"The aims of all their professional activities should be clearly communicated by anthropologists to those among whom they work"; "Whether they are engaged in academic or nonacademic research, anthropologists must be candid about their professional identities"; "Anthropologists have responsibility to be truthful to the publics that read, hear, or view the products of their work"; "Anthropologists must not represent as their own work, either in speaking or writing, materials or ideas taken directly from other sources"; "Anthropologists should acknowledge orally and in print student assistance in research and preparation of their work"; "In all dealing with employers, clients, and sponsors anthropologists should be honest about their qualifications, capabilities, and aims"; and, finally, "Anthropologists should be honest and candid in all dealings with their own governments and host governments." It is evident from these injunctions that anthropologists hold the value of honesty in high esteem: candor, sincerity, and truthfulness are judged to be good, while secrecy, dissimulation, and misrepresentation are judged to be bad.

Value Statements

In and of themselves, value positions have no factual content. The values for life, liberty, and the pursuit of happiness are simply preferences; they are normative rather than existential, and as such they make no propositional assertions. If I say I value beauty, or intelligence, I am making no factual claims (other than, of course, the implicit claim that I am being sincere in my assertion). However, if I say that the paleoanthropologist Loren Eiseley wrote beautifully or that the cultural anthropologist Charles Wagley was intelligent, then I am making factual claims that can be judged against the evidence.

Value statements, in fact, often contain synthetic propositions. For example, if I claimed to know that Franz Boas, who is generally regarded as the father of American anthropology, was a good anthropologist, it would be possible to determine the truth or falsity of my claim by examining the evidence (provided of course that I defined what I meant by "good anthropologist"). If I said a good anthropologist was one who published prolifically, then the evidence would show that I had made a true synthetic statement: Franz Boas, whose bibliography contained hundreds of citations, was a good anthropologist. Conversely, if I stipulated that a good anthropologist was one whose doctoral dissertation made some significant contribution to anthropological knowledge, then the evidence would show that I had made a false synthetic statement: Dr. Boas, whose dissertation dealt with the color of seawater, was not a good anthropolo-

gist after all (indeed, since Boas received his doctorate in physics, he was not, strictly speaking, even an anthropologist at all). In either case, however, my synthetic proposition would have remained embedded in an emotive statement. It is not necessary to know precisely what I mean by "good" to recognize that I have expressed a value position (it is, of course, essential to know precisely what I mean by "good" in order to *evaluate* my value position).

Evaluating Value Statements

It may be helpful to pursue this example further. If someone were to disagree with the criteria I had specified for a "good anthropologist" (which would be quite likely, given these examples), then it would be pointless to examine Boas's bibliography or dissertation to determine whether he was in fact "good." In that case, the debate would focus entirely on value questions: What does it mean to say something is "good"? What makes my definition of "good" better than someone else's? On the other hand, if I were to decline to specify what I meant by "good anthropologist"—if I were simply to assert my judgment that Franz Boas was a good one—then my statement would contain no factual information and would be purely emotive. Again, in that event it would be pointless to examine the facts in the case, and there would be little profit to be gained in discussing the issue with me.

Fact and Value in Anthropology

These kinds of difficulties are commonplace when attempting to evaluate emotive statements. Often, people will decline to specify the criteria inherent in their value judgments, or the criteria they do specify reveal themselves to be questionable or even objectionable. Consider, for example, this statement from the interpretive anthropologist Paul Stoller:

> Anthropology has one strength: ethnography. . . . Despite its taken-for-granted status, ethnography, rather than cultural materialism, structuralism, or any other "ism," has been and will continue to be our core contribution. It is time to appreciate ethnographers, who produce works of art that become powerful vehicles of theoretical exposition. (Stoller 1986:56)

This is obviously and explicitly a value statement: Stoller's contention is that ethnography is the most valuable part of anthropology and that it should be more highly valued by anthropologists. His statement, however,

is filled with vague and undefined terms. Is it true that ethnography is the discipline's "one strength"? We cannot decide until we know what Stoller means by "one strength." Is ethnography our "core contribution"? Again, we would have to know the meaning of the phrase before deciding. In what sense is Stoller using the phrase "works of art"? Surely he is not implying that anthropology has produced ethnographies comparable to the masterpieces of world literature. Is he suggesting, as he seems to be, that ethnography should be regarded as the central feature of the discipline? If so, he faces a significant challenge from those anthropologists who believe the discipline's primary mission is to describe and explain the entire course of human biological and cultural evolution and that the role of ethnography is to provide only part of the evidence needed in that endeavor.

Stoller is certainly entitled to his values and to their free expression. All anthropologists take their personal values into consideration when making choices about career directions and research topics, as Stoller obviously has. If he wishes to persuade other anthropologists to adopt his values, however, Stoller has an obligation to state his values as explicitly as possible and to specify as clearly as possible the assumptions that link his premises and conclusions. Regrettably, his failure to do so is typical of anthropology, perhaps of all social science. The scholarly literature is littered with equally vague and equally tenuous emotive statements. Whenever emotive statements are presented as factual statements, they can only hinder the pursuit of propositional knowledge.

Propositional and Emotive Statements

Thus it is crucially important to distinguish between propositional and emotive statements. Whereas propositional statements assert factual claims that are either true or false on the basis of the evidence, emotive statements assert value preferences that are either attractive or unattractive on the basis of psychological orientation. Therefore the evidence that is relevant to the truth or falsity of factual claims has no direct bearing on the validity of value preferences. Individuals can sometimes be persuaded to recognize that their value judgments are founded upon an incorrect perception of the facts, it is true. It is also true that individuals can sometimes be persuaded to adopt or abandon values on the basis of some emotional appeal or logical argument. However, no evidence from the world of experience could ever guarantee that people would be *compelled* to alter their value positions in the same way that factual evidence can be sufficient to compel people to alter their propositional beliefs. For example, it

would be possible for a reasonable person to disagree with the value assertion that "love is good" (perhaps by arguing that love is inevitably painful), but no reasonable person could disagree with the factual assertion that "the earth is a sphere."

This does not mean, incidentally, that value statements are immune to reasonable critique. It is possible to construct highly persuasive arguments that generosity is more praiseworthy than miserliness, that courage is more laudable than cowardice, and that nobility is more commendable than pettiness—it is just not possible to demonstrate conclusively that these things are necessarily so. (After more than two millennia of scholarly philosophy, no one has been able to "prove" that morality is better than immorality.) What all this does mean is that facts and values are fundamentally different in kind (even though particular value judgments are often based on factual premises).

Subjective and Objective Statements

There is an additional complexity that needs to be considered at this point. When confronted with either propositional or emotive assertions, it is possible to respond from either a subjective or an objective point of view. If we are being *subjective*, we take ourselves as the relevant subject matter and focus on our own states of thinking and feeling. If we are being *objective*, we attempt to transcend ourselves and approach the question at hand without prejudice, illusion, or distortion. From a subjective perspective, our own thoughts and feelings are everything; from an objective perspective, they are entirely irrelevant. From a subjective point of view, we would ask ourselves "Do *I* believe this?" in response to a propositional assertion, and "Do *I* agree with this?" in response to an emotive assertion. From an objective point of view, we would ask ourselves "Is this *true*?" in response to a propositional assertion, and "Is this *right*?" in response to an emotive assertion.

Let me anticipate a likely objection before moving on. Clearly the distinction between subjectivity and objectivity is a relative one. Obviously it is impossible for any one of us to ever be fully objective, because it is literally impossible for us to step outside ourselves. Our knowledge of the external world can come only through our own personal sensory organs; all of our thoughts and perceptions are unavoidably embedded in the full context of our personalities, life histories, and expectations. As living beings who experience pain and pleasure, we have a vested interest in the outcome of events; our predilections can color our perceptions just as much as our preconceptions.

Objectivity, then, is an ideal. It is one that is never fully realized, admittedly, but it is an extremely valuable heuristic device nonetheless. When attempting to evaluate propositional assertions, it is useful for us to consider the nature of our subjective biases. Do we believe a given assertion because it is objectively true, or do we believe because we would like to believe? Is the assertion comforting, intriguing, or otherwise attractive on subjective grounds, or is it well substantiated on objective grounds? If we are honest with ourselves and attempt to be critically aware of our preconceptions and predispositions, it is possible to minimize our errors in judgment. If we do not make a consistent attempt to be objective, on the other hand, we will be liable to egregious mistakes in reasoning, because our subjective biases are notoriously unreliable guides to propositional knowledge.

By way of example, consider the case of Grover Krantz, a professor at Washington State University and one of the few professional anthropologists who believes in the existence of Sasquatch (the large hominoid, also known as "Bigfoot," that supposedly lives in the forests of the Pacific Northwest). Krantz is a biological anthropologist whose knowledge of primate evolution is well respected, but with regard to the question of Bigfoot, he has allowed his subjective biases to override his objective judgment. In a book describing the purported evidence for the existence of Sasquatch, Krantz (1992:131) repeatedly admits that his "first reaction" to tales of Bigfoot and other stories of unusual phenomena has always been that he "wanted to believe." For Krantz, the world would be a less interesting place without Bigfoot, and he has persuaded himself that what he would like to be true is true. Further, Krantz apparently takes some satisfaction in his self-perceived role as a lone prophet valiantly pursuing the truth in a prejudiced world that is hostile to his innovative message. He looks forward to the day when the existence of Sasquatch is proved and his "own prestige in the scientific world will rise a couple of notches" (Krantz 1992:273).

I will return to this example later and explain in detail why an objective appraisal of the evidence clearly reveals that Krantz is mistaken. For the moment, however, my point is that even intelligent and well-informed people are susceptible to subjective bias, as Krantz illustrates with his illogical belief in Sasquatch. The vast majority of other biological anthropologists, unhampered by Krantz's personal predilections, have no difficulty in being objective about the question of Sasquatch. As a result, the vast majority of biological anthropologists are convinced that Sasquatch does not exist, as the evidence overwhelmingly indicates. Overwhelming evidence is often insufficient to overcome our hopes and fears, however,

and that is why it is crucial to distinguish between subjective and objective approaches to knowledge.

Four Kinds of Knowledge Statements

In sum, there are four basic kinds of statements people habitually make when they claim to know something: subjective-propositional, objective-propositional, subjective-emotive, and objective-emotive. Table 2.1 illustrates these four types, with representative statements in each of the quadrants. The letter *F* in the two upper quadrants stands for any factual claim (i.e., any claim that is either true or false on the basis of the evidence, such as the claim that Neandertals deliberately buried their dead). The letter *V* in the two lower quadrants stands for any value preference (i.e., any ascription of positive or negative value, such as the assertion that prehistoric cave paintings in Lascaux are aesthetically superior to prehistoric rock engravings in Australia).

Thus, if I make a *subjective-propositional* statement (for example, "I believe Neandertals were capable of at least rudimentary speech"), I am simply declaring that I believe a particular propositional claim to be credible. It is subjective, because I am the subject of my statement. I am communicating information about myself by publicly declaring the state of my mind, and I am not necessarily claiming anything else beyond that. At the same time, my statement is also propositional, because I am speaking about a factual claim, one that is either true or false depending upon the evidence.

If I make an *objective-propositional* statement, on the other hand, (for example, "Corn was first domesticated in the New World"), I am declaring more than simply the state of my mind. I am making a declaration that transcends myself or any other individual, and I am claiming that everyone is compelled by the evidence to recognize the truth of my factual assertion.

When I make a *subjective-emotive* statement (for example, "I like the sound of English spoken with a West Indian accent"), I am declaring a personal value preference and nothing more. Implicit in my statement is the recognition that intelligent, informed people could reasonably disagree.

An *objective-emotive* statement, however (for example, "Anthropologists

Table 2.1
Four Kinds of Knowledge Statements

	Subjective	Objective
Propositional	"I believe (or disbelieve) *F*"	"*F* is true (or false)"
Emotive	"I like (or dislike) *V*"	"*V* is good (or bad)"

should strive to protect the welfare of their research subjects"), does not allow room for disagreement. When I make an objective-emotive statement I am attempting to articulate a value that all intelligent, informed, well-intentioned people would embrace without exception.

The Imprecision of Anthropological Debate

With this in mind, it is possible to appreciate the reasons for much of the confusion and imprecision in the debate between scientists and humanists in anthropology. The debate's participants frequently fail to recognize what kind of statements their opponents are making and as a result generally respond inappropriately. A subjective-emotive statement, for example, is completely irrelevant as a response to an objective-propositional statement. If someone were to claim that scarification and tattooing are common cross-culturally, it would be inappropriate for someone else to challenge that claim by responding that scarification and tattooing are ugly. Similarly, if someone were to claim that male supremacy is a cultural universal, it would be inappropriate for someone else to challenge that claim by responding that male supremacy is immoral.

Unfortunately, that is precisely the kind of dialogue in which anthropologists frequently engage. Recall Shweder's (1991:49) contention that it is wrong to deny the existence of "gods, ghosts, souls, witches, and demons" on the grounds that such a denial "degrades" the people who hold those beliefs. Shweder's argument contains both a propositional issue (the factual question of whether or not gods, ghosts, souls, witches, and demons exist) and an emotive issue (the value question of whether or not it is wrong for anthropologists to deny the existence of gods, ghosts, souls, witches, and demons). Clearly the two questions are linked—the emotive conclusion is derived from the propositional premise—but Shweder does not indicate whether his propositional and emotive statements are intended in a subjective or objective sense, which leaves his argument highly ambiguous. Consider the four possible interpretations of his reasoning:

First, Shweder may simply be making a *subjective-propositional* statement that *he* believes that gods, ghosts, souls, witches, and demons exist. If so, however, that premise hardly leads to the conclusion that it is necessarily wrong for everyone else to deny the existence of those entities. Certainly Shweder is entitled to his point of view, but if it is simply his subjective opinion that paranormal beings exist, then he must be willing to grant equal legitimacy to the subjective opinions of other people. Thus Shweder would have to recognize the right of people who do not believe in the existence of paranormal beings to declare their belief—or offer an

argument as to why it would be harmful for them to do so (see the fourth possibility below).

Second, perhaps Shweder is making an *objective-propositional* statement that gods, ghosts, souls, witches, and demons do in fact exist, which would clearly establish that it *would* be wrong for anyone to deny the existence of such entities (anyone who did so would be mistaken at best and mendacious at worst). If that is Shweder's intention, however, he is clearly mistaken, because the fact of the matter is that no such paranormal entities exist (I will explain in detail in chapter 3 how we know this to be the case, when I discuss the relationship between objectivity and empiricism).

Third, Shweder may simply intend to offer the *subjective-emotive* statement that he likes or admires or sympathizes with people who hold paranormal beliefs. Again, however, that would hardly lead to the conclusion that everyone else should avoid denying the existence of paranormal beings. If it is simply Shweder's subjective opinion that paranormal believers deserve sympathy, he must be willing to grant equal legitimacy to people who hold the subjective opinion that paranormal believers deserve disdain for their willful ignorance and extreme gullibility.

Finally, the fourth possibility is that Shweder may be making the *objective-emotive* argument that it is wrong to deny the existence of paranormal beings, regardless of the propositional merit of the beliefs, on the grounds that doing so harms the dignity and/or psychological welfare of the believers. (This may be the most accurate characterization of his position, although he does not provide sufficient guidelines for us to be certain.) If that is his argument, however, it is highly vulnerable to attack. The propositional merits of paranormal beliefs cannot be ignored; emotive conclusions always depend upon propositional premises. *If* paranormal beings *did* exist (or if the truth about their existence were unknown or unknowable), then clearly Shweder would be correct in concluding that it would be wrong to deny the existence of such beings. To do so would be presumptuous and indefensible. But *if* paranormal beings did *not* exist, then Shweder would be on much shakier ground. In that case it would be patronizing to withhold the truth from people out of some misguided concern for their feelings. Withholding the truth from people hardly respects their dignity as autonomous, rational human beings capable of responding to reality in a responsible fashion. (As it happens, it is certain that paranormal beings do not exist, for reasons that I will explain in chapter 3, so Shweder's argument is in fact insupportable in whatever form it is intended.)

The point for the moment, however, is that Shweder's argument is phrased in a manner that makes it unclear whether it is intended to be

subjective-propositional, objective-propositional, subjective-emotive, or objective-emotive. Such ambiguity frequently engenders confusion in anthropological discourse. Further confusion results when anthropologists jump back and forth from one type of statement to another or fail even to be aware of what type of statement they themselves are making. Consider Stoller's (1986:56) passage again. When he says "it is time to appreciate ethnographers" because they are responsible for anthropology's "one strength," he is presumably making an objective-emotive statement. That is, he is asserting a value that he maintains should receive universal assent (just as one would expect the objective-emotive assertion "murder is wrong" to receive universal assent). As I have already suggested, however, it would be entirely possible for a reasonable anthropologist to question Stoller's value about the preeminence of ethnography. It could be argued instead that the role of ethnography in anthropology is important but not central. Ethnography could reasonably be regarded as a means to the end of ethnology; ethnology could be viewed in turn as a necessary but not sufficient condition for anthropology, which would require the contributions of archeology, biological anthropology, and linguistics as well. Stoller could simply have made a subjective-emotive statement—"I like ethnography"—but then what force or significance would his statement have had? Stoller's claim that "ethnography . . . is our core contribution" sounds like an objective-propositional statement, but without a definition of what he means by "core contribution," we are left without any means of judging the claim's truth or falsity. The statement is thus reduced again to a subjective-emotive assertion—Stoller likes ethnography—although the manner of its phrasing has disguised that fact.

Distinguishing Propositional and Emotive Statements

This, in fact, is one of the principal difficulties in distinguishing between propositional and emotive statements: the latter are frequently disguised as the former. Not all subjective-emotive statements are explicitly preceded by the phrase "I like," as they logically should be, and not all objective-emotive statements contain immediately recognizable value terms, as they ideally should. Therefore it is necessary to have some means of testing a statement to determine whether it is propositional or emotive (some means, that is, apart from depending on the integrity and self-awareness of the speaker). Fortunately, such a means is readily available. There is a simple, logical test that can determine whether any statement is propositional or emotive, and its application requires no special knowledge, training, background, or experience.

If you wish to determine whether a given statement is propositional or emotive, simply ask yourself this question: is there any conceivable evidence that would compel the statement's author to abandon his or her position? (This assumes, of course, that the statement's author is willing to be bound by reasonable rules of evidential analysis; since belief is a matter of psychological assent, no evidence is ever sufficient to compel someone to abandon willful ignorance.) If the answer is yes, however (i.e., if there is evidence that would compel reasonable people to abandon their position), then the statement is propositional; if the answer is no, then the statement is emotive. If evidence exists *or could conceivably exist* that would prove the statement false, then the evidence is obviously relevant to the truth or falsity of the claim. (In other words, the evidence would matter.) That means that the statement is propositional, because it makes a factual assertion. On the other hand, if no evidence exists *or could conceivably exist* that would prove the statement false, then the evidence is obviously irrelevant to the truth or falsity of the claim. (That is to say, the evidence would not matter.) That means the statement is emotive, because it has no factual content. This test works invariably for a simple reason: the evidence *always* matters in the case of propositional statements, and it *never* matters in the case of emotive statements.

Let me illustrate this concept with an ethnographic example from Pakistan, a country where I lived for a time during one of my earliest cross-cultural experiences. On the streets of Karachi one frequently hears the expression "Allah wills" used as a comment about the vicissitudes of fate. If a man misses an appointment because his car breaks down, he may shrug his shoulders and say, with a combination of resignation and acceptance, "Allah wills." For devout Muslims, of course, the phrase "Allah wills" encapsulates a central element of Islamic cosmology. Since Allah is believed to be omnipotent, it follows that everything that happens in the universe happens with Allah's acquiescence. Since Allah is also believed to be omniscient and benevolent, it follows as well that whatever happens must ultimately be for the best. Such a fatalistic outlook can be a source of comfort and solace when assailed by the slings and arrows of outrageous fortune. Why was the grain eaten by rats? Because it was Allah's will. Why did your child die before reaching maturity? Because Allah willed it so. Such a concept also provides a convenient explanation for an enormous variety of phenomena. Why do the tides ebb and flow? Why does the moon wax and wane? The answer to each of these questions is the same: Allah wills.

Thus many Pakistani's regard the expression "Allah wills" as a propositional statement, and at first glance it might seem that they are correct.

The setting and rising of the sun is either the result of Allah's will or it is not; Allah either wills the monsoons to come or he does not. Ask yourself this question, however: is there any *conceivable* evidence that would *compel* devout Muslims to abandon their belief in the universal operation of Allah's will? Would the untimely death of a revered leader be proof that Allah's will was not operative? Would the persistence of hunger and disease demonstrate conclusively that some other causal force was at work? The answer, obviously, is no. No matter what happens, the devout will still adhere to their belief. For those who believe that Allah wills, the evidence will always be irrelevant. Whether it rains or does not rain, they will still insist that the weather is a product of Allah's will. The statement "Allah wills" thus has no factual content at all and communicates no propositional information whatsoever (now that you know that the sun rises in the east because "Allah wills," what do you know that you did not know before being informed of that "fact"?). When people say "Allah wills," they are simply making an emotive statement that expresses their feelings about the vagaries and mysteries of life.

Similarly, when Paul Stoller says that ethnography is the "core contribution" of anthropology, he is simply making an emotive statement that expresses his feelings about the value of ethnographic research. What conceivable evidence could compel Stoller to admit that ethnography is not anthropology's "core contribution"? If we assume that Stoller is proposing a synthetic statement, then we must know what factual claim is contained in the phrase "core contribution" before we can attempt to answer that question. What characteristics would ethnography possess if it were anthropology's "core contribution," and what characteristics would it lack if it were not? Since Stoller neglects to provide that critical information, we can only conclude that his statement is not propositional. He is either making a subjective-emotive statement (he values ethnography), or he is making an objective-emotive statement (ethnography is preeminently valuable), but in neither case is it likely that he could be convinced to abandon his position. It is true that it might be possible, using carefully constructed and politely phrased arguments, to persuade Stoller that ethnography is less valuable than he originally thought. The point, however, is that no possible evidence could *compel* him to come to that conclusion. By that simple test, Stoller's assertion is revealed to be an emotive statement.

The Test of Falsifiability

This fundamental means of distinguishing between propositional and emotive statements is one the philosopher of science Karl Popper (1959)

calls the test of falsifiability. A statement is said to be *falsifiable* if it is possible to conceive of evidence that would prove the statement false. If it is logically possible for a statement to be proven false, then the statement is propositionally meaningful (i.e., it is either true or false, and a review of the evidence will determine which). Propositional statements are always falsifiable, and all falsifiable statements are both propositional and testable. A statement is said to be *nonfalsifiable* if it is not possible to conceive of evidence that would prove the statement false. If it is not logically possible for the statement to be proven false, then the statement is propositionally meaningless (i.e., it is neither true nor false, and a review of the evidence would be irrelevant). Emotive statements are always nonfalsifiable, and all nonfalsifiable statements are either emotive or meaningless.

Falsifiability versus Verifiability

Popper's insight was to recognize that no synthetic proposition can ever be demonstrated to be absolutely true (only analytic propositions, as discussed earlier, can be absolutely certain). A synthetic proposition, after all, is a factual assertion; it is either true or false on the basis of the evidence. Thus it always remains logically possible that additional evidence could be uncovered that would call into question a proposition that had previously been supported by the evidence. Consider this synthetic proposition, which no reasonable person could doubt: "The sun always rises in the east." As far as we can determine, the evidence of the past four-and-a-half billion years supports the truth of this assertion, and everything we know about gravitation and celestial mechanics suggests that the evidence will continue to support it in the future. None of this, however, makes it *logically impossible* that the sun could rise in the west tomorrow morning. Enormously improbable, yes, but not logically impossible.

Accordingly, no amount of evidence can ever finally *prove* the truth of any factual assertion. As Popper realized, however, a single piece of contradictory evidence could easily *disprove* any factual assertion, if such contradictory evidence were uncovered. If the sun were in fact to rise in the west tomorrow morning, then the proposition "The sun always rises in the east" would have been *falsified* (i.e., demonstrated by the evidence to be false). In the pursuit of propositional knowledge, we must be continually on the lookout for falsifying evidence. If the knowledge we claim to have is genuinely propositional (i.e., if it is falsifiable), and if a relentless search has failed to uncover any falsifying evidence (i.e., if the proposition is *unfalsified*), then we are justified in making our claim to knowledge. In

that sense, I "know" that the sun always rises in the east, even though I cannot ultimately "prove" it (although I can, of course, adduce overwhelming evidence in support of that proposition). All knowledge of synthetic propositions is therefore tentative by its nature. That does not mean, however, that all claims to synthetic propositional knowledge are equally plausible. I will return to this issue when I discuss the scientific approach to propositional knowledge. For now, however, my point is simply that the test of falsifiability provides an infallible means of distinguishing between propositional and emotive statements.

Falsifiability versus Falsification

Let me mention one final example before I move on. I suggested earlier that it is impossible, on the basis of presently available evidence, ultimately to prove or disprove the synthetic proposition that "a scientifically unrecognized hominoid called Sasquatch lives in the Pacific Northwest." The evidence is overwhelmingly against the proposition, as I mentioned earlier, but the evidence is not *logically* sufficient to *prove* that Sasquatch does not exist. The problem is not that the evidence is ambiguous (it is, in fact, quite clear and compelling). Instead, the problem is a logical one: it is impossible to prove a negative.

Consider the contrast between positive and negative assertions. The proposition that Sasquatch *does not* exist is clearly falsifiable. If you are attempting to falsify that proposition, you are attempting to prove a positive statement—namely, that Sasquatch *does* exist. It is easy to imagine the kind of evidence that would decisively prove the existence of Sasquatch; a single Sasquatch skull would suffice. On the other hand, the proposition that Sasquatch *does* exist cannot, in the ultimate logical sense, be falsified. If you are attempting to falsify that proposition, you are attempting to prove a negative statement—namely, that Sasquatch *does not* exist.

That would be an impossible task. No amount of evidence you could conceivably collect could possibly *prove*, beyond any possibility of logical doubt, that Sasquatch does *not* exist. Even if you were to uproot and shred every plant in the Pacific Northwest, capture and dissect every animal, and excavate and sift every shovelful of dirt in the entire region to a depth of ten meters, the fact that you failed to uncover any evidence of Sasquatch would not provide absolute proof that Sasquatch does not exist. It would still be logically possible that Sasquatch had somehow escaped detection (perhaps by hiding in some deep undiscovered cavern), and those who wish to believe that Sasquatch exists invariably take refuge in just such fanciful rationalizations.

None of this means that it is impossible to come to a definitive conclusion about the existence of Sasquatch, nor does it mean that the claim lacks propositional content. The assertion that Sasquatch exists is falsifiable in principle, because the truth or falsity of the claim ultimately depends upon the evidence. In practice, however, any attempt at falsification must confront the issue of how much evidence is sufficient to falsify the claim. Those who wish to believe in the existence of Sasquatch demand an impossible standard of evidence before they will admit that their claim has been falsified: they demand evidence that would make their claim logically impossible. No amount of evidence, however, could prove that the existence of Sasquatch is logically impossible, just as no amount of evidence could prove that the existence of Santa Claus is logically impossible. Nevertheless, while many synthetic propositions such as these cannot be falsified beyond any *logical* possibility of error, they can be falsified beyond any *practical* possibility of error.

Sufficient evidence exists that would persuade any reasonable person to conclude that Sasquatch does not exist, and I will review that evidence in detail in the next chapter. For the moment, however, the point of this illustration is that it is necessary to have reliable guidelines for assessing and evaluating the evidence relevant to any claim. We must be able to distinguish between those propositions that *could* be true (an infinite set consisting of all propositions that are not self-contradictory) and those propositions that *are* true (a much smaller set consisting of all propositions that are congruent with objective reality). We must be able to recognize when a proposition has been falsified beyond any *reasonable* possibility of error. That brings us to the scientific approach to knowledge, which is the subject of the next chapter.

3

The Scientific Approach to Knowledge

Science is a technique for acquiring factual knowledge that combines the fundamental principles of logical analysis with practical guidelines for evidential appraisal. Science begins by employing the logical rule of falsifiability to recognize the distinction between emotive and propositional claims (between statements of value and statements of fact, in other words) and then utilizes the rule of public verifiability to recognize the distinction between subjective and objective perspectives (i.e., between those points of view that are wholly personal and internal and those points of view that are entirely impersonal and external). *The scientific method is nothing more and nothing less than the systematic application of reason in the pursuit of propositional knowledge.* Accordingly, the nature of science deserves our detailed attention.

Misconceptions about Science

It is important at the outset to dispel some common misconceptions about science and the scientific approach to propositional knowledge. Science does not deny the legitimacy or appropriateness of alternative epistemological approaches that are concerned exclusively with emotive statements. Instead, science recognizes that some questions, such as the question of how to create a work of art that will have lasting aesthetic value, are best addressed from a nonscientific perspective (at least given the present limitations of scientific knowledge). Science does not claim to be a perfect approach to propositional knowledge or to be free of subjective bias, error, or fraud. Instead, science claims to be a superior approach to propositional knowledge and to be better able to detect and correct subjective bias, error, and fraud than any of its competitors. Science does not claim absolute certainty, nor does it deny that the perception of reality is a

process of active interpretation rather than passive reception. Instead, science claims provisional certainty based upon a process of unrelenting skeptical inquiry in which no premise or assumption is ever considered to be beyond question. Science does not deny that the pursuit of objective-propositional knowledge is a highly problematic undertaking. Instead, science merely denies that all claims to propositional knowledge are equally valid, and the scientific method provides a demonstrably reliable set of standards by which to evaluate competing claims.

Assumptions of Science

It should be admitted as well that science is founded upon a pair of assumptions that are ultimately unprovable, at least in the logical sense. The first of these is the assumption that objective reality exists independent of the perceptions, interpretations, motivations, feelings, desires, wants, or needs of individual human beings. The second is the assumption that objective reality is amenable to human inquiry (in other words, that human beings are able, at least to some significant degree, to apprehend and understand the reality beyond their own minds). While it may not be possible to logically prove the truth of these two assumptions, however, neither is it possible to reasonably doubt either of them. The pragmatic justification for the belief in the existence of an independent objective reality is overwhelming, and it is pure solipsism to think otherwise. Our lives are not mere illusions, and we do not live in worlds of our own. Indeed, all of our notions of moral accountability are based on that factual premise: we are not responsible for what we do in each other's dreams, for example. The pragmatic justification for the belief in the efficacy of human inquiry into objective reality is similarly overwhelming; the myriad technological accomplishments of science establish that in dramatic fashion. Think only of the twentieth-century accomplishments of science in the fields of transportation, communication, and medicine and then think of trying to deny the efficacy of the scientific method.

The Essential Elements of the Scientific Perspective

The goal of the scientific approach to knowledge is to achieve the highest possible degree of certainty about objective synthetic propositions. In the pursuit of that goal, science is both open-minded and self-correcting. No proposition, no matter how improbable or far-fetched, is ever rejected by science on an a priori basis (the truth or falsity of synthetic propositions, after all, can only be known a posteriori, following a review of the

evidence). Hence the scientific method can be applied to any synthetic propositional question whatsoever (contrary to the common misperception, that includes both empirical and nonempirical questions, as I will explain later). Further, no proposition, no matter how plausible or well substantiated, is ever embraced by science with absolute assurance. Scientific knowledge, as mentioned earlier, is by definition tentative. Every scientific claim is vulnerable to revision in the light of new evidence or superior analysis.

Among scholars both inside and outside anthropology, there is virtual unanimity concerning the essential defining elements of the scientific method. The philosopher of science Ernest Nagel (1961:4) is not alone in his view that science is a precise, rigorous, and internally consistent version of common sense: "It is the desire for explanations which are at once systematic and controllable by factual evidence that generates science; and it is the organization and classification of knowledge on the basis of explanatory principles that is the distinctive goal of the sciences." Similarly, the anthropologists Pertti and Gretel Pelto (1978:22) locate the essence of science in the twin goals of identification and generalization: "Science is the structure and the processes of discovery and verification of systematic and reliable knowledge about any relatively enduring aspect of the universe . . . and the development of concepts and propositions for interrelating and explaining such observations." Another anthropologist, Tim O'Meara (1989:354), adds a key qualification to the definition of science as a system of description and explanation: "[Science is] the systematic description and classification of objects, events, and processes, and the explanation of those events and processes by theories that employ lawful regularities, *all of the descriptions and explanatory statements employed being testable against publicly observable data*" (emphasis added).

O'Meara's caveat is perhaps the single most crucial aspect of the scientific approach to knowledge, as many other scholars have recognized. The anthropologist Melford Spiro (1986:272), for example, locates the essence of science in the notion of testability: the scientific "method consists in the formulation of explanatory theories . . . and the employment of both empirical and logical procedures which, at least in principle, can lead to their verification or falsification." The philosopher Reuben Abel (1976:81) observes similarly that "there is no single scientific method other than the unremitting criticism of evidence and reasoning in every way possible." The anthropologist Richard Watson (1991:276) concurs, noting that "science in the most general sense is an attempt to learn as much as possible about the world in as many ways as possible with the sole restriction that what is claimed as knowledge be both testable and

attainable by everyone." The philosopher Karl Popper (1963:256), of course, is merely the most notable of those scholars who identify testability as the sine qua non of science: "a system is to be considered as scientific only if it makes assertions which may clash with observations."

The Definition of Science

These observations lay the foundation for a precise and succinct definition of the scientific method: *Science is an objective, logical, and systematic technique for acquiring synthetic propositional knowledge.* That definition paraphrases one proposed by the philosopher of science Carlo Lastrucci (1963:6). Beyond the phrase "synthetic propositional knowledge," which we have already examined, it contains three key terms: "objective," "logical," and "systematic." Each of these terms is being used in a very particular way. Let me review in detail exactly what I mean by each.

Science Is Objective

We have already seen that complete objectivity is an unattainable ideal. In the first place, objectivity requires a measure, a reference point, a place from which to start. Viewed from the "objective" perspective of the total mass of the universe, for example, the whole of humanity is an infinitesimal speck; from the "objective" perspective of the evolution of the cosmos, the whole of human history is an unnoticed flash. Obviously, objectivity must have a human face. As human beings we can only concern ourselves with the reality that we can perceive or infer; we can only concern ourselves with those phenomena that impinge upon our lives, however directly or indirectly. That is what the ancient Greek philosopher Protagoras meant when he said, "Man [i.e., *Homo sapiens*] is the measure of all things," and that is what the twentieth-century philosopher Michael Polanyi (1962:3) means when he says that "any attempt to eliminate our human perspective from our picture of the world must lead to absurdity." Furthermore, our perception of objective reality is obviously constrained by our humanity. It is limited by the nature and range of our sensory organs and by the ability of our minds to devise instruments to extend those limits. Our perception of reality is never purely passive but is always a process of active interpretation filtered through the myriad biases of our cultural contexts and personal histories.

Obviously, then, science cannot claim to be objective in some absolute or transcendent sense of the term. Instead, science recognizes that objec-

tivity must be defined with reference to human beings, because there is an unavoidably human dimension to our knowledge. What we know is inextricably linked not only to our perceptual and cognitive abilities but to our interests and goals as well. However, as mentioned earlier, science also proceeds on the assumption that objective reality exists independent of human capacities and concerns. Although our ability to perceive that reality may be imperfect, objective reality itself is not affected by our perceptions or our understandings. From that unarguable premise, science infers that no two conflicting accounts of objective reality can both be correct (see Cunningham 1973). Both could be incorrect, or one correct and the other incorrect, but it is logically impossible for both to be correct. (Christians, for example, believe that the one true messiah has already come, while Jews believe that the one true messiah will come in the future; obviously both cannot be correct, but both could be incorrect—the one true messiah may *never* come.) The challenge, therefore, is to develop a set of epistemological procedures that can reliably distinguish between competing attempts to describe and explain objective reality. The scientific ideal of objectivity constitutes just such a set of procedures.

According to that ideal of objectivity, the truth or falsity of any propositional claim must be completely independent of the claimant's predispositions and prejudices. Further, if science aspires to distinguish between conflicting propositional claims, it must be possible to establish the truth or falsity of any proposition in a reliable fashion. As numerous critics have pointed out, however, there are fundamental difficulties with both of these requirements. Science is a human activity, practiced by human beings, which means that no individual scientist can ever be completely unbiased. How then can any scientific claim be entirely independent of the claimant's predispositions and prejudices? Science aspires to attain synthetic propositional knowledge, but such knowledge is by definition tentative. Only analytic propositions can be known with certainty; synthetic knowledge is provisional rather than definitive. How then can science claim to distinguish in a definitive fashion between competing propositional claims?

Science answers these questions, not by claiming superhuman powers for individual scientists nor by claiming infallibility for the scientific method, but by defining objectivity as a critical, two-pronged approach to knowledge. Charles Frankel explains:

> There are two principal reasons why scientific ideas are objective, and neither has anything to do with the personal merits or social status of individual scientists. The first is that these ideas are the result of a cooperative

process in which the individual has to submit his [or her] results to the test of public observations which others can perform. The second is that these ideas are the result of a process in which no ideas or assumptions are regarded as sacrosanct, and all inherited ideas are subject to the continuing correction of experience. (Frankel 1955:138–39)

Objectivity Defined

The philosopher of science Carl Hempel (1965:334) puts the point more succinctly when he declares that scientific statements are objective if they are "capable of test by reference to publicly ascertainable evidence." Thus scientific objectivity is a procedure rather than a product. The scientific definition of the term recognizes that complete objectivity is an ideal that can only be approximated and never attained. Objectivity, therefore, consists of an open-ended, self-correcting set of procedures designed to ensure that the ideal will be approximated as closely as possible. To state the matter very directly: a propositional statement is *objective* in the scientific sense of the term if it is both *publicly verifiable* and *testable*. Thus defined, objectivity does not guarantee certainty, but it does guarantee a higher degree of certainty than any nonobjective approach to synthetic propositional knowledge. Objectivity is a relative quality. Its virtue lies in its comparative superiority, not in any presumptive omniscience.

This is a point that is commonly missed by critics of the scientific method. Recall Rabinow and Sullivan's (1979:6) rejection of scientific objectivity on the grounds that "there is no privileged position, no absolute perspective, no final recounting." The fact that there is no absolute perspective is exactly why we need a standard of scientific objectivity: because there are so many competing perspectives, we need to be able to distinguish the reliable from the unreliable ones. The inescapable inference that can be drawn from Rabinow and Sullivan's position is the conclusion that reliable knowledge is impossible. That conclusion is simply wrong, as every critic of science intuitively knows. No critic of science is prepared to jump out of an airplane without a parachute to demonstrate the uncertainty of knowledge. Every critic of science knows with complete certainty exactly what will happen, and no critic of science will attempt the experiment to prove otherwise.

Public Verifiability in Practice

The scientific rule of public verifiability constitutes a practical solution to a logical problem. Because perception is invariably a process of active

interpretation rather than passive reception, and because our perceptual interpretations are inextricably embedded in the complicated context of our personal prejudices and predispositions, it is always logically possible that our perceptions could be illusions. Even if generally unlikely, it is possible that our perceptions could be nothing more than the unreliable products of our uniquely individual subjective states. The events, perceptions, and recollections contained in dreams, hallucinations, and false memories can be misconstrued as actual phenomena occurring in the real world. Objective reality can be and often is misperceived. Furthermore, it is always logically possible that an appreciable number of people could share the same misperception (perhaps stemming, for example, from a shared cultural bias).

However, it is fairly improbable that large numbers of independent observers from various backgrounds would share the same misperception. By requiring observations to be publicly verifiable, science attempts to minimize the probability of subjective misperception and enhance the probability of objective perception. In the pursuit of those goals, science incorporates a number of methodological guidelines. Thus the rule of public verifiability demands that scientific concepts be defined precisely and unambiguously in both a *conceptual* and an *operational* sense.

Bernard (1995:26) explains the distinction between these two terms: "Conceptual definitions are abstractions, articulated in words, that facilitate understanding. They are the sort of definitions we see in dictionaries. . . . Operational definitions consist of a set of instructions on how to measure a variable that has been conceptually defined." Thus acculturation might be conceptually defined as culture change that results from intensive culture contact and operationally defined as the particular percentage of people in a given society who learn new languages, adopt new clothing styles, acquire new dietary habits, and so forth. *Operationalism* facilitates public verifiability by providing scientists with a common language for communication, a language that prescribes the specific procedures used to verify observations (see Pelto and Pelto 1978).

In addition, the scientific rule of public verifiability requires observations to be *replicable*: scientific observations must be repeatable, both in principle and in practice, by independent observers employing the same operationalized procedures. Purely subjective perceptions are, by their nature, unique to the individual; thus there is a high probability that idiosyncratic observations will be subjective rather than objective. The rule of replicability enables science to distinguish novel observations that are objectively valid from those that are only subjectively meaningful. The rules of operationalism and replicability thus provide the methodological

guidelines that enable scientific observations to approach the ideal of public verifiability.

Testability and Falsifiability

The rule of public verifiability alone, however, is not sufficient to make science objective. While operationalism and replicability may reduce the probability of a shared illusion, they do not entirely eliminate the possibility. In the final analysis, scientific claims to knowledge must be tested against something other than the consensus of observers, something that stands entirely outside any individual or collective subjectivity. The rule of falsifiability, which requires scientists to identify the publicly verifiable criteria that would falsify their claims, ensures that such claims can be tested against objective evidence.

As we have seen, falsifiable statements are vulnerable to the possibility of evidential refutation, which means that they are testable. If it is logically possible that evidence could exist that would falsify a given claim, then the actual search for such evidence can be undertaken. That is why any statement must be falsifiable before it can be testable. Nonfalsifiable statements, on the other hand, are immune to evidential refutation. If no conceivable evidence could ever prove the claim false, then no actual evidence could ever be relevant to the claim. If no evidence could be relevant to the claim, then it would obviously be impossible to test the claim against the evidence. That is why nonfalsifiable statements are never testable (and also why they are propositionally meaningless). The rule of falsifiability thus lies at the heart of what it means to be reasonable. As the philosopher of science Imre Lakatos (1970:92) puts it, "intellectual honesty consists . . . in specifying precisely the conditions under which one is willing to give up one's position."

I think I can offer an especially provocative and particularly revealing example of the way in which testability is fundamentally dependent upon falsifiability. My example concerns an issue that is the focus of contentious public debate in the United States in the late twentieth century: the insanity defense. The world view of contemporary American culture includes the notion that some people who commit illegal acts are "mentally ill" and should therefore be absolved of criminal and moral responsibility for their behavior. To most Americans, in fact, it is only common sense to assume that a wife who would cut off her husband's penis, or a son who would murder his parents, must be "sick." This commonsense idea has been extensively embraced by both the medical and legal professions. As a result, it has become firmly institutionalized in American society. Nev-

ertheless, the insanity defense is illogical and insupportable, for a very simple reason: there is no such thing as mental illness.

Let me hasten to explain what I mean. Obviously there are some pathological conditions of the brain that do give rise to aberrant and unwelcome behavior; neurosyphilis and senile dementia are two familiar examples. Most alleged instances of "mental illness," however, involve no physiological damage to the brain whatsoever. Instead, they involve putative damage to the *mind*, the epiphenomena of the brain's activity that we call consciousness. The overwhelming majority of "mental illnesses," including virtually all of those that allegedly cause criminal behavior, can be diagnosed only by observing the "patient's" *behavior*; physiological symptoms are wholly absent. The psychiatrist Thomas Szasz (1961; 1973; 1987) has long been a leading critic of the concept of mental illness. As he has repeatedly pointed out, the metaphor of mental illness is entirely misplaced. The mind simply cannot become "ill," in the ordinary, familiar, and meaningful sense of the term, because the mind is not a bodily organ. Illness, after all, involves something that *happens* to us; it does not entail something we *do*. As Szasz explains, "mental illness" is nothing more than a label for behavior, and the diagnosis of mental illness is nothing more than a value judgment:

> Inevitably the idea of illness, whether of the mind or the body, implies deviation from a norm. In the case of physical illness, the norm is the structural and functional integrity of the human body or some part of it. In the case of mental illness, it is impossible to name a single norm which is not stated in psychological, social, moral, or legal terms—all typical psychiatric symptoms or diseases, from agoraphobia to sexual intercourse with animals, conform to and illustrate this principle. (Szasz 1984:15)

Proponents of the concept of mental illness (which would obviously include the vast majority of psychotherapists) are divided between those who believe that mental illness is caused by some underlying set of physiological or chemical processes (which they have yet to discover) and those who believe that mental illness is caused by a variety of psychological or social processes (which they never precisely identify). Neither group, however, can offer a definition of mental illness that consists of anything other than deviance from some nonphysiological norm.

In a telling analogy, Szasz (1984:13) equates psychiatry with theology. The existence of God is the central premise of theology, just as the existence of mental illness is the central premise of psychiatry. Theologians can neither define God nor demonstrate his existence, just as psychiatrists can neither define mental illness nor demonstrate its existence. For

theologians, the existence of God is a given beyond any question. For psychiatrists, the existence of mental illness is equally self-evident. As far as theologians and psychiatrists are concerned, only the ignorant or the perverse would presume to challenge the existence of God or mental illness. Neither psychiatrists nor theologians, however, can specify any conceivable evidence that would force them to abandon their fundamental beliefs. Both the claim that God exists and the claim that mental illness exists are nonfalsifiable. Neither, therefore, is testable, and both, accordingly, are propositionally meaningless.

Consider the case of John Hinckley, the would-be presidential assassin who shot Ronald Reagan in Washington, D.C., in 1981. In his subsequent trial, Hinckley was found not guilty by reason of insanity. The jury reached its verdict after hearing expert testimony from a number of eminent psychiatrists. The psychiatrists retained by the prosecution, of course, diagnosed Hinckley as sane, while those retained by the defense diagnosed him as insane. The problem was not simply that the various experts disagreed as to the nature of the evidence; each of the experts had equal and ample opportunity to examine the "patient." The problem instead was that none of the psychiatric experts could offer a falsifiable definition of mental illness. Lacking that, no conceivable test could possibly have determined whether Hinckley was or was not "mentally ill," because no imaginable evidence would have been relevant to the question. Nothing that Hinckley could have said or done could possibly have *proven* his sanity or insanity. Since the concept of "mental illness" has no propositional content whatsoever, the psychiatrists who disagreed with each other about Hinckley's sanity were thus engaged in nothing more than a debate about values (most important, of course, the value question of whether Hinckley should or should not be punished for his actions). Regrettably, however, most psychiatrists maintain the fantasy that the debate over mental illness is propositional rather than emotive, and they have persuaded both the legal system and the general public to share their illusion. It is no coincidence that psychiatry is both the least successful and the least scientific of all branches of contemporary medicine.

Objectivity and Empiricism

One final point remains to be made before we conclude this section on objectivity. The scientific approach to knowledge is often characterized as empirical, and in the broadest sense that is true. *Empiricism* can be defined as an approach to knowledge that relies exclusively upon experience and

observation. An empirical statement, strictly speaking, is simply a synthetic propositional statement, because its truth or falsity can only be known a posteriori, following a review of experiential evidence. Even though the scientific method may employ intuition and imagination in the formulation of theories and hypotheses, in the final analysis, scientific knowledge can be validated only by experience, so science is obviously empirical in that sense.

The term "empirical," however, is frequently understood to connote specifically knowledge obtained via *sensory* experience, which would limit science to the analysis of data that can be seen, heard, smelt, felt, or tasted. This is the position taken by those who maintain that "empirical science" cannot be used to determine the truth or falsity of religious beliefs about supernatural beings, since, by definition, such beings can be neither seen, heard, smelt, felt, nor tasted. In fact, however, science is empirical only in the broad sense that scientific knowledge must be validated by experience. Despite the common misconception, science makes no a priori judgment that the relevant experience must entail sensory data. Science demands only that the experience itself, and ultimately the claim to knowledge upon which it is based, be both publicly verifiable and testable.

I do not wish to be misunderstood on this point. While science is not empirical in the sense that it restricts itself to *sensory* experiences in its approach to knowledge, science is empirical in the sense that it restricts itself to *objective* experiences in the pursuit of knowledge. In practice, it is true, the scientific requirements for public verifiability and testability have invariably resulted in a requirement for sensory data, but that is only because nonsensory data have never yet passed the test of objectivity. Nevertheless, it remains logically possible that nonsensory experiences could be objective, and it would be prejudicial of science to rule out that possibility.

This means that objective science *can* be used to investigate the truth or falsity of religious beliefs about supernatural beings, as noted earlier. If such beings did exist as part of objective reality, and if they did have some impact on human lives (as it is invariably alleged), then it would be possible to uncover publicly verifiable and testable evidence of their existence. That, however, has never been the case (see Lett 1997). Worldwide investigation has revealed instead that all claims about the existence of supernatural beings are either nonfalsifiable (i.e., propositionally meaningless) or have been decisively falsified (i.e., proven wrong).

This is an important point, and one that deserves some elaboration. Recall Shweder's (1991) argument denouncing anthropology for denying

the existence of "gods, ghosts, souls, witches, and demons." Ironically, Shweder's characterization of the anthropological perspective is only partially correct. In practice, it is true, most anthropologists implicitly assume that paranormal beliefs are false, and then they proceed, in the words of Ernest Gellner (1988:26), to "explain how witchcraft [and other paranormal] beliefs can function notwithstanding their falsity." At the same time, however, relatively few anthropologists *explicitly* deny the existence of supernatural beings or paranormal phenomena. Instead, most anthropologists appear to believe, like Shweder, that the epistemological principles of empirical science cannot be applied to the supernatural content of paranormal beliefs. In *Theories of Primitive Religion,* Evans-Pritchard (1965:17) offers a familiar formulation of that position: "He [the anthropologist] is not concerned, *qua* anthropologist, with the truth or falsity of religious thought. As I understand the matter there is no possibility of his *knowing* whether the supernatural beings of primitive religions or of any others have any existence or not, and since that is the case he cannot take the question into consideration."

Not all anthropologists take this point of view, of course; some *do* claim to know whether or not supernatural beings exist. Murdock (1980:54), for example, says "there are no such things as souls, or demons, and such mental constructs as Jehovah are as fictitious as those of Superman or Santa Claus," while Schneider (1965:85) declares "there is no supernatural; ghosts do not exist." I think it is fair to say, however, that most anthropologists are sympathetic to Evans-Pritchard's contention that empirical science and supernatural beliefs are incommensurable. Anthony Wallace (1966:vi), for example, recognizes that supernatural beliefs are "inconsistent with scientific knowledge," but he nevertheless chooses to adopt a neutral position and to regard religion as "neither a path of truth nor a thicket of superstition." Similarly, Edward Norbeck (1974:7) explicitly restricts the scientific study of religious beliefs to "interpretations of their role in human life and of the factors that have molded the customs into their particular forms." Even Marvin Harris (1979:6) maintains that science "does not dispute the doctrines of revealed religions as long as they are not used to cast doubt on the authenticity of the knowledge science itself has achieved."

Despite its popularity in anthropology, this point of view is insupportable. Evans-Pritchard is mistaken: it *is* possible for anthropologists to know whether supernatural beings exist or not. All that is required is for anthropologists is to apply the standards of reason embodied in the scientific approach to knowledge. Claims about the existence of supernatural beings can clearly be evaluated on that basis. The fact that such claims

concern nonempirical reality does not place them beyond reasonable analysis. Science does not dismiss the possibility of nonempirical reality on an a priori basis; science simply demands that any claim to knowledge about nonempirical reality be both publicly verifiable and testable. To date, however, no paranormal claim has ever passed that test. Instead, all paranormal claims have revealed themselves to be either nonfalsifiable or falsified.

Consider the statement "God exists." Is that statement falsifiable? Before we can answer, we must know precisely what is meant by the term "God," and that presents a significant problem. The many denominations of the world's three major monotheistic religions have widely varying conceptions of God's attributes and characteristics. However, there is general agreement among Jews, Christians, and Muslims that God is an omnipotent (all-powerful) and omniscient (all-knowing) supernatural being whose attitude towards humans is one of loving care and concern. As philosophers have long recognized, however, such a being would be logically inconsistent with the presence of evil in the world. It would be logically possible for God to allow evil to exist, despite his benevolence and omnipotence, if he were unaware of its existence; alternately, it would be logically possible for God to allow evil to exist, despite his benevolence and omniscience, if he were powerless to prevent it. Assuming he was not malevolent, however, an omnipotent and omniscient God could not allow evil to exist—and yet evil does exist. Misery, suffering, deprivation, disease, misfortune, and exploitation are all facts of human existence.

For the overwhelming majority of Jews, Christians, and Muslims in the world, however, these facts are not sufficient to falsify the claim that a benevolent, omnipotent, omniscient deity exists. The world's monotheistic religions dismiss the problem of evil with familiar rationalizations (e.g., "God works in mysterious ways"). For the faithful, the belief that God exists is not falsifiable. No possible evidence could persuade them to abandon their belief; they will maintain their convictions no matter what happens. Since the facts are completely irrelevant to the statement "God exists," that claim is propositionally meaningless. It is an emotive statement with no factual content whatsoever.

Most paranormal beliefs around the world, like the belief in a monotheistic deity, are nonfalsifiable. In those relatively rare instances when paranormal beliefs are falsifiable, objective analysis has invariably revealed them to be erroneous. Consider the beliefs about the age of the earth and the origin of the human species promulgated by the world's monotheistic religions. If these beliefs are taken at face value, they are

clearly falsifiable (although the majority of Jews, Christians, and Muslims probably regard them as nonfalsifiable metaphors rather than as literal propositions). The evidence from geology, physics, chemistry, biology, anthropology, and the like has decisively falsified each of the monotheistic origin myths: the earth is *not* merely six thousand years old, it has *never* been covered by a universal flood, and the human species did *not* originate in a spontaneous creation in the middle of the Holocene.

I began this chapter with the observation that the scientific method is nothing more and nothing less than the systematic application of reason in the pursuit of propositional knowledge. Reason clearly shows that all paranormal claims are either propositionally meaningless or factually erroneous; hence the scientific approach *can* be applied to the content of religious beliefs. The distinction between science and religion does not lie, as Evans-Pritchard and many anthropologists would have it, in the distinction between empiricism and supernaturalism. Instead it lies in the distinction between rationality and irrationality. Science and religion are not at odds because science is "empirical" while religion is "supernatural"; instead, science and religion are at odds because science insists upon being rational (relying exclusively upon beliefs that are both falsifiable and unfalsified), while religion insists upon being irrational (relying ultimately upon beliefs that are either nonfalsifiable or falsified).

Objectivity Summarized

It should be apparent now that any reasonable approach to synthetic propositional knowledge must rely exclusively upon epistemological procedures that are both verifiable and testable. These two essential components of scientific objectivity are unavoidable in the pursuit of reliable knowledge. If the epistemological procedures employed were not publicly verifiable, then they would be ultimately subjective, and there would be no limits (other than the limits of the human imagination) upon what could be claimed as knowledge. Without the rule of verifiability, any dream, any fantasy, any hallucination could be regarded as real and true. It is logically possible, of course, that everyone in a given community of observers could share the same illusion at the same time. For that reason, it is not sufficient that a claim to knowledge be verifiable; objectivity demands that it be testable as well. If the claim to knowledge were not testable, then it would not be propositional, and any and all evidence would be irrelevant to the truth or falsity of the claim. Without the rule of testability, propositionally meaningless statements could be regarded as significant and substantive.

In the final analysis, an objective claim to knowledge is a tentative claim to knowledge, because objectivity is open-ended. Any verifiable and testable assertion is always vulnerable to correction in the light of evidence. The provisional nature of objective knowledge is hardly an epistemological weakness, however. By ensuring that scientific knowledge is subject to revision, objectivity lays the groundwork upon which the development and accumulation of scientific knowledge is based. Objective claims to knowledge may be tentative, but so too are all claims to synthetic propositional knowledge. Every epistemological approach must attempt to maximize the degree of certainty in the knowledge it generates, yet epistemological approaches that eschew verifiability and testability leave themselves prone to errors that could be easily prevented. The rule of scientific objectivity provides the most reliable means yet developed of consistently overcoming the myriad difficulties inherent in the pursuit of propositional knowledge.

Objectivity and Interpretive Anthropology

The central premise of interpretive anthropology, as we have seen, is that no one cultural tradition or epistemological system can claim authority over any other. With what we have reviewed to this point, it is now possible to recognize the ultimate untenability of that position. Epistemological systems that incorporate the rules of verifiability and testability are demonstrably superior to those that do not. Recall Stephen Tyler's (1986b:135) reference to the "scientific illusion of reality" and his contention that "reason is simply the means by which we justify the lies we tell" (Tyler 1986a:37). His argument in support of this startling proposition is completely unconvincing. Instead of offering an alternative approach to reality that would be more authoritative than the scientific approach, Tyler maintains that no authoritative alternative is possible, since, according to him, all claims to knowledge are particular to time and place. Such extreme forms of epistemological relativism entail a logical contradiction: if nothing can be known, how can we know that nothing can be known? Epistemological relativism refutes itself, as the philosopher Harvey Siegel makes clear:

> The relativist cannot regard her [or his] beliefs, or her [or his] relative truths, as warranted or worthy of belief. Similarly for action. The relativist is thus left in the position of being unable to recognize relative merits of propositions, knowledge-claims, or actions—all are as worthy as the rest, and the very notion of worthiness has been jettisoned—and therefore cannot rationally prefer any relative truth to any other. (Siegel 1987:20)

Despite its obvious illogic, epistemological relativism is embraced by many interpretive anthropologists. Consider again Michael Jackson's (1989:13) admonition that we should "judge the value of an idea, not just against antecedent experiences or the logical standards of scientific inquiry but also against the practical, ethical, emotional, and aesthetic demands of life." Undoubtedly Jackson was motivated by the best of moral intentions, but his position contains a basic logical error. The ethical, emotional, and aesthetic demands of life have nothing to do with the truth or falsity of any propositional claim. Certainly the *consequences* of applying propositional knowledge should be evaluated with due regard for ethical considerations, but the *validity* of any propositional claim can be judged only against the evidence. Evaluating that evidence from an objective perspective results in knowledge that is collectively recognized and evidentially substantiated. In short, objective evaluation results in scientific knowledge. Because he denies the possibility of objectivity, Jackson (1989:13–14), like so many interpretive anthropologists, dismisses scientific knowledge as a "consoling illusion, one stratagem for making sense of an unstable world, not an accurate representation of reality."

The kind of relativism advocated by Jackson and others is circular and self-defeating. If the scientific representation of reality is simply one stratagem, one consoling illusion, then so too is Jackson's own representation of reality, and that of his informants, his colleagues, and everyone else. Why could not someone's representation, even if by sheer chance, come close to accurately depicting objective reality? Why is everyone necessarily restricted to mere illusions of reality? If the rules of verifiability and testability do not offer a reasonable chance of apprehending objective reality, what rules instead would have a greater probability of achieving that end? Neither Jackson nor his fellow interpretive anthropologists offer answers to these questions.

Instead, interpretive anthropologists are likely to characterize the scientific concept of objectivity as the unfounded prejudice of a powerful subculture. Consider once more Stephen Tyler's (1986b:124) assertion that, in the scientific pursuit of knowledge, "agreement among scientists [is] more important than the nature of nature." Tyler's argument might have some semblance of substance if scientific objectivity consisted simply of the rule of public verifiability. Unfortunately for Tyler, scientific objectivity also includes the rule of testability, which means that claims about the nature of nature can be measured against the evidence. Ultimately, Tyler's argument boils down to the contention that no one knows anything, so anything anyone says is equally plausible, since no claim to

knowledge has any more merit than any other. It is difficult to imagine anyone taking such an argument seriously.

Unfortunately, however, many do. The interpretive anthropologist Jean-Paul Dumont (1992:45), for example, suggests that scientists tend to take "shelter behind the consensus of the scientific community" without recognizing that they "can be strongly suspected of sharing *a priori* a similar if not identical ideology, that of the Western world, so that two 'independent' scientists will agree to see in the Pleiades a star cluster in the same way that two 'independent' Panare will agree to see in the same Pleiades a mythical being." Dumont is mistaken, and his attempt to "demystify" what he calls "the persistent and tenacious myth of anthropological objectivity" (1992:44) is misguided. Scientists and the Panare do *not* arrive at their views of the Pleiades "in the same way." While both the scientific and the Panare approaches to knowledge may be publicly verifiable within their respective communities of observers, the scientific view of the Pleiades is falsifiable and unfalsified. The Panare view is not. Scientific knowledge is much more than simply a matter of cultural consensus. It is characteristic of interpretive anthropology to fail to understand that scientific objectivity entails not only the rule of verifiability but also the rule of testability.

Science recognizes that achieving synthetic propositional knowledge is a problematic undertaking, but science refuses to abandon the task simply because of its difficulty. Instead, science has developed a set of procedures designed to overcome the inherent difficulties of epistemic endeavors. The appropriateness of those procedures is amply demonstrated by the unparalleled success science has achieved in the acquisition of reliable propositional knowledge. The rule of objectivity, which requires claims to knowledge to be both publicly verifiable and testable, is simply the first of the procedures that constitute the scientific method. Besides being objective, science is also logical and systematic. We move now to a consideration of the second of those three attributes.

Science Is Logical

The scientific method requires logical consistency. *Logic* can be simply defined as a set of rules governing the validity of inference. The principles of logic are used to evaluate the legitimacy of philosophical arguments. An *argument* is a group of statements in which one (the conclusion) is said to follow from the others (the premises). The premises constitute the evidence or reasons from which it is claimed that the conclusion can be

derived. The premises are identified, either implicitly or explicitly, by words or phrases such as "since," "because," "for," "as," or "inasmuch as." The conclusion is preceded, either implicitly or explicitly, by words or phrases such as "therefore," "hence," "so," "thus," or "as a result." Determining whether or not the conclusion can be inferred from the premises is the task of logical analysis.

Necessary and Sufficient Conditions

In identifying the causal links between premises and conclusions, logicians make frequent reference to the distinction between necessary and sufficient conditions. A *necessary condition* is a cause that must be present in order for the effect to occur. Water, for example, is a necessary condition for human life. If *P* is a necessary condition for *Q*, then the absence of *P* will guarantee the absence of *Q*; the presence of *P*, however, will not guarantee the presence of *Q*. (This is so because other conditions could be necessary as well; human beings also need food to survive, for example.) A *sufficient condition* is any cause that is enough by itself to make the effect occur. Decapitation, for example, is a sufficient condition for human death. If *P* is a sufficient condition for *Q*, then the presence of *P* will guarantee the presence of *Q*; the absence of *P*, however, will not guarantee the absence of *Q*. (This is so because other conditions could be sufficient as well; prolonged oxygen deprivation will also cause death, for example).

Syllogisms

In the terminology of philosophy, arguments are often called syllogisms. A *syllogism* is an explicit argument that conforms to one of a number of recognized forms, each of which can be expressed in formal, abstract fashion. As an example, consider the following argument:

> If the incest taboo is a cultural universal, then it must be biologically based and/or culturally adaptive.
>
> The incest taboo is a cultural universal.
>
> Therefore, the incest taboo must be biologically based and/or culturally adaptive.

Logicians identify this form of syllogism as *modus ponens*, and express it symbolically in this fashion:

Modus ponens
If *P*, then *Q*
P
Therefore
Q

Similarly, other common syllogistic forms have been recognized and named by philosophers specializing in the study of formal logic. These include:

Modus tollens
If *P*, then *Q*
Not *Q*
Therefore
Not *P*

Dilemma
Either *P* or *Q*
Not *P*
Therefore
Q

Hypothetical
If *P*, then *Q*
If *Q*, then *R*
Therefore
If *P*, then *R*

Contraposition
If *P*, then *Q*
Therefore
If not *Q*, then not *P*

In each of the syllogisms represented above, the conclusion can be inferred from the premises. Substitute any proposition for the variables *P*, *Q*, and *R*, and the conclusion follows logically from the premises in each case. In philosophical terms, each of these syllogistic forms is valid.

Valid Arguments

A *valid argument* is one in which the conclusion necessarily follows

from the premise(s). If the argument is valid, it is impossible for the premises to be true and the conclusion to be false. (In other words, if the premises are true in a valid argument, then the conclusion *must* be true.) This makes it an easy matter to determine whether any given argument is valid or invalid. Simply ask yourself whether you can imagine a counterexample in which the premises could be true but the conclusion would still be false. If you can imagine such a counterexample, then the argument is invalid. If no such counterexample is logically possible, then the argument is *valid*.

By way of example, consider the following two arguments:

Argument 1
All horticultural societies are matrilineal.

The Yanamamo are horticultural.

Therefore, the Yanamamo are matrilineal.

Argument 2
All horticultural societies are matrilineal.

The !Kung San are matrilineal.

Therefore, the !Kung San are horticultural.

Argument 1 is valid. If all horticultural societies are matrilineal, and if the Yanamamo are horticultural, then the Yanamamo *are* matrilineal. Argument 2, however, is invalid, as demonstrated by the method of counterexample. It is logically possible that both premises could be true—all horticultural societies could be matrilineal, and the !Kung San might be matrilineal—yet the conclusion could still be false. It is logically possible that the !Kung San could be agriculturalists rather than horticulturalists, providing a counterexample to the argument. (In other words, the !Kung San could employ draft animals, permanent plots of land, and artificial replenishment of soil nutrients rather than relying exclusively upon human muscle power and shifting cultivation, and yet at the same time calculate descent through the female line. The first premise of the argument states that all horticultural societies are matrilineal—it does not say that only horticultural societies are matrilineal.)

Now notice something important. One of these arguments is valid, the other invalid, *yet both come to a false conclusion*. The Yanamamo are patrilineal, not matrilineal, and the !Kung San are foragers, not horticulturalists. It should not be surprising to learn that the conclusion of an invalid

argument is likely to be unreliable; no conclusion based solely upon invalid reasoning is ever justified. It may be surprising, however, to realize that the conclusion of a valid argument can be unreliable. The reason is simple: valid arguments can contain false premises. In Argument 1, the conclusion follows logically from the premises, but the first premise is not true: all horticultural societies are *not* matrilineal.

Remember that the truth or falsity of the premises has nothing to do with whether or not an argument is valid. Validity is simply a measure of the argument's *form*. Both of the premises in Argument 2 are false, but the argument would still be invalid even if those premises happened to be true. Because the argument is invalid, there is no obligation to give its conclusion any credence. However, the fact that an argument is valid is not sufficient justification for accepting its conclusion (as Argument 1 demonstrates). An additional criterion is required before the argument can be regarded as compelling, and that criterion is one philosophers call logical soundness.

Sound Arguments

A *sound argument* is one in which the conclusion necessarily follows from the premises and in which all of the premises are true. If an argument is sound, its conclusion is necessarily true. Notice, however, that the question of whether the premises are true cannot be determined by logical analysis alone. (Lacking anthropological information, you would not know whether all horticultural societies were matrilineal or not, and no amount of purely logical analysis would answer the question.) If the premises entail synthetic propositions, their truth or falsity can be determined only by empirical investigation. The rule of logic requires that all arguments be sound, but identifying sound arguments requires both the analysis of logical validity and the investigation of empirical fact.

Logic and Semantics

Determining whether any particular argument is sound requires something else as well: all of the terms used in the premises and the conclusion must have precise, unambiguous meanings. In the two examples above, the meaning of the terms is relatively clear and straightforward. The term "horticultural" designates a particular mode of production that is readily distinguished from foraging, pastoralism, agriculture, and industrial agriculture, just as the term "matrilineal" designates a particular descent system that is readily distinguished from patrilineal, bilateral, and ambilineal

systems. There is, admittedly, some ambiguity in the terms "Yanamamo" and "!Kung San" (exactly which groups of people are we talking about at which point in their histories?), but that ambiguity is easily resolved if we stipulate that we are speaking about the ethnographic present of a few decades ago.

By way of contrast, let us return one last time to Paul Stoller's (1986:56) argument about the value of ethnography. Consider that argument in its syllogistic form:

> If ethnography is anthropology's one strength and core contribution, then ethnography should be more appreciated within anthropology.
>
> Ethnography is anthropology's one strength and core contribution.
>
> Therefore ethnography should be more appreciated within anthropology.

The difficulties that present themselves in determining whether this argument is sound should be obvious. Clearly the argument is valid, since it takes the form of a *modus ponens* syllogism. In order to determine whether the premises are true, however, we would have to know what the terms "one strength" and "core contribution" mean, just as we would have to know what it would mean for ethnography to be "more appreciated" within anthropology. Does "core contribution" mean "more grants secured"? Does it suggest "more monographs produced"? Or does it imply something else altogether? Does "more appreciated" mean "more offers of tenure"? Does it intimate "more Distinguished Lecture invitations"? Or does it refer to some entirely different sort of reward? The ambiguities are virtually endless. The argument is so semantically muddled that it is logically opaque.

Deductive and Inductive Arguments

There is an additional subtlety to be considered before we move on to an examination of common logical fallacies, and that is the distinction between deductive and inductive arguments. A *deductive argument* is one in which the conclusion can be inferred from the premise(s) with absolute certainty (i.e., the premises necessarily entail the conclusion). Given the premise that all contemporary societies have some form of musical art, for example, it follows with absolute certainty that any particular contempo-

rary society will include some type of music in its artistic repertoire. An *inductive argument*, on the other hand, is one in which the conclusion can be inferred from the premise(s) with some degree of probability (i.e., the premises suggest or support the conclusion but do not entail it necessarily). Given the premise that all contemporary societies have some form of musical art, it follows with a high degree of probability that any particular contemporary society will have percussion and/or string instruments.

All other things being equal, deductive arguments are much more compelling than inductive arguments. When an appeal is made to an inductive argument, however, it is often because there is insufficient information available to formulate a deductive argument. For example, if your car will not start and its lights will not come on, you might draw the inductive conclusion that the battery is dead. That conclusion would be probable but not necessarily correct, since it might be the case that the battery cable is disconnected. Deductive arguments require knowledge of all the relevant variables. It is a broad but essentially accurate generalization to say that deductive reasoning is more common in the natural sciences while inductive reasoning is more common in the social sciences. Anthropologists, for example, have reached the inductive conclusions that patrilineality stems from patrilocality and that matrilineality stems from matrilocality, but those conclusions are only generally true rather than invariably true.

Logical Fallacies

To this point we have traced the fundamental outlines of logical analysis. There is, of course, a good deal more that could be said (the study of logic, in fact, constitutes an entire field of specialization within the discipline of philosophy), but what has been said is sufficient to delineate the distinction between logical and illogical thinking. In practice, however, there are numerous pitfalls in the application of logical analysis, and nearly everyone is prone to at least occasional errors in sound reasoning. It is useful, therefore, to be able to recognize some of the more common fallacies in the use of logic. What follows is a representative sample.

Non sequitur (Latin for "does not follow"). This is the generic term that covers all logical fallacies: it means simply that the conclusion does not follow from the premises (i.e., that the argument is invalid). For example, given the premises that all horticultural societies are matrilineal and that the !Kung San are matrilineal, the conclusion that the !Kung San are horticultural is a non sequitur. Non sequiturs are the products of many different kinds of errors in reasoning, including all of the logical fallacies that follow.

Begging the question (in Latin, *petitio principii*). The fallacy of begging the question is committed by assuming the conclusion in the premise(s). Begging the question is also called circular reasoning, or arguing in a circle. It would beg the question, for example, to argue that the scientific method cannot be applied to the study of human affairs simply on the grounds that human affairs are not amenable to scientific inquiry. When people commit the fallacy of begging the question, they often simply reiterate their conclusion in different words ("I know that the incest taboo is instinctive because humans are genetically programmed to abhor incest").

Fallacy of equivocation. The fallacy of equivocation is committed by using two different senses of the same term in a single argument. Consider this syllogism, for example:

Anthropology has an ethical obligation to focus on matters of public interest.

The public has an interest in Sasquatch.

Therefore anthropology has an ethical obligation to focus on Sasquatch.

The fallacy of equivocation results from using the term "public interest" in two different senses. In the first premise, "public interest" means "public welfare," but in the second premise it means "popular diversion." As a result, the argument is invalid.

The fallacy of equivocation is frequently evident in the postmodernist critique of scientific objectivity. The argument commonly offered is that science cannot be objective because individual scientists cannot be objective. Stated in that manner, the argument commits the fallacy of equivocation: the first use of the term "objective," as it applies to science, means "verifiable and testable," whereas the second use of the term "objective," as it applies to individuals, means "impersonal, unfeeling, and unbiased."

Fallacy of composition. An argument is guilty of the fallacy of composition if it assumes that what is true of the parts is also true of the whole. For example, consider this obviously erroneous argument:

Individual human beings possess consciousness.

Societies are comprised of individual human beings.

Therefore societies possess consciousness.

This example is not entirely hypothetical or facetious. An argument could be made that Alfred Kroeber's (1948:253–54) overwrought metaphor of the "superorganic" stemmed from a similar fallacy of composition. The concept of "culture" is, after all, an abstraction; it refers to recurring patterns of shared beliefs and customary behaviors. Individuals can hold certain beliefs and behave in certain ways, but "culture" itself is incapable of believing or doing anything, because "culture" is not a discrete concrete entity. In developing the concept of the superorganic, Kroeber seems to have reified the abstract notion of culture and given it an independent, irreducible existence comparable to the independent, irreducible existence of culture's constituent parts (namely individual human beings).

Fallacy of division. The fallacy of division is the opposite of the fallacy of composition; it consists of assuming that what is true of the whole is also true of the parts. The following argument illustrates the fallacy of division:

Religion is a cultural universal.

Every individual in the world belongs to some culture.

Therefore every individual in the world holds religious beliefs.

The error inherent in the fallacy of division is obvious, since it is well known that groups can have emergent properties not shared by their constituent parts. That is the insight, in fact, behind the dictum that the whole is often greater than the sum of its parts.

Genetic fallacy. The genetic fallacy is committed when an argument asserts that a given claim is either true or false on the basis of its origins. Alfred Russell Wallace reportedly conceived the principle of natural selection while in a delirium; to dismiss the theory of evolution on that basis would be to commit the genetic fallacy. Postmodernists who reject scientific claims to knowledge on the grounds that those claims emerged from the hegemonic discourse of a powerful elite are likewise guilty of the genetic fallacy.

False dilemma. The fallacy of false dilemma is committed when an argument presents a choice between two alternatives and ignores other logical possibilities. The historical particularist dictum that "anthropology must either be history or nothing" is an example of the false dilemma because it ignores other logical possibilities, such as the possibility that anthropology could be a nomothetic science.

Straw argument. (This logical fallacy is traditionally referred to as the "straw man" fallacy, but in practice neither its use nor its application is limited to a single sex.) The straw argument fallacy is committed when

an argument deliberately misrepresents an opposing position in order to attack that position more easily. The straw argument consists of exaggerating and caricaturing an opposing position and then proceeding to attack the exaggerations and caricatures while ignoring the merits and complexities of the original position. The following argument provides an example:

> Anthropologists cannot hope to understand or explain India's sacred-cow complex if they ignore the role religion plays in influencing Indian farmers' treatment of their cattle.
>
> Cultural materialists who attempt to explain the origins and functions of India's sacred-cow complex ignore the role religion plays in Indian farmers' treatment of their cattle.
>
> Therefore cultural materialists cannot hope to understand or explain India's sacred-cow complex.

The straw argument in this syllogism lies in the second premise, which is an egregious misrepresentation of the cultural materialist position. Cultural materialists do not ignore the role religion plays in Indian farmers' treatment of their cattle; to do so would be to commit an obvious and ridiculous error. Instead, cultural materialists attempt to explain the reasons why religion has such an influence on Indian farmers by identifying the adaptive causes of the religious system. (This is an actual example from the literature on India's sacred cattle; see Lett 1987:144.)

Ad hominem (abbreviation of the Latin *argumentum ad hominem,* attack against the person). The ad hominem fallacy consists of an attack against a claim's proponent rather than the claim itself. Creationist debaters who attempt to refute evolutionary theory by calling their opponents immoral salacious atheists are guilty of the ad hominem fallacy. The ad hominem attack can have great emotional appeal, which must account for the frequency with which it is used, because the illogic of the device is transparent. The merits of an argument have nothing whatsoever to do with the character or personality of its proponent. Ignorant, unintelligent, malicious people can offer sound arguments, just as knowledgeable, intelligent, well-intentioned people can make absurd claims.

Appeal to ignorance (in Latin, *argumentum ad ignoratiam*). The fallacy of the appeal to ignorance comes in two varieties: (1) using an opponent's inability to disprove a claim as proof of the claim's validity, and (2) using an opponent's inability to prove a claim as proof of the claim's invalidity. Here are two examples: (1) Anthropologists have not disproved the exis-

tence of Sasquatch, therefore Sasquatch does exist; and (2) Scientists have not proven that the self-proclaimed psychokinetic Uri Geller cheats every time, therefore Geller does not cheat every time. The error underlying this fallacy is readily apparent: the absence of disconfirming evidence is not the same as the presence of confirming evidence.

In an example mentioned previously, Stephen Tyler offers a classic illustration of the second variety of the fallacy of appeal to ignorance. Arguing that "no one has ever demonstrated the independence of reason, of logic and mathematics, from the discourses that constitute them," Tyler (1986a:37) concludes that the knowledge alleged to derive from reason, logic, and mathematics is an illusion. Not only is Tyler's logic faulty, but his premise is wrong as well. The objective independence of reason, logic, and mathematics has been demonstrated, and demonstrated decisively, on pragmatic grounds if nothing else.

Appeal to authority (in Latin, *argumentum ad verecundiam*). An appeal to authority to buttress a claim is often legitimate, but it becomes fallacious when the authority cited lacks genuine expertise in the relevant field. For example, Margaret Mead, perhaps the most famous American anthropologist of the twentieth century, is frequently cited by parapsychologists and other proponents of paranormal phenomena, despite the fact that Mead had no training, background, or experience in researching paranormal claims. What she did have, however, was a lifelong sympathy for the paranormal that can only be characterized as irremediable gullibility (Gardner 1988:19–24). For example, Mead (1977:48) was persuaded that "some individuals have capacities for certain kinds of communications which we label telepathy and clairvoyance" even though there has long been overwhelming evidence to the contrary (see Lett 1991a; 1991b; 1992). To cite Mead as an expert on paranormal claims is to commit the fallacy of appeal to authority.

Logic, Anthropology, and the Paranormal

Margaret Mead was right about one thing when it comes to claims of paranormal phenomena, however: the questions posed by such claims are highly relevant to anthropology, and not only because paranormal beliefs are prevalent in every culture in the world. Claims of paranormal phenomena present a fundamental challenge to the legitimacy of anthropological knowledge. If human beings do have the capacity for telepathy, clairvoyance, and precognition, for example, then our anthropological understanding of human nature is seriously deficient. If the reincarnated personalities of dead individuals can manifest themselves in the bodies of

living human beings, then our anthropological concept of enculturation is obviously flawed. If extraterrestrials were responsible for the monumental architecture of ancient civilizations, then our anthropological reconstruction of cultural evolution is decidedly inadequate. If nonhuman hominoids are living in the Pacific Northwest, then our anthropological understanding of primate evolution is woefully inadequate.

Accordingly, such paranormal claims demand an anthropological response. The fact of the matter, of course, is that each of these propositions is false. Each one, like every paranormal claim that has ever been offered by anyone anywhere in the world, has either been decisively falsified or is nonfalsifiable (and hence propositionally meaningless). The challenge paranormal claims pose to the legitimacy of anthropological knowledge is illusory. Most anthropologists are probably aware of these facts. Most, at least, do not share Margaret Mead's sympathy for claims of paranormal phenomena. Nevertheless, the anthropological approach to paranormal claims is frequently characterized by logical inconsistency, especially by those anthropologists who favor interpretive approaches. Let me offer a few examples that will serve to illustrate the principles of logic that we have just reviewed.

My first example concerns T. M. Luhrmann's (1989:4) interesting and stimulating ethnography *Persuasions of the Witch's Craft: Ritual Magic in Contemporary England,* which provides a detailed ethnographic account of "ordinary middle-class English people who become immersed in a netherworld of magic and ritual." Luhrmann's primary goal, as she carefully explains, is to identify "the process that allows people to accept outlandish, apparently irrational beliefs" (Luhrmann 1989:7). Luhrmann herself has no gullibility about claims of paranormal phenomena. At one point, she declares that "I never have and do not now 'believe' in magic" (Luhrmann 1989:18). The essential premise of her monograph, in fact, is that magical beliefs are false: "The purpose of this book is to examine a case in which apparently irrational beliefs are held by apparently rational people, and to identify the elements which seem important in explaining how they do so" (Luhrmann 1989:13).

The central argument of Luhrmann's book might be represented syllogistically as follows:

> If otherwise rational people hold false and irrational beliefs, then it is necessary to explain how they can do so.
>
> Otherwise rational people hold false and irrational beliefs.
>
> Therefore it is necessary to explain how they can do so.

Luhrmann's argument, presented this way as a *modus ponens* syllogism, is obviously valid. A review of the evidence in the book indicates that the argument is sound as well. The first premise is incontestably true, and Luhrmann documents the truth of the second premise in rich ethnographic detail. Moreover, Luhrmann's explanation of how otherwise rational people come to accept irrational beliefs (via a process she calls "interpretive drift") is highly provocative and largely persuasive. Nevertheless, there is a fundamental error in logic that mars an otherwise valuable book.

That error comes in an unnecessary and disjunctive caveat that Luhrmann includes in her introductory remarks. "Whether the claims that magical rituals can alter physical reality or not is beside the point of the present essay," Luhrmann (1989:16) states. She goes on to say that "neither here nor elsewhere in the book shall I consider the question of whether the rituals might work, and whether the strange forces and abilities spoken of in magic might actually exist," and she concludes that "magical ideas are not incontestably true; neither are they incontestably false" (Luhrmann 1989:16). On this last point, of course, Luhrmann is mistaken—magical ideas *are* incontestably false—but notice what this new premise does to her central syllogism:

> If otherwise rational people hold false and irrational beliefs, such as the belief in magic, then it is necessary to explain how they can do so.
>
> Otherwise rational people hold magical beliefs, but we either cannot or will not determine that magical beliefs are false and irrational.
>
> Therefore it is necessary to explain how otherwise rational people can hold magical beliefs.

The argument is now clearly invalid. If we cannot determine that magical beliefs are false and irrational, then why is it necessary to explain how people can hold those beliefs? If the beliefs happened to be true and rational, then any explanation of how people come to hold such beliefs would be superfluous. If the "strange forces and abilities spoken of in magic" *actually existed*, then *that* would be the reason witches believe in magic. "Interpretive drift" would have nothing to do with it. Whether the claims that magical rituals can alter physical reality or not is hardly "beside the point," as Luhrmann claims. Instead, whether or not magic actually works is the central premise of the entire work. Remove the assumption that magical ideas are false and irrational and the whole rationale of the book collapses.

Luhrmann's illogical decision to avoid confronting the reality of witchcraft is characteristic of the interpretive approach to paranormal claims. The ethnographer Paul Stoller provides another illustration. He describes a fieldwork encounter with a Songhay diviner that he says he was "not able to explain or understand" (Stoller 1986:55). The episode involved a mysteriously broken vial of perfume, and from Stoller's description it is obvious that he was duped by a standard bit of misdirection and sleight of hand. A woman of his acquaintance, a "magician-sorcerer" by the name of Fatouma, sent Stoller to a shop to purchase a vial of perfume that she needed for a spirit offering. She directed him to bring it to her at five o'clock that afternoon. When Stoller returned at the appointed hour, Fatouma informed him that he had purchased the wrong kind of perfume and that the spirits would not appreciate the offering. Reluctantly, however, she decided to proceed with the ritual, so she placed the vial in a closed container in an inner room. Later, when she reopened the container in Stoller's presence, the vial was discovered to be broken.

Stoller (1986:55) admits to being puzzled by the event: "How could I explain, after all, the broken vial? . . . Sleight of hand? . . . Perhaps the force of the spirit broke the vial? Maybe this woman, despite our long acquaintance, was, for any number of reasons, trying to deceive me?" For those who are familiar with the modus operandi of magicians, Stoller's puzzlement suggests considerable naiveté. Granted, Stoller can be forgiven for not knowing how the magic trick was done, just as he can be forgiven for not knowing that Fatouma's pattern of misdirection, dissemblance, and sleight of hand is the standard stock-in-trade of illusionists in every culture in the world. He can even be forgiven for not realizing that shamans around the world commonly and deliberately deceive their closest acquaintances while believing themselves to be acting in a completely ethical manner (from the shaman's point of view, magic tricks are simply a means of helping ordinary people perceive the paranormal reality that would otherwise be hidden from them).

When he suggests a paranormal hypothesis as one possible explanation for the phenomenon, however, Stoller commits a logical error that is much more difficult to condone. If he was indeed witness to a genuine paranormal event—if the spirit did indeed break the vial—then Stoller was in a position to make a momentous discovery, since no such paranormal phenomenon has ever been authenticated in the history of the human species. Surely that opportunity should have inspired him to undertake a thorough and conscientious investigation of the objective reality of the matter. Stoller (1986:55), however, admits that it did not: "Perhaps I abandoned too rapidly an epistemology in which the goal is to

produce ideal, verifiable, and replicable knowledge that we might use as a data base for comparison," he says, but he did so because he had chosen "a more subjective approach to fieldwork."

I would not want the point of my criticism to be misconstrued. It is apparent from Stoller's ethnographic works that "more subjective" means, for him, more empathic, more involved, more compassionate, more sensual. No one could argue with these goals. Stoller is obviously a talented ethnographer and an evocative writer. His ethnographies are richly detailed and clearly demonstrate an intimate knowledge of the Songhay. His empathy for the culture he studies and his compassion for its people are beyond question. It is these many laudable features of his work that make his occasional lapses into illogical reasoning so regrettable. In order to be a sensitive, caring, effective ethnographer, it is not necessary to abandon scientific standards of evidential reasoning. Charles Wagley, for example, is arguably one of the finest ethnographers anthropology has ever produced. Wagley's (1977) lyrical ethnography of the Tapirapé Indians, *Welcome of Tears*, is an eloquent and poignant document that openly displays his deep personal affection for the people he studied. At the same time, however, Wagley never abandons his explicit concern for the accurate documentation of objective fact, nor does he ever lose sight of the goal of contributing to a cumulative body of objective knowledge.

Yet another example of the illogical approach to the paranormal within interpretive anthropology concerns Michael Jackson, who maintains that the scientific world view is "just one of many consoling illusions" (Jackson 1989:13). Jackson has conducted fieldwork among the Kuranko of Sierra Leone, who believe that some individuals have the capacity to turn themselves into animals. The Kuranko call these individuals "shape-shifters." As an interpretive anthropologist, Jackson is unwilling to claim authority for his own culturally determined world view over that of his informants, even though he himself is apparently skeptical about the reality of shape-shifting. Instead, Jackson (1989:66) discloses "an interest in dissolving the boundary which in anthropological discourse contrasts them [paranormalists] and us [anthropologists] in terms of a distinction between magic and science," and he accordingly refuses to unequivocally repudiate the claim that one of his informants can turn himself into an elephant. Expressed syllogistically, the essence of his argument could be rendered as follows:

If every perception of reality is the product of a particular cultural tradition, then no perception of reality can claim authority over any other.

The Western perception of reality is the product of a particular cultural tradition.

Therefore the Western perception of reality cannot claim authority over the Kuranko perception.

Despite being valid, that argument is clearly unsound, because the first premise is blatantly false. Epistemological systems that derive their knowledge from falsifiable and unfalsified propositions *can* claim authority over epistemological systems that affirm knowledge based upon non-falsifiable or falsified propositions. It is true that the epistemology of science is the product of a particular cultural tradition, but to deny the authority of scientific epistemology on that basis alone is to commit the genetic fallacy.

When considered in its larger context, Jackson's argument has truly astonishing implications. Anthropology is the study of the biological and cultural evolution of the human species. As such, anthropologists are supposed to know something about human variation, and they are supposed to know something about human nature. When anthropologists are unwilling or unable to say that human beings lack the capacity to turn themselves into elephants, there is something fundamentally wrong with anthropology. Think, for example, about the recent revival of "scientific" racism illustrated by the publication of Herrnstein and Murray's (1994) book *The Bell Curve*. Since the time of Franz Boas, anthropologists have been trying to tell the world that race, language, culture, and intellectual capacity are unrelated variables. How can we expect the world to believe us when we say we know that no "race" is intellectually inferior to any other when at the same time we say we do not know whether or not people can turn themselves into elephants?

My final example concerns a paranormal claim to which I have alluded previously: the purported existence of Sasquatch. As mentioned earlier, there is one professional anthropologist, Grover Krantz, who is convinced that a scientifically unrecognized nonhuman hominid lives in the woods of Washington, Oregon, and northern California. In a book entitled *Big Footprints: A Scientific Inquiry into the Reality of Sasquatch*, Krantz (1992) presents the details of his unusual conviction. He believes that Sasquatch is an extremely large, heavyset, fur-covered, smelly, bipedal, flat-footed hominid pursuing a largely solitary, furtive, nocturnal existence in the temperate forests of the Pacific Northwest. Most anthropologists would characterize this claim as inherently improbable, to say the least, especially given the complete lack of any fossil evidence of any hominoid in the New World

prior to the arrival of *Homo sapiens sapiens* at the end of the Pleistocene. Krantz, however, believes that Sasquatch represents a previously undetected descendant of a large Asian hominoid that disappeared from the fossil record some 500,000 years ago. Krantz has assigned the creature a scientific nomenclature, *Gigantopithecus blacki,* and he has calculated that the present Sasquatch population includes at least two thousand individuals.

In *Big Footprints,* Krantz describes the various kinds of evidence that have led him to believe in the reality of Sasquatch. That evidence includes, most importantly, eyewitness reports, plaster casts of footprints, and a short film, shot in 1967, of an alleged Sasquatch. A close examination of that evidence, however, reveals Krantz's interpretation of the facts to be highly questionable. He consistently emphasizes the evidence that might seem to support his conclusion while ignoring the evidence that would contradict it.

For example, when considering the hundreds of eyewitness sightings of Sasquatch that have been made over the years, Krantz largely confines his discussion to reports from the heavily wooded regions of the Pacific Northwest, which he maintains is the animal's exclusive habitat. He does not mention that Bigfoot "has been reported in every state except Hawaii and Rhode Island and has been spotted in semi-urban areas that simply do not have sufficient forest cover capable of harboring such an animal" (Boston 1994:530). The existence of numerous such reports (and similar reports describing sightings of unicorns, werewolves, vampires, leprechauns, fairies, gremlins, trolls, incubi, succubi, and the like) would imply to any objective observer that eyewitness accounts of paranormal phenomena should be regarded with a high degree of skepticism. Krantz, however, neglects to draw that implication. Similarly, he fails to consider the implications of the more outlandish Sasquatch descriptions. He is favorably disposed towards eyewitness reports that match his preconception of Sasquatch, but he glosses over or ignores reports of "transparent Bigfoots, Bigfoots that wore ragged trousers, Bigfoots that tried to communicate through crude hand signals, [and] Bigfoots who scrawled cryptic messages in the ground" (Boston 1994:530).

As another example, Krantz is particularly impressed with the quality of the footprint evidence. He maintains that many of the tracks show peculiarities, such as indications of dermal ridges, that strongly suggest authenticity. Further, Krantz claims to have identified two features in the footprints that enable him to distinguish genuine tracks from fraudulent ones. Krantz has never revealed publicly what those two features are, because he does not want to alert people who might be inclined to fake tracks. As a result, of course, his scientific colleagues are unable to evaluate his claim,

but Krantz feels no need for peer review; he maintains that he cannot be fooled by fraudulent footprints. In *Big Footprints*, Krantz describes the footprints of a "crippled" Sasquatch from Bossburg, Washington, as especially compelling evidence of authenticity. What he does not tell the reader, however, is that the Sasquatch enthusiast who led Krantz to the crippled footprint, Ivan Marx, "has a history of fabricating Bigfoot evidence," nor does Krantz mention that on two occasions Marx "attempted to pass off phony Bigfoot films" (Boston 1994:529). Similarly, Krantz describes a set of footprints found in Oregon's Mill Creek Watershed in 1982 that showed indications of dermal ridges; what Krantz does not say is that the Forest Service patrolman who found the prints, Paul Freeman, is a former employee of an orthopedic shoe company who "has admitted to faking footprints of Sasquatch" (Dennett 1989:269). Most tellingly, in 1990 Krantz examined a footprint cast that had been sent to him from Indiana and pronounced it authentic: "The track also passed all of my own criteria, published and private, that distinguish Sasquatch tracks from human tracks and from fakes" (Krantz 1992:200). The construction worker who sent Krantz the cast, J. W. Parker, later admitted that the track had been faked; Parker wanted to see if Krantz could in fact recognize a fraudulent track as he claimed to be able to do (Dennett 1994).

Krantz's analysis of the notorious "Patterson film" provides another illustration of his dubious reasoning. The film was allegedly shot on 20 October 1967 in northern California by Roger Patterson and Robert Gimlin, who were on a horseback expedition in search of Sasquatch. The 16mm film, which is 53 seconds long, is jerky and poorly focused (Patterson says he was startled by the sudden appearance of the Bigfoot). The film shows a distant shot of a bipedal creature that looks something like a large ape walking across a shallow stream; neither Patterson nor Gimlin appears in the film. Krantz (1992:92), who claims to have studied the film meticulously, draws this conclusion: "Given the apparent size, posture, and walking stride, the only possible hoaxing method would have to be a large man wearing a fur suit." I have not studied the film meticulously, but I have seen it, and that is *exactly* what it looks like to me. Regardless, Krantz fails to consider just how wildly improbable it is that the film could be authentic. *If* Sasquatch does exist, and *if* a Bigfoot enthusiast and his companion were able to shoot nearly a minute of genuine footage in 1967, why has not anyone else been able to do the same since? Given the technological revolution in video cameras, the number of people who would have had the opportunity to obtain footage of Sasquatch in the past three decades must be enormous. What about professional wildlife photographers who regularly journey to the remotest corners of the earth

to capture on film the most intimate details of the lives of the rarest species of animals? Why have not any of them used their talents and resources to film Sasquatch? Surely the extraordinary recognition they would gain by doing so would be a compelling motivation.

Despite the presence of the word "scientific" in the subtitle of his book, Krantz's approach to the question of Bigfoot's existence is not scientific at all, and not simply because of his frequent violations of the rules of logic and objectivity. Because paranormal phenomena are exceptional by their very nature, they demand exceptional rules of evidential reasoning, and a genuinely scientific approach would apply those rules to the analysis of paranormal claims (see Lett 1991a). There are three important guidelines to the study of paranormal phenomena that are widely recognized among reasonable investigators:

First, *extraordinary claims demand extraordinary evidence*. This is simply a question of balance. You might be justified in accepting at face value my statement that I majored in anthropology at the College of William and Mary, but you would hardly be justified in accepting at face value my statement that I can turn water into wine. For such an extraordinary claim, you would have to demand extraordinary evidence; at the very least you would expect to see a demonstration under carefully controlled conditions that eliminated the possibility of trickery. Krantz seems to recognize the necessity of this rule, even if he does not apply it consistently: "Science requires solid evidence for the existence of a new species—footprints and sightings by local people are never enough. . . . The more unusual and/or unexpected it is, the more proof is required to establish its existence" (Krantz 1992:3–4).

Second, *the burden of proof for any paranormal claim rests on the claimant*. We have already discussed the rationale behind this injunction: it is logically impossible to prove a negative. The burden is on Krantz to prove that Sasquatch exists; the burden is not on the skeptics to prove that Sasquatch does not exist. In the opening pages of *Big Footprints*, Krantz explicitly affirms the appropriateness of this rule. Throughout the remainder of the book, however, Krantz repeatedly admonishes his colleagues in biological anthropology for their refusal to examine his footprint casts. That admonition is undeserved. No anthropologist is under any obligation to examine the casts, because the evidence of the footprints is simply not worth considering at this stage. Extraordinary claims require extraordinary evidence. When Krantz obtains a Sasquatch skull, then he will be justified in demanding that his colleagues examine his evidence. In the meantime, the burden is not on the skeptics to disprove the meager evidence Krantz has collected.

Third, *in and of itself, eyewitness testimony is* never *sufficient to establish the authenticity of any paranormal claim.* Given the inherently improbable nature of any paranormal claim, it is always more likely that the eyewitness is either mistaken or lying than that the paranormal phenomenon actually occurred. After all, paranormal phenomena are, by definition, highly extraordinary, whereas human error and deceit are, in fact, quite ordinary. This does not mean, of course, that any paranormal claim can be dismissed out of hand on an a priori basis; a reasonable person must grant the logical possibility that the evidence could eventually substantiate the claim. It simply means that eyewitness testimony *by itself* is never sufficient to warrant belief; at most, it may be sufficient to warrant careful investigation. In his evaluation of the testimonial evidence for the existence of Sasquatch, Krantz blatantly violates this rule. Krantz (1992:251) says he reviewed the 75 eyewitness observations that were reported directly to him, and found "7 that simply cannot be doubted." Krantz is seriously mistaken in that judgment. All seven of those reports can be doubted, regardless of how seemingly sincere, detailed, or internally consistent they might be. Anyone can make a mistake, and no one has ever developed a foolproof means of detecting dishonesty.

These violations of the scientific rules of evidential reasoning are typical of Krantz's reasoning; *Big Footprints* is replete with glaring errors of logic. Two additional examples will serve to illustrate the point. In the book's introduction, Krantz relates the history of other species that were once unrecognized by science:

> The first skin of a colobus monkey to reach Europe was called a fake; clearly, in the opinion of experts, the many long white hairs had been artificially inserted into a solid coat of shorter black hairs. The first skin of a platypus was greeted with even more derision; the bill and tail were obviously attached to some mammal's skin. Yet these soon proved to be real animals, just as their skins had first indicated. (Krantz 1992:4)

Krantz is not explicit about his point, but his line of reasoning can lead only to one of two possible conclusions. The first conclusion would be that Sasquatch *could* exist, since other unusual animals, once dismissed by the experts, have since been proven to exist; the second conclusion would be that Sasquatch *does* exist, since other unusual animals, once dismissed by the experts, have since been proven to exist. The first conclusion would be completely superfluous, because the logical possibility of Sasquatch is not in dispute. Every reasonable person grants that Sasquatch *could* exist; the question is whether Sasquatch does *in fact* exist. The second conclu-

sion would be an inexcusable non sequitur; the fact that Sasquatch *could* exist hardly means that it *does* exist. By that logic, Krantz could also claim to have proven the existence of the Abominable Snowman, the Loch Ness Monster, or the Easter Bunny.

A few pages later, Krantz develops this argument in greater detail. In the case of rare, remote, or exotic species such as the gorilla, okapi, and coelacanth, he says, our knowledge has grown in five stages:

> Stage 1. Local residents describe the animal. . . . sometimes other evidence is found, like footprints, feces, or nests. At this stage is might be described as 'cryptozoological.'
> Stage 2. Skeletal material is brought to the attention of scientists. . . . At this point the animal is studied, classified, and becomes a scientific reality.
> Stage 3. A complete body is recovered, maybe several, for more detailed anatomical studies and comparisons.
> Stage 4. The first live specimen is captured.
> Stage 5. The species is studied in its native habitat to learn (among other things) if it is endangered and, if so, what might be done to assist its survival. (Krantz 1992:8)

"Sasquatch," Krantz (1992:8) observes, "is presently at Stage 1 of this sequence," but he implies that Sasquatch, like the gorilla, okapi, and coelacanth before it, will eventually move to Stage 5. Consider this argument in its syllogistic form:

> Some animals that were once unrecognized by science were eventually proven to exist.
>
> Sasquatch is an animal that is presently unrecognized by science.
>
> Therefore Sasquatch will eventually be proven to exist.

It is immediately apparent that the argument is invalid. The fact that some animals once unrecognized by science have been proven to exist does not mean that all such animals have been proven to exist. Indeed, the great majority of mysterious animals that started out at Stage 1 *never moved beyond* Stage 1 (unicorns, griffins, dragons, werewolves, mermaids, the Yeti, and the Loch Ness Monster are all still there). Ironically, Krantz's argument actually undermines the rationale for belief in the existence of Sasquatch. If Sasquatch is typical of the animals that started out at Stage 1, as Krantz implies, then Sasquatch too is destined to remain there.

Krantz's illogical conclusion that Sasquatch exists represents a triumph

of wishful thinking over the scientific rules of evidential reasoning. Consider that the evidence relevant to the purported existence of Sasquatch includes the following items:

- a complete lack of fossil evidence

- a complete lack of biological specimens

- a complete lack of unambiguous, well-focused photographs, video footage, or motion pictures

- a complete lack of eyewitness testimony that is objectively corroborated

- numerous pieces of indirect physical evidence (e.g., footprints) that are known to be fraudulent

- no pieces of indirect physical evidence that could not have been faked

- admissions from numerous Sasquatch hoaxers

- the common presence of humanoid creatures in the mythology and folklore of cultures around the world

Anyone who examines that evidence and concludes that Sasquatch exists is being neither objective nor logical. That is demonstrably true of Krantz. His tortured reasoning includes repeated violations of the rule of falsifiability, for example. If a thriving population of large-bodied hominids did exist in the Pacific Northwest, it would be reasonable to expect to encounter certain kinds of evidence, including well-focused photographs, extensive video and/or film footage, well-documented ethological observations, and the remains of Sasquatch bodies. From any reasonable perspective, the complete absence of any such evidence would seem to falsify the claim that Sasquatch exists. Rather than admit that his claim has been falsified, however, Krantz resorts to a number of evidentially unfounded and inherently improbable speculations to explain away the falsifying evidence. Why have none of the hundreds of people who have reported sightings of Sasquatch ever managed to take even a single unambiguous photograph? Because, according to Krantz (1992:6), "a Sasquatch might be photographed only if you are well prepared, calm, fast, and lucky," and apparently no one, not even Sasquatch hunters, has ever managed to be well prepared, calm, fast, and lucky. It is also difficult to photograph Sasquatch, Krantz asserts, because Sasquatch is nocturnal.

That is a convenient excuse, but Krantz has no evidence whatsoever to support his speculation. He also seems undisturbed by the fact that a nocturnal lifestyle would be highly unlikely for a hominoid (of course, a temperate habitat would also be highly unlikely for a nonhuman hominoid, but that does not seem to disturb Krantz either). Why have primatologists never observed Sasquatch? Because, Krantz believes, Sasquatch is shy and furtive and probably afraid of humans. Why have no skeletal remains of a Sasquatch ever been found? Because, according to Krantz, Sasquatches are not subject to predation by other animals, and because they always seek out a hiding place when they are dying. Such violations of the rule of falsifiability are called "multiple outs" (Lett 1991a), and they are a characteristic rationalization of paranormal apologists.

Throughout the pages of *Big Footprints*, Krantz rails repeatedly against the "Scientific Establishment," which he believes is unjustly critical of his work on Sasquatch. Krantz portrays the "Scientific Establishment" as a conservative institution unwilling to consider novel ideas, and he resents the fact that his idiosyncratic interest in Sasquatch has adversely affected his professional career. In fact, of course, science is a remarkably dynamic enterprise that is continually expanding into new frontiers of knowledge. If there were compelling evidence of Sasquatch's existence, large numbers of anthropologists would be eagerly following the trail. It is not the fact that Krantz is interested in a novel research topic that makes him the target of negative criticism; instead, it is the fact that Krantz violates the scientific rules of evidential reasoning in the pursuit of his topic that inspires the disapproval of his colleagues. Krantz (1992:273) imagines that his "prestige in the scientific world will rise a couple of notches" if Sasquatch is ever proven to exist, but he is mistaken. In the enormously unlikely event that Sasquatch does turn out to be real, Krantz will have been right for all the wrong reasons. His notoriety among the general public would undoubtedly increase, but his reputation among scientists and other critical thinkers would be unimproved.

I began this section on logic by observing that the scientific method requires logical consistency. The necessity of that requirement should now be obvious. The failure to adhere consistently to the principles of logical analysis opens the door to egregious errors in reasoning, and that is why the scientific approach to knowledge incorporates logical vigilance. To this point, we have reviewed two of the three defining elements of science. Objectivity and logic, as we have seen, are necessary conditions for science, but they are not sufficient. We turn now to a consideration of the third and final essential element: the systematic nature of the scientific enterprise.

Science Is Systematic

To say that science is systematic is simply to say that there is a *method* to scientific research. H. Russell Bernard, the author of the preeminent text on research methodology in cultural anthropology, has observed that the word "method" can be understood in three distinct senses. "First, method refers to *epistemology*, to sets of assumptions about how we acquire knowledge" (Bernard 1994:168). In our review of objectivity and logic, we explored in detail the epistemological assumptions science makes about the acquisition of propositional knowledge. "Second, method refers to *strategic approaches* to the accumulation of actual data" (Bernard 1994:168). Methodological approaches in the social sciences include the experimental method (involving the manipulation of variables under controlled conditions) and the naturalistic method (involving the observation of phenomena in their natural setting). "And third, method refers to *techniques* or sets of techniques for collecting and analyzing data" (Bernard 1994:168). The techniques used in the social sciences include such things as interviews, questionnaires, content analysis, and componential analysis.

I want to review briefly the systematic nature of the scientific method, but I do not want to address the many intricacies of research design at the strategic and technical levels. Questions about dependent and independent variables, control groups, sample selection, statistical analysis, and the like are all important elements of the systematic approach taken by science in the pursuit of knowledge, but those questions belong in a book devoted primarily to methodology. As I explained in the preface, this book is concerned primarily with scientific "method" (or "theory") in the first sense of the term, as a set of fundamental assumptions about the acquisition of knowledge. Therefore I want to explore the epistemological rationale that underlies the systematic nature of the scientific method.

The twin goals of scientific inquiry are the accumulation of propositional knowledge and the identification of causal relationships. Science is therefore *cumulative* and *nomothetic*. It is cumulative because it produces a body of knowledge that is continually expanding, every element of which is (or should be) mutually compatible; it is nomothetic because it produces a corpus of theories that identify lawful regularities, each one of which has (or should have) predictive power. In the pursuit of those goals, as we have seen, science relies exclusively upon the epistemological principles of objectivity and logic.

As a practical matter, however, it can be difficult to achieve the ideals of scientific inquiry, particularly for individual human beings, since all individuals are handicapped by at least some degree of ignorance and

bias. Science is practiced most successfully as a cooperative activity among individuals of complementary knowledge and varying biases. As the scientific approach to knowledge has evolved, therefore, it has developed a set of standard procedures that are intended to ensure the consistent application of reason in the communal pursuit of knowledge. Those procedures constitute a system whose general outlines are well known, as the anthropologist Roy D'Andrade explains:

> There is general agreement that doing science is (1) trying to find out about the world by making observations, (2) checking to see if those observations are reliable, (3) developing a general model or account that explains those observations, (4) checking this model or account against new observations and (5) comparing it to other models and accounts to see which model fits the observations best. Science is simply a systematic way of trying to find out about the world. (D'Andrade 1995:1)

In reality, of course, the actual system used in science is more formal and more detailed, but D'Andrade provides an excellent overview. He suggests an outline of science that is based on straightforward common sense, and he is absolutely correct. The systematic nature of scientific inquiry has evolved naturally in response to a variety of practical problems. Two of those problems are especially salient: the need for criticism and the need for cooperation. The first problem is one that was discussed earlier: science requires an epistemological approach that is impersonal and unbiased, yet no individual scientist could ever be completely impersonal or unbiased. To solve that problem, as we have seen, science incorporates the rules of public verifiability and testability. Many of the systematic procedures of contemporary scientific research, which I will review momentarily, were developed to facilitate the continual public critique of scientific claims.

The second practical impediment to scientific inquiry is readily apparent: the enormous accumulation of scientific knowledge, particularly in the past century, has made it impossible for any single individual scientist in any discipline to master the entire realm of knowledge within his or her field. Moreover, no single individual could possibly possess the full range of imaginative insight that has been responsible for all the scientific breakthroughs of the past two or three centuries. The successful application of the scientific approach to knowledge requires a cooperative effort among many individuals. Many of the systematic procedures that characterize contemporary scientific activity were developed to foster cooperation among scientists. (This does not deny that the institutionalization of rewards in the scientific community also encourages competition among individual scientists.)

In broad outline, then, the system of research that has evolved in contemporary science consists of an orderly sequence of six procedural steps. In its ideal form, scientific research requires its practitioners to follow these half-dozen steps in this order: (1) define the problem, (2) review the literature, (3) formulate the hypotheses, (4) collect the data, (5) draw the conclusion, and (6) publish the results. Let me briefly review the rationale behind each of these procedures.

Define the Problem

It is axiomatic that the kinds of questions asked determine the kinds of answers obtained. Since the goal of science is the accumulation of propositional knowledge, the necessary first step in scientific inquiry is the identification of the domain of propositional knowledge that is being sought. The more precisely that domain is defined, the better, because completely open-ended questions are never fully answerable. No ethnographer, for example, could ever hope to describe every aspect of every indigenous culture in Amazonia, but a researcher could hope to identify the role protein availability plays in village fissioning among the Yanamamo. In science, the problem should be defined at the outset in the clearest possible terms.

In interpretive ethnography, in contrast, the problem is frequently defined in the vaguest possible terms. G. N. Appell (1989:196) comes to a conclusion that is widely shared by scientific anthropologists: "It has been my observation that the frame 'interpretation' is sometimes used as a cover for sloppy fieldwork, poorly phrased questions, or a lack of theoretical clarity." The contrast between scientific anthropology and interpretive anthropology, in fact, is apparent when one examines the problems the two define for themselves. Interpretive anthropology, as we have seen, demonstrates little interest in generating propositional knowledge, and as a result it demonstrates little interest in asking answerable questions. Instead, as Johannsen (1992:74) remarks, interpretive ethnographies "are characterized by a distinctive fixation on self-criticism."

Ernest Gellner (1988:29) perfectly captures the tone of many interpretive ethnographies: "The argument tends to be: because all knowledge is dubious, being theory-saturated/ethnocentric/paradigm-dominated/interest-linked (please pick your preferred variant and cross out the others, or add your own), etc., therefore the anguish-ridden author, battling with the dragons, can put forward whatever he pleases." On the basis of their ethnographic research, interpretive anthropologists frequently conclude that the subjects of their study live in a cultural world that is incom-

mensurable with our own and that no account of that world by an outsider could ever be anything other than partial and contingent. This leaves scientific anthropologists wondering what the point of the ethnographic research could have been in the first place. What knowledge did the interpretive ethnographers hope to acquire?

Review the Literature

The goal of the scientific enterprise is to accumulate an ever-expanding body of mutually compatible knowledge that grows by accretion and correction. Every contemporary scientific discipline, however, has already accumulated a body of knowledge that is far larger than the amount of information that any single scientist could possibly absorb. Accordingly, the standard procedures of scientific research require scientists to review the literature relevant to the problem they have defined for themselves before they proceed with their investigations. Reviewing the literature provides a number of benefits. It gives scientific researchers the opportunity to familiarize themselves with the current consensus of knowledge on a given topic. It allows them to learn from the successes and failures of their colleagues. And it provides them with a source of inspiration that can be very valuable in the formulation of hypotheses.

Formulate the Hypotheses

A hypothesis can be defined as a testable statement of the relationship between two or more variables. Hypotheses are generally phrased as "if-then" statements. Here is an anthropological example: If a society has a horticultural mode of production and lacks the opportunity for territorial expansion, then it is likely to engage in endemic warfare and practice female infanticide as a means of population regulation. Since scientific claims to knowledge are founded upon falsifiable propositions, the central importance of testable hypotheses is self-evident.

There are two clear difficulties that present themselves in the attempt to formulate hypotheses, however. The first is the requirement for imaginative and even intuitive insight. Causal relationships do not emerge automatically from descriptive data; recognizing such relationships requires the creative use of inductive logic, and some individuals are better at it than others. It takes imagination to envision relationships between previously unrelated variables, and that is why paradigms, which provide the context and stimulus for the creation of hypotheses, are critically important to scientific research (see Lett 1987).

The second difficulty in formulating hypotheses involves translating the intuitive insights of inductive logic into the falsifiable propositions of deductive logic, which must be done in order to validate a scientific claim to knowledge. The problem, alluded to earlier, lies in developing operational definitions of the variables to be measured that match the conceptual definitions of those variables (see Bernard 1995:25–32). Given the hypothesis that some particular ethnic group is more or less intelligent than others, for example, the crucial question becomes how intelligence is to be measured.

The solution to these problems, of course, is for scientists to collaborate with each other in the formulation of hypotheses, sharing their intuitive insights and drawing imaginative inspiration from each other, and to critique each others' hypotheses, analyzing the internal logic of the suppositions and evaluating the appropriateness of operational definitions. To facilitate collaboration, scientists are enjoined to review the scientific literature; to facilitate criticism, scientists are expected to publish their data, methods, and results.

Collect the Data

Once a testable hypothesis has been formulated, the next step in scientific research is to collect the data. The exact procedures and techniques vary considerably from one scientific discipline to another and from one hypothesis to another, but all scientific data collection methods have one thing in common: they are all publicly verifiable. (This is not necessarily true, of course, of the methods used in interpretive anthropology, as discussed earlier.) Data collection techniques in anthropology span a very broad range and include everything from excavation and exhumation to phonological analysis and participant observation.

Most discussions about scientific "methodology" generally focus on this one aspect of the scientific enterprise. Without doubt, identifying the advantages and disadvantages of particular procedures and techniques is an involved and important undertaking. Bernard (1995), for example, devotes more than five hundred pages to a careful analysis of the topic. For our purposes, however, it is sufficient to observe that scientific data collection techniques must be publicly verifiable and that the particular technique employed must be capable of either confirming or disconfirming the hypothesis.

There is one other point about data collection methods that is relevant to epistemological issues in anthropology, however, and one that is therefore relevant to our concerns here. In ethnography and ethnology, the

description and comparative analysis of contemporary cultures presents a peculiar problem. Human beings are the subject of anthropological study, yet human beings also study themselves. As a result, the world view of every human culture includes a set of theories about the entire range of anthropological concerns, including the origins of humanity, the motivations for human behavior, the characteristics of human nature, and the form and function of human social systems. This is true, obviously, of the cultures from which anthropologists themselves emerge. As a result, anthropologists are obliged to distinguish, in some defensible way, between those theories that they hold as informed scientists and those theories that they hold as enculturated individuals.

Since 1954, anthropologists have used the concept of emics and etics to make that distinction (see Headland, Pike, and Harris 1990). The two terms, originally coined by the linguist Kenneth Pike, are best understood as referring to purely epistemological constructs (see Lett 1990; 1996a). *Emic* constructs are accounts, descriptions, and analyses expressed in terms of the conceptual schemes and categories regarded as meaningful and appropriate by the native members of the culture whose belief and behaviors are being studied. *Etic* constructs are accounts, descriptions, and analyses expressed in terms of the conceptual schemes and categories regarded as meaningful and appropriate by the community of scientific observers. Scientific anthropology recognizes that both emic and etic knowledge are essential. Emic constructs are essential for cross-cultural communication, while etic constructs are essential for cross-cultural comparisons. Interpretive anthropology, on the other hand, denies the validity and/or utility of etic knowledge.

Draw the Conclusion

If the data collection techniques are properly chosen and applied, then it will be possible to either confirm or deny the hypothesis. The conclusion that eventually must be drawn, however, goes beyond the narrow decision to accept or reject the particular hypothesis. Science is a nomothetic activity that attempts to derive lawful generalizations from particular cases. Ideally, then, the conclusions drawn from any particular research should be applied to the broader range of disciplinary knowledge: if those conclusions do not either replicate or repudiate existing knowledge, then they should expand upon it.

The goal of any scientific discipline is to uncover the operative principles that determine cause and effect within its domain of inquiry and then to articulate those principles in the form of predictive laws. To achieve

that goal, science follows a dialectical process, using deductive logic to reach conclusions about the results of hypothetical tests and then using inductive logic to formulate new hypotheses. The six procedural steps in the scientific method constitute a continuous loop.

Publish the Results

Within the academy, publication has become virtually an end in itself, and the requirement to either publish or perish is keenly felt by many scholars both inside and outside science. The requirement to publish the results of scientific research, however, evolved as a means to an important end, not as an end in itself. The pursuit of scientific knowledge demands public scrutiny of research results, which means that scientific researchers must be in communication with each other. Anthropology is a relatively small discipline, yet there are still more than ten thousand professional anthropologists in the United States alone. Obviously a community of that size could not undertake the continuous peer review required by science simply on the basis of personal communication. Some form of publication is clearly essential.

Anthropology has followed the model provided by other scientific disciplines in institutionalizing the peer-reviewed journal as a standard means of communication among practicing professionals. Unlike most other scientific disciplines, however, anthropology has also emphasized single-author books as a major forum for professional communication, especially within cultural anthropology. New developments in the technology of communication such as electronic mail will undoubtedly cause a continuing evolution in the procedural norms of science in general and of anthropology in particular. The necessity of publication in the pursuit of scientific knowledge is virtually self-evident, and I will not belabor the point. Obviously there would be no literature to review if scientists failed to published the results of their research. Without a literature to review, there would be little public verification of scientific claims and procedures, and without public verification there would be no correction of error, bias, or fraud.

The Trappings of Science

It should be quickly admitted that the foregoing sketch of the scientific method is highly idealized. As Cerroni-Long (1996:52) says, "in reality the actual practice of science is a messy, bumbling, all-too-human affair." This does not mean that there is anything wrong with the ideal of science,

however; it simply means that science is practiced by human beings. More important, it should be recognized that the six procedural steps outlined here are neither necessary nor sufficient for the acquisition of scientific knowledge. They are enormously useful, certainly, but they are neither completely indispensable nor wholly adequate in and of themselves. They are not necessary, because there have been cases in the history of science where independent geniuses, working alone without benefit of collaboration or criticism, have made major contributions to scientific knowledge. They are not sufficient, because it is possible for scholars to adhere closely to all six procedural steps and still make no contributions to scientific knowledge whatsoever. That is possible even for scholars who are exceptionally intelligent, unusually imaginative, and especially diligent. All they have to do to ultimately fail is abandon the epistemological principles of objectivity and logic.

Preserving all the external trappings of science while rejecting or ignoring the fundamental epistemology of science is characteristic of many contemporary disciplines (education, psychotherapy, and parapsychology are three obvious examples). I believe it is true of interpretive anthropology as well. Interpretive anthropologists conduct fieldwork, publish monographs, form associations, attend meetings, review journals, and engage in mutual critique, but they do not pursue the goal of objective propositional knowledge obtained via publicly verifiable data collection procedures. Many interpretive anthropologists are highly intelligent, broadly informed, personally engaging, and thoroughly well intentioned, but few have made any substantive contribution to anthropological knowledge about the human condition.

Notwithstanding these concerns, the systematic nature of the scientific enterprise makes an unquestionable contribution to the pursuit of scientific knowledge. Despite the dangers of reification, there is considerable benefit to be derived from systematizing the epistemological norms of science. The procedural system of science is undoubtedly an ideal, but, as Marvin Harris (1979:27–28) says, "it is precisely as an ideal that the uniqueness of science deserves to be defended." In the final analysis, of course, there is only one standard of what is and is not scientific. In the words of the philosopher Reuben Abel (1976:81), quoted earlier, "there is no single scientific method other than the unremitting criticism of evidence and reasoning in every way possible." That unremitting criticism applies as well to the evolving system of procedures that constitutes the activity of science.

4

Reason and Contemporary Anthropology

We return now to the central question with which we began our discussion of the principles of rational inquiry in chapter 2: What is *reason*? I have attempted in the intervening pages to provide a detailed answer, but now I can offer a brief summary: Reason is the exercise of critical judgment in the pursuit of reliable knowledge. Reason entails the recognition of the distinction between propositional and emotive statements; reason also entails the recognition that both propositional and emotive statements can be expressed in either subjective or objective terms. Accordingly, reason requires that a consistent distinction be made between subjective-propositional, objective-propositional, subjective-emotive, and objective-emotive statements. Reason avoids the confusion that stems from confounding these four types of statements. In the pursuit of objective-propositional knowledge, reason employs a set of self-correcting epistemological procedures that can be characterized as the scientific method. Thus reason demands that claims to synthetic propositional knowledge be both publicly verifiable and testable. Those demands are met by following a variety of guidelines, including the rules for operationalism, replicability, and falsifiability. Reason further demands a steadfast adherence to the rules of logic. In that regard, reason distinguishes between necessary and sufficient conditions, recognizes the difference between inductive and deductive arguments, and evaluates the appropriateness of syllogisms by appeal to the logical principles of validity and soundness. Reason requires the recognition and rejection of all forms of fallacious argumentation, including begging the question; the fallacies of equivocation, composition, and division; the genetic fallacy; false dilemma; straw and ad hominem arguments; and appeals to ignorance and to authority. In the pursuit of an expanding and nomothetic body of knowledge and theory, reason recognizes the value of a systematic

approach founded upon the efforts of a self-critical community of researchers. To achieve that goal, therefore, reason utilizes the six steps of the scientific method: define the problem, review the literature, formulate the hypotheses, collect the data, draw the conclusion, and publish the results. Finally, reason recognizes that all claims to synthetic propositional knowledge are tentative and provisional, subject to revision in the light of additional evidence or superior analysis. Reason rejects the proposition, however, that all claims to knowledge are of equal merit, and reason maintains that claims to knowledge that are incongruent with the principles of rational inquiry are insupportable.

It should now be possible to fully appreciate the wisdom of Gellner's (1988:29) observation that justifying the preeminence of reason "is a deep and difficult matter." It should be equally apparent, however, that claims for the preeminence of reason are eminently justifiable. Vincent Crapanzano's (1992:7–8) challenge to specify the meaning of reason is readily met. It should be apparent as well that the interpretive approach championed by Crapanzano and other anthropologists will not entirely fulfill the criteria of reasonable inquiry (see Lett 1996b).

These points are widely appreciated within contemporary anthropology. Many anthropologists reject the tenets of postmodernism, and many of them have assembled forceful critiques of the various errors inherent in nonrational approaches to anthropological knowledge. Now that we have explored the essential elements of rational inquiry in some detail, we are prepared to appreciate fully the import of those critiques. Accordingly, I would like to review briefly the assessment interpretive anthropology has received from those anthropologists who are committed to the exclusive use of reason.

Let me begin that review with an important point. Any reasonable analysis of interpretive anthropology will naturally reveal a number of logical errors in the postmodernist approach, but any such analysis will also reveal a number of valid points and positive contributions stemming from the interpretive movement. Despite its flaws, interpretive anthropology is not entirely without merit.

The Disciplinary Contributions of Interpretive Anthropology

Interpretive anthropology has made an undeniable contribution to the reasonable analysis of contemporary anthropological knowledge, as many scientific anthropologists have noted. One of the basic contentions of interpretive anthropology is the insistence that the implicit genre conventions of ethnographic writing deserve explicit scrutiny, and all rea-

sonable critics of interpretive anthropology have conceded that point. Scientific anthropologists are united in recognizing the truth of Marcus and Cushman's (1982:29) claim that "ethnographic description is by no means the straightforward, unproblematic task it is thought to be in the social sciences, but a complex effect, achieved through writing and dependent upon the strategic choice and construction of available detail." The scientific requirement for critical self-scrutiny demands examination of the implicit assumptions of ethnographic writing, and interpretive anthropology has made a genuine contribution to the discipline as a whole in calling attention to those issues.

The scientific anthropologist Robert Carneiro (1995:9), for example, readily concedes that "post-modernists have had a valid point to make" in their critique of ethnography and the ways in which ethnographic reality is represented. Traditionally, Carneiro (1995:9) admits, ethnographers have tended "to smooth things up" in the effort to "present a single 'authoritative' statement of a particular custom or belief," despite the fact that every competent ethnographer knows that "informants' versions of a custom or belief often vary all over the map." Such "official" versions of ethnographic reality, Carneiro acknowledges, mask the actual complexity of the culture, just as interpretive anthropologists have argued:

> But what does this 'official' version of a culture really represent? . . . Is it the opinion of one's best-liked informant? Or the most reliable one? Is it the response of one informant or of several? And if several, and if their range of responses has been 'averaged,' then what is this 'average' that gets printed in the monograph—the mean, the median, or the mode? (Carneiro 1995:9–10)

While scientific anthropologists have recognized that the genre conventions of ethnographic writing deserve critical scrutiny, however, they have refused to accept the premise that analyzing those conventions requires abandoning the epistemological principles of science. Atkinson (1992:3–4), for example, readily admits that "our methods of reading and writing in ethnography are thoroughly conventional and contrived," but he argues that "there need be no immediate threat [to science] from the fact that many of the 'literary' characteristics of ethnography are shared with other genres, including fiction." Sangren (1988:421), too, argues that the interpretive approach is only partially correct: "Like [interpretive anthropologists], I believe that anthropology is and ought to constitute a kind of reflexive cultural critique; unlike them, I believe that such a critique must emanate from a holistic and explicit allegiance to scientific values." Magnarella comes to an identical conclusion:

Much of what the modern interpretationists have to say is valuable. We should try to understand others and our ways of understanding them better. We should critique culture and society, especially when our disciplines are being used to create injustices. We must always be skeptical about historical accounts, especially nationalist histories. However, none of these concerns justifies eliminating science. On the contrary, science can be used to further all of these goals. (Magnarella 1993:143)

In the same vein, Appell (1989:196) admits that ethnography includes "narrative treatment of experienced reality" that "inevitably lacks the rich detail of lived experience," but he argues that the task facing anthropology, as a result, "is to discover in what way and manner styles of ethnographic narrative distort field experiences so that our skills in communicating a cultural reality are not only improved but conform to the standards of a scientific community so that knowledge can be certified." Similarly, Spiro (1986:274) recognizes that "insight, imagination, empathy and the like are indispensable as techniques of inquiry," but he insists that "however indispensable these subjective procedures may be for the formulation of interpretations and explanations, in the scientific mode of inquiry they are entirely disqualified as a method for their validation."

Earlier, in exploring the systematic nature of science, we saw that scientists have an obligation to apply unremitting criticism to the procedural steps of the scientific method. Cultural anthropologists have not always followed that injunction. While they have always published the results of their ethnographic research, until recently they have rarely done so in a critical and reflective manner. Interpretive anthropology has made a significant contribution by inspiring ethnographic writers to identify and examine their implicit assumptions. As a result, Roscoe (1995:500) suggests that "the discipline as a whole might begin to discuss pragmatic ways to destabilize the self-confirming, self-serving, authorial monopoly that most ethnographers still enjoy over their subject matter."

This is a crucial point for ethnographers who aspire to contribute to the production of scientific knowledge. Unlike natural scientists, who typically engage in team research, ethnographers are likely to pursue individual investigations. In comparison with their colleagues in other scientific disciplines, ethnographic researchers receive little collegial scrutiny of their claims. In a significant departure from standard scientific procedure, the results of ethnographic research are rarely replicated. The style and scope of traditional ethnographic monographs have few parallels in other scientific disciplines. These issues have not received sufficient examination in anthropology.

These are some of the insights that have emerged from interpretive

anthropology, and they are important ones. The interpretive approach has made an undeniable contribution to the discipline. Where interpretive anthropology has erred is in rejecting the scientific approach to knowledge. Magnarella (1993:143) suggests the only reasonable solution to the ongoing competition between the interpretive and scientific approaches in anthropology: "To contribute to the understanding of humans and their relationships to our earth, humanistic approaches must be combined with more scientific paradigms in a complementary, rather than in an alienated, manner." Scientific anthropology has begun to recognize and incorporate the insights of the interpretive approach; it remains for interpretive anthropology to embrace the fundamental principles of rational inquiry. So far it has failed to do so. Neither of the two fundamental premises of interpretive anthropology can hold up in the light of reason.

The Intellectual Significance of Interpretive Anthropology

The first essential premise of interpretive anthropology, as we have seen, is the contention that evocation and interpretation are sufficient goals for the anthropological enterprise. As we have seen as well, that premise is universally rejected by anthropologists who are committed to the use of reason. Keesing (1987:161), you will recall, maintains that the mission of anthropology "goes well beyond interpreting cultural meanings," and Jarvie (1988:429) insists that anthropology "is not general curiosity about exotics (including ourselves seen as exotics) the main methodological problem of which is then how we are to conduct the study, description, representation, satisfaction of this curiosity." This fundamental assumption of interpretive anthropology leads to intellectual products that many scholars, both inside and outside anthropology, find trivial at best and embarrassing at worst.

Melford Spiro (1986:278), for example, argues that the essential premises of interpretive anthropology can lead only to unimportant conclusions: "For if, in principle, ethnographic studies . . . can only contribute to unique understandings of this or that belief or custom or this or that primitive or peasant culture in all of its particularity, what possible intellectual relevance might such studies have?" Elsewhere, Spiro quotes an early comment by Kroeber (1920:380) to demonstrate that this point has been appreciated by many anthropologists for many decades: "As long as we continue offering the world only reconstructions of specific detail, and consistently show a negative attitude toward broader conclusions, the world will find very little profit in ethnology."

Indeed, the world outside anthropology has found very little of value

in the research findings of interpretive anthropology. The physicist Charles Nissim-Sabat (1987:935), for instance, observes that the "thou-shalt-not-judge" relativism of interpretive anthropology "has produced much predication, obfuscation, confusion, and contradiction in what even the most prominent anthropologists have written for the general public." It is not simply the general public that remains unimpressed by the prod-ucts of interpretive anthropology, however. "Even in academia," says Salzman (1994:37), "the area specialists, and colleagues in sister disci-plines, have strong doubts about whether anthropologists are up to very much, other than having lots of nice vacations in exotic places."

It is important to remember that scientific anthropologists have never doubted that interpretive anthropologists *could* evoke and interpret cul-tures. Scientific anthropologists have simply questioned whether their interpretive colleagues *should* pursue evocation and interpretation as *exclusive* goals. No one argues that interpretation is impossible, but many anthropologists argue that it has limited value. One such anthropologist is Roy D'Andrade, who identifies the comparative triviality of interpre-tive anthropology with some telling observations:

> In my view, anthropology without science is not much: a small but interest-ing sampling of the humanities; embarrassing stories about the 'real great political adventures of me;' some heartfelt moral denunciations and a large corpus of evocative but unverifiable interpretations.
>
> In contrast, doing science has produced a substantial body of good anthropology, including a corpus of ethnography, an extensive account of prehistory and a detailed record of human evolution and physical variation. (D'Andrade 1995:4)

Thus there is an emerging consensus among anthropologists who are committed to the use of reason that interpretive anthropology has very lit-tle to offer. Allen Johnson (1995:13), for example, asks "how often and in how many ways can you say, 'Reality is culturally constructed,' and still be interesting?" Indeed, the products of interpretive research are neither substantive in themselves nor relevant to other fields of knowledge. Mar-vin Harris made this point in characteristically provocative fashion in a Distinguished Lecture delivered before the American Anthropological Association in 1991. With regard to the unanticipated and revolutionary collapse of state communism in Europe during the late 1980s and early 1990s, Harris offered these comments:

> What do anthropologists have to say about all this? A branch of the human sciences that ignores these immense events, that interprets them exclusive-

ly in terms of relativized 'local knowledge,' or that derides the attempt to understand them in terms of nomothetic principles runs the risk of being confined to the backwaters of contemporary intellectual life. (Harris 1992: 295)

Similarly, Carneiro argues that interpretive anthropology's exclusive fixation on evocative *ethnography* loses sight of a much more important goal, namely explanatory *ethnology*:

> For it is here, in ethnology, that broad theories are built and generalizations crafted; where the major questions of anthropology are asked and answered. Here it is that we debate the origin of clans, the invention of agriculture, the function of cross-cousin marriage, the role of age grades, the rise of chiefdoms, and the development of states. What have post-modernists contributed to the solution of these great problems? Nothing. (Carneiro 1995:14)

The central implication of these arguments by Harris and Carneiro, of course, is that anthropology can and should do more than simply evoke and interpret cultural phenomena. Like other scientific anthropologists, they reject the contention that subjective evocations and interpretations are sufficiently valuable in their own right. Even if one were to grant this central premise of interpretive anthropology, many of its products would still be relatively shallow and insignificant. As Carneiro (1995:12) observes, much of postmodern ethnography has become so "supremely self-centered" that it has descended into "a miasmal swamp of subjectivism, solipsism, and narcissism." In the final analysis, however, the biggest problem with interpretive anthropology is not its advocacy of intellectually inconsequential goals; instead, the paradigm's biggest failing lies in its unfounded rejection of the possibility of science.

The Fundamental Misconception of Interpretive Anthropology

Anthropologists familiar with the essential principles of rational inquiry are united in rejecting the second essential premise of interpretive anthropology, namely the contention that objective scientific knowledge about human affairs is unattainable. As many critics have observed, the interpretivist rejection of science is neither coherent nor compelling. The reason is very evident. The interpretivist attack against science is based upon a straw argument. Interpretive critiques of the principles of rational inquiry are invariably directed not against *science* but against *scientism*.

I identified the basic outlines of this straw argument earlier when I

described some common misconceptions about science. Science does not claim to be free of bias, error, or fraud; that is scientism. Science does not claim absolute certainty; that is scientism as well. Science does not claim that perception is simply a matter of passive reception; that too is scientism. Paul Roscoe (1995:500) is one of many critics who have recognized the straw argument in the interpretive critique of science: the "ire" evident in the interpretive attack on science, he says, "suggests the covert presence of a further target, and I suspect this is scientism: the unreflective, epistemological, and theoretical arrogance with which positivists supposedly deploy the precept of methodological naturalism, smugly deriding all knowledge not generated by what they take to be scientific method." As Roscoe makes clear, that characterization of science is nothing more than a caricature.

"Bluntly put," in the words of S. P. Reyna (1994:564), "literary [i.e., interpretive] anthropologists have not made a cogent case against science." Interpretive anthropologists, in fact, have failed even to address the epistemological principles of genuine science, let alone undermine those principles. Sangren (1988:420) is correct in the observation that "postmodernist critics confuse science as critical judgment with science as revealed authority." Rejecting what they perceive to be the rigid epistemological absolutism of science, interpretive anthropologists embrace instead what they believe to be a flexible epistemological relativism. In so doing, they commit the fallacy of the false dilemma. There is a second alternative to absolutism that avoids the self-contradictions of relativism, as the philosopher Harvey Siegel (1987:161) explains: "This second position does not require that knowledge be incorrigible or certain.... Knowledge-claims can be objectively assessed in accordance with presently accepted criteria (e.g. of evidential warrant, explanatory power, perceptual reliability, etc.), which can in turn be critically assessed."

The notion of absolute truth is foreign to the epistemology of science. Truth, in science, has a provisional quality. A scientific proposition is considered to be true if it is falsifiable and unfalsified; a scientific theory is considered to be true if it generates empirically supportable explanations and makes no false predictions. Scientific propositions and theories are never known to be true in any absolute sense, however. They are always vulnerable to the possibility of refutation on either logical or empirical grounds.

These principles are well appreciated by scientific anthropologists, none of whom claims the kind of infallible authority that is so angrily derided by interpretive anthropologists. Reyna (1994:557), for example, admits that "science is not concerned with the production of what is uni-

versally true, but with the construction of what is approximately true—explanations that last only until the imagination and creativity of scientists construct truer explanations." In the same vein, Harris (1994:65) denies that "science guarantees absolute truth free of subjective bias, error, untruths, lies, and frauds," and affirms instead that "science is the best system yet devised for reducing subjective bias, error, untruths, lies, and frauds." D'Andrade (1995:1–4), to cite one more example, recognizes that "doing science does not guarantee correct answers" and that "people doing science, like people everywhere, are often biased," but he is also aware that "bias does not destroy science," since science "is a public activity in which people check on each other's observations and reasoning."

In an especially cogent analysis of interpretive anthropology, Reyna explains that interpretivists have two options if they wish to convince their fellow anthropologists to abandon the epistemology of science:

> Prudent thinkers might be persuaded to reject science provided that two questions had been answered. The first of these is whether criticisms of science are compelling. The second is whether there is another, more powerful mode of knowing than science, so that investigators might turn to a replacement that would help them to address reality more adequately than has science. (Reyna 1994:557)

Reyna's first question has obviously not been answered. Interpretive anthropologists have relied exclusively upon a straw argument in their critique of science, and that strategy has been distinctly unsuccessful. The failure of interpretive anthropologists to answer Reyna's second question has been equally dramatic. Interpretive anthropology has no reasonable alternative to offer to the scientific approach to knowledge. Spiro (1986:274) is indisputably correct in his observation that "the proposition that the study of man [i.e., humanity] and culture requires a subjective method of inquiry including empathy, intuition, Verstehen, and the like, rather than the objective methods employed in the study of natural phenomena is a fallacy."

Magnarella (1993:3) provides a measure for weighing the relative merit of the interpretive and scientific approaches in anthropology: "The extent to which a paradigm can be used as the basis for generating more useful and numerous empirically supported hypotheses than alternative paradigms is the degree to which it is a superior way of understanding sociocultural systems." Clearly the epistemology of science is enormously more productive in this regard. Indeed, far from facilitating the production of

knowledge, the epistemology of interpretive anthropology actually precludes the generation of new knowledge. As Reyna (1994:576) says, "literary anthropologists' demands for the repudiation of science, and for its replacement with a thick description innocent of validation, means that they hold a doctrine that allows them to know next to nothing."

This fact is apparent to many scientific anthropologists, even if it might be obscure to many interpretive anthropologists. Appell, for instance (1989:198), notes that the interpretive program "dissolves understanding and knowledge rather than expanding it." Roth (1989:555) is on solid ground when he complains that interpretive anthropology's "union of epistemology and literary criticism spawns no epistemological insights." Reyna (1994:576) sees a central tendency towards nihilism in the epistemology of interpretive anthropology: "A danger with nihilism is that is stops practices that lead to the acquisition of knowledge of how to proceed in all realms." Spiro faults interpretive anthropology for its consistent failure to propose workable alternatives to the scientific approach it criticizes:

> That any and all of the generalizations and theories of the social sciences (including anthropology) may be culture-bound is a proposition that has long been entertained by anthropologists, and appropriately so. But the proper scholarly response to this healthy skepticism is not, surely, the a priori rejection of generalizations and theories, but rather the development of a research program for their empirical assessment. (Spiro 1992:21)

It is probably superfluous to observe that interpretive anthropology has proposed no such research program. As we saw in chapter 1, interpretive anthropologists have essentially abandoned "the attempt to construct a general theory of culture" (Marcus and Fischer 1986:16). In the final analysis, the interpretive approach has no coherent critique to offer of the epistemology of science; it has no legitimate epistemological alternatives to propose; and it has no appreciable body of significant knowledge to share.

Marvin Harris has an additional charge to lay against interpretive anthropology: he contends that many interpretive anthropologists are fundamentally ignorant of anthropological fact and theory. It is evident, according to Harris (1991:83), that interpretive anthropologists have not "made a systematic study of the positivist corpus of theories that deal with the parallel and convergent evolution of sociocultural systems." Thus Harris finds it unconscionable that interpretive anthropologists should dismiss scientific anthropology as a failed enterprise:

[In the second half of the twentieth century] unprecedented strides have been made in solving the puzzles of sociocultural evolution through a genuinely cumulative and broadening corpus of sophisticated and powerful theories based on vastly improved and expanded research methods. . . . It is ironic, then, that at the very moment when anthropology is achieving its greatest success, anthropologists who have never tested the positivist theoretical corpus that they condemn, hail the death of positivist anthropology and the birth of a 'new' humanistic paradigm. (Harris 1991:83)

Adam Kuper makes the same point, although in a more implicit and less provocative fashion. In an editorial written while he was editor of *Current Anthropology,* Kuper (1989:266) identifies "a perceptible current of fresh intellectual excitement" that is manifesting itself in a concern "with critical *empirical* tests of anthropological knowledge." Kuper cites several examples in this "definite trend," including a reexamination of the evidence for the domestication of fire in the Lower and Middle Pleistocene and a reappraisal of the evidence for deliberate Neandertal burials. Interpretive anthropology, which fails to recognize or respond to the scientific capacity for self-correction, is the implicit target of Kuper's argument. "If refutation is possible," Kuper (1989:266) concludes, "then so too is authoritative description, and in consequence comparison and even generalization may be on everybody's agenda once again."

The fact that comparison and even generalization are not on the interpretive agenda is just what Harris finds so ironic. Like other scientific anthropologists, he is impatient with interpretive anthropology's comparative triviality and inherent irrationality. There is another level of irony in the interpretive rejection of science, however, as Harris is well aware. Interpretive anthropologists misguidedly condemn science for the immorality inherent in its allegedly imperialistic hegemony, yet the ironic fact of the matter is that interpretive anthropology itself is highly vulnerable to moral criticism. In addition to being arguably trivial and occasionally irrational, the interpretive approach is also potentially dangerous. I do not use the term lightly. The premises and assumptions of interpretive anthropology lead inescapably to immoral positions.

The Moral Implications of Interpretive Anthropology

The scientific anthropologist Tim O'Meara offers an incisive warning about the latent immorality of the interpretive approach:

I hold that epistemological relativism is evil. It is an instrument of subjugation, not liberation. No matter how righteous the cause, it is dangerous as

well as false to claim a special 'way of knowing' about the physical world
that produces 'knowledge' which is immune to empirical testing and logi-
cal contradiction. Well-meaning people should stop handling that ven-
omous snake—which they apparently do not understand and certainly can-
not control—before it turns fascist and bites us all. (O'Meara 1995:427)

O'Meara's point is one that is well known to everyone familiar with the
fundamental principles of rationality: normative (i.e., ethical) conclusions
are necessarily founded upon existential (i.e., factual) premises. We can only
decide what *should* be the case if we know what *is* the case. Rational people,
for example, have decided that they should not be held morally responsible
for what they do in each others' dreams, because they have determined that
they have no control over what they do in each others' dreams. If I wished
to hold you morally accountable because you murdered someone in my
dream, you would surely object that you had not *in fact* murdered anyone.
Whether or not you had actually murdered someone would obviously be
the crucial determinant of whether you had any moral culpability.

Imagine, then, that I argued that the events of my dream were indis-
tinguishable from facts. Imagine that I argued that all perceptions of real-
ity were historically, politically, and culturally contingent and that no
description of reality could claim authority over any other. Imagine that I
argued that the reality I perceived in my dream was as well founded and
as defensible as the reality you perceived in your waking state. Imagine
further that I denied the possibility of any objective account of what actu-
ally transpired in your life and mine while I was dreaming. If you accept-
ed that argument, you would be forced to accept your moral culpability
for the murder you committed in my dream.

By refusing to make unequivocal determinations of objective fact,
interpretive anthropology renders itself incapable of making sound moral
judgments. The interpretive anthropologist Richard Shweder provides a
clear example. In an article discussing the goals of anthropology, Shwed-
er (1996:1) explains that he regards the discipline not as a "science
designed to develop general explanatory theories and test specific
hypotheses about objectively observable regularities in social and mental
life," but instead as a pluralistic activity "dedicated to the ethnographic
study of multiple cultural realities and alternative ways of life." As
Shweder describes it, the epistemology underlying that conception of
anthropology stands in clear contrast to the epistemology of science:

The rock bottom foundational truth for such an intellectual enterprise is the
claim that the knowable world is incomplete if seen from any one point of

view and incoherent if seen from all points of view at once. Given the choice between incompleteness and incoherence, this type of pluralistic anthropology opts for incompleteness, which it tries to overcome by staying on the move from one cultural reality to the next. (Shweder 1996:4)

Shweder's two choices pose a false dilemma. There is a third alternative to viewing the world from the incomplete perspective of a single culture's world view or the incoherent perspective of every culture's world view, and that is to view the world from the objective perspective of science. Shweder's refusal to exercise that option prevents him from having any basis for making sound moral judgments, as his ensuing discussion of the cultural relativity of morality demonstrates.

Shweder (1996:4) lists five things that anthropologists know about moral judgments in cultures around the world: "1. Moral judgments are ubiquitous." This is obviously correct; every culture in the world has an ethos, a shared perception of the difference between right and wrong. "2. Moral judgments do not spontaneously converge over time." This is evidently correct as well; it is entirely possible for different cultures to persist in making contradictory moral judgments. "3. Moral judgments are experienced as cognitive judgments and not solely as aesthetic or emotive judgments," while at the same time "4. Moral judgments are experienced as aesthetic and emotive judgments and not solely as cognitive judgments." Again, both of these observations are clearly true; every culture's ethos is explicitly deduced from its world view, its shared understanding about the nature of reality, while at the same time every culture's ethos is embodied in a set of emotionally powerful and frequently ineffable cultural symbols. "5. The supposed truths or terminal 'goods' asserted in moral judgments around the world are many, not one." Once again, Shweder is unarguably correct about this as well; the "ultimate goods" imagined by different cultures include personal freedom, autonomy, justice, loyalty, benevolence, piety, duty, respect, gratitude, sympathy, chastity, purity, sanctity, and so forth.

Shweder's limited epistemology forces him to draw an indefensible conclusion from these correct observations, however. Given these five facts about moral judgments around the world, he argues, in essence, that the best we can do is understand and empathize with different cultures that hold different ultimate goods. Shweder (1996:5) suggests that no objective judgment is possible about which "ultimate goods" are more or less defensible: "In some ultimate sense we must all live in error, ignorance, and confusion (or in 'mystery,' if you prefer that word), which is not necessarily a bad thing."

Shweder is mistaken. We do not have to live in error, ignorance, or

confusion unless we choose to do so. Interpretive anthropologists like Shweder make that choice when they refuse to pursue an epistemological approach that will allow them to make objective determinations of fact. It is possible to determine whether or not a moral judgment is defensible by evaluating the *consequences* of that judgment. Moral judgments inevitably employ some particular type of logic to draw a conclusion from some particular perception of reality. Hence ethical propositions are every bit as susceptible to rational analysis as factual propositions, and it is both illogical and immoral to deny this.

Obviously, then, O'Meara is not using hyperbole when he declares that epistemological relativism is *evil*. His allusion to fascism is clearly appropriate as well. Fascist dictators assume exclusive authority to determine and proclaim the truth for their subjects, and they do so without regard to internal consistency or external constraint. In sharp contrast, the epistemology of science demands both internal consistency (i.e., science is logical) and external constraint (i.e., science is objective). Marvin Harris is one of many scientific anthropologists who recognize the immoral implications of the interpretive approach and the moral superiority of science:

> To claim the political-moral high ground one must have reliable knowledge. We have to know what the world is like, who is doing or has done what to whom, who and what are responsible for the suffering and injustice we condemn and seek to remedy. If this be so, then science-minded anthropologists may plausibly claim that their model is not only moral but morally superior to those that reject science as a source of reliable knowledge about the human condition. (Harris 1995a:424)

This is not to suggest that interpretive anthropologists are evil or immoral people. Quite the contrary, in fact. Most if not all of them are highly sensitive, well-intentioned individuals with completely legitimate moral concerns about the evils of sexism, racism, colonialism, and other forms of exploitation. Good intentions do not guarantee sound judgment, however. If you start with the premise that objective descriptions of human affairs are unattainable, then it is impossible to derive sound moral judgments about human activity. Interpretive anthropologists need to recognize that premise for the venomous snake that it is, and they should heed O'Meara's warning to stop handling it.

The Popular Appeal of Interpretive Anthropology

If, as its many critics contend, interpretive anthropology suffers from several serious flaws, then an obvious question emerges. Why is the inter-

pretive approach so popular among so many anthropologists? Steven Sangren (1988:422) suggests that much of the answer lies in the "institutional efficacy of postmodernism as a career strategy." As he observes, the salient feature of interpretive anthropology is its radical and even strident critique of conventional anthropological wisdom. As Sangren puts it, there is a "striking millennial tone" in the rhetoric of interpretive anthropology:

> It is, of course, a classic characteristic of millennial movements that the present order be stripped of legitimacy, often by defining it as rife with corruption and decay. The old order is exposed as inviable, immoral, extinct; out with the old, in with the new! (Sangren 1988:408)

Interpretive anthropologists who adopt that tone, Sangren (1988:422) submits, can reap important benefits: "Institutionally, although undoubtedly with the best of individual intentions, an important effect of this stance is that young critics can undercut the authority and prestige of established scholars . . . while appropriating their best insights and at the same time inoculate themselves against criticisms of the same order." Sangren (1988:422) argues persuasively that "there is a connection between the structure of the arguments loosely glossed as 'postmodernist' and the institutional success of those arguments as manifested in scholars' careers and academic publications."

Sangren's explanation for the popularity of interpretive anthropology has a definite ring of plausibility, but there may be more to the story. As Sangren suggests, interpretive anthropologists undoubtedly have the best of individual intentions. It is unlikely that many of them are self-conscious careerists deliberately maintaining an intellectual pose to which they owe no personal allegiance. Instead, the fundamental premises of the interpretive approach undoubtedly have a genuine attraction for most interpretive anthropologists. Part of that attraction, some critics have suggested, lies in the fact that the interpretive approach can provide a convenient rationalization for avoiding the sometimes onerous burdens of scientific research.

Many "humanistic" anthropologists reject the possibility of a scientific approach to the study of humankind on the grounds that "human behavior is simply too complex for any genuine regularities, let alone any laws, to be teased out of it," as the scientific anthropologist Robert Carneiro explains. As Carneiro goes on to demonstrate, however, that argument is clearly mistaken:

> But is complexity of behavior solely a problem for the anthropologist? Not at all. The phenomena of physics are intricate and complex too. Of the

thousands of leaves on a tree, no two fall to earth exactly the same way. Yet physics was able to see past the unique and erratic behavior of each fluttering leaf, and to formulate a general law of falling bodies. Could it be, then, that the anthropological humanist has given up finding any underlying laws in human behavior because he has not looked for them hard enough? When he triumphantly proclaims the impossibility of formulating any cultural laws, could he merely be making a virtue out of his own shortcomings?" (Carneiro 1995:7)

Interpretive anthropology can be attractive because interpretation means never having to say you're wrong. As Magnarella (1993:135) observes, the goal of interpretive anthropology is the construction of evocative interpretations, but that is "a goal that places it beyond truth and makes it immune to judgment." The nonfalsifiability of interpretive anthropology has undeniable emotional appeal, even if its intellectual merit is dubious at best. In the competitive world of scientific research, where every claim is subject to critical scrutiny, there are true propositions and there are false ones. In the cooperative world of interpretive discourse, where every voice is given equal legitimacy, there are no entirely wrong interpretations. At worst, any interpretation can only be less elegant, less inclusive, less impressive, less poetic, or less aesthetic than its rival (and even then there is the possibility, through the artful use of lofty rhetoric, of persuading at least some people to prefer the original interpretation). Robert Carneiro again:

> Now, teasing subtexts from a main text is surely slippery business, but it's also a lot of fun. It's a game *any*one can play, and *every*one can win, because there are no rules. There is no correct interpretation, no right answer. Any answer is as good as any other. (Carneiro 1995:11)

The situation is quite different in science. As we have seen, the successful practice of science is a difficult and painstaking endeavor fraught with myriad impediments and pitfalls. Pursuing propositional knowledge in an objective and logical fashion while continually questioning one's own perceptions, observations, and conclusions is a daunting task, to say the least, and one that frequently results in failure. The principles of interpretive anthropology, on the other hand, allow one to say virtually anything (e.g., "human beings may be able to turn themselves into elephants, for all I know") and still be "successful." The subjective approach of the interpretive program, which violates logical consistency and avoids external validation, allows the interpretive anthropologist what Sangren (1988:422) calls "the luxury of experimenting without taking on the

responsibility for defending the logic of his/her arguments."
Incidentally, this is why interpretive anthropologists are forced to reject the legitimacy of the scientific approach to knowledge and why they are unwilling to imagine a world in which interpretive anthropology and scientific anthropology might coexist. If objective descriptions and explanations of human affairs *were* attainable, then the subjective evocations and interpretations produced by the interpretive approach would be revealed as relatively inconsequential in comparison. Objective descriptions and explanations *are* possible, of course, and that is why Cerroni-Long (1996:52) says that "those anthropologists who go on telling stories or making poetry do so as personal choice, not because the study of culture requires it." It is a personal choice to which they are entitled, but it is not one they are prepared to defend on its own merits. For interpretive anthropologists, the only way to clear the field for evocations and interpretations is to deny the possibility of descriptions and explanations.

The Impenetrable Rhetoric of Interpretive Anthropology

There is an additional criticism that reasonable observers have made of interpretive anthropology, and, ironically, it echoes a criticism that interpretive anthropologists have made of traditional ethnography. The interpretive anthropologist Paul Stoller (1986:62) complains that "flat, neutral, and 'sludgy' writing is endemic in anthropological discourse." Although Stoller's observation may have some merit, scientific anthropologists find it highly ironic, because a major proportion of the writing produced by interpretive anthropologists is simply unreadable. In their writing style, many interpretive anthropologists have emulated the convoluted syntax and arcane lexicon of the French philosophers from whom they have derived their intellectual inspiration. The result is a set of rhetorical conventions that leans heavily in the direction of verbosity, pomposity, and impenetrability.

This sentence from the interpretive anthropologist Stephen Tyler (1986b:135) provides an illustration: "Neither the scientific illusion of reality nor the religious reality of illusion is congruent with the reality of fantasy in the fantasy reality of the post-modern world." I have read and reread this sentence in its full original context, and I confess I have no idea what it is supposed to mean. Many other anthropologists share my confusion, and they have declared their objections to the interpretive style of writing. Birth (1990:555), for example, observes that "when highly trained, intelligent people—that is, informed readers—have trouble reading an article, then it is not the competency of the readers that should be called

into doubt as much as it is the ability of the writing to guide its readers." Keesing (1987:161) warns that "the word magic of a Geertz can become pretentious and obfuscatory when emulated by a lesser writer." Reyna (1994:576) describes interpretive writing as "Panglossian nihilism," after Doctor Pangloss, "the character in Voltaire's *Candide* who specialized in talking intellectually pretentious nonsense." Carneiro (1995:13) finds it "quite ironic that persons so concerned with 'meaning' as postmodern ethnographers claim to be, should show so little regard for the process of *conveying* meaning, namely, communication." And Harris suggests that many interpretive writers are being deliberately obfuscatory:

> In conformity with their commitment to a disjointed, collagelike view of the human condition, postmodernists have achieved the ability to write about their thoughts in a uniquely impenetrable manner. Their neo-baroque prose style with its inner clauses, verbal pirouettes, curlicues, and filigrees is not a mere epiphenomenon; rather it is a shocking rejoinder to anyone who would try to write simple intelligible sentences in the modernist tradition. (Harris 1995b:63–64)

In *The Summing Up*, the novelist W. Somerset Maugham (1938:30–31) offers some characteristically trenchant observations that are relevant to the bombastic style of much of interpretive anthropology: "There are two sorts of obscurity that you find in writers. One is due to negligence and the other to wilfulness. . . . It is very easy to persuade oneself that a phrase that one does not quite understand may mean a great deal more than one realizes." After laboring through the tortuous syntax and superfluous jargon in Vincent Crapanzano's (1992) *Hermes' Dilemma and Hamlet's Desire* (whose four parts are subtitled "The Textualized Self," "The Dialogic Self," "The Experienced Self," and "The Submerged Self"), I find it hard to believe that Crapanzano is not being willfully obscure. Crapanzano's book is representative of much of the contemporary work in interpretive anthropology, and many scientific anthropologists are convinced that interpretive writers like Crapanzano are inclined to equate opacity with profundity. Robert Carneiro is one of them:

> If literature is their forte, and the discovery of meaning their aim, why do post-modernists couch their discourse in language so elusive and obscure? I have a private theory about this—one I would never *dare* express in public—that post-modernists like Geertz and Tyler really don't *want* to be understood. In the guise of bringing enlightenment, they enjoy sowing the seeds of confusion. Deep down in their hearts, they relish being arcane and unfathomable. Why? Because they hold to the secret premise that *to appear abstruse is to be thought profound*. (Carneiro 1995:14)

Carneiro's comments appear in a droll critique of interpretive anthropology entitled "Godzilla Meets New Age Anthropology." To illustrate his observations about the indecipherability of postmodernist writing, Carneiro quotes the following description of postmodern ethnography from the interpretive anthropologist Stephen Tyler:

> The break with everyday reality is a journey apart into strange lands with occult practices—into the heart of darkness—where fragments of the fantastic whirl about in the vortex of the quester's disoriented consciousness, until, arrived at the maelstrom's center, he loses consciousness at the very moment of the miraculous, restorative vision, and then, unconscious, is cast up onto the familiar, but forever transformed, shores of the commonplace world. (Tyler 1986b:126)

Carneiro's (1995:13) comment on the metaphorical delirium of this passage is the single and eloquent word "Whew!" If I may be permitted to pursue the spirit of Carneiro's tongue-in-cheek approach to the impenetrability of postmodern writing, I would like to offer one additional example. In 1990, Brian Morton, the book review editor for the journal *Dissent*, published a short article entitled "How Not to Write for *Dissent*." The article is a hilarious caricature of postmodern writing. In reprinting a portion of the article, I am not pretending to examine the writing style of *Hermes's Dilemma and Hamlet's Desire* or any other particular work of interpretive anthropology. Vincent Crapanzano and every other interpretive anthropologist would immediately reject this parody as a straw argument, and all of them would surely recognize the humor in it. For anyone who has ever read a theoretical work of interpretive anthropology, however, the parallels will be clear and instructive. I offer the following excerpt in the spirit of Aldous Huxley, who noted in *Point Counter Point* that "parodies and caricatures are the most penetrating of criticisms."

> The hegemonic discourse of postmodernity valorizes modes of expressive and 'aesthetic' praxis which preclude any dialogic articulation (in, of course, the Bakhtinian sense) of the antinomies of consumer capitalism. But some emergent forms of discourse inscribed in popular fictions contain, as a constitutive element, metanarratives wherein the characteristic tropes of consumer capitalism are subverted even as they are apparently affirmed. A paradigmatic text in this regard is the television series *Gilligan's Island*, whose seventy-two episodes constitute a master-narrative of imprisonment, escape, and reimprisonment which eerily encodes a Lacanian construct of compulsive reenactment within a Foucaultian scenario of a panoptic social order in which resistance to power is merely one of the forms assumed by power itself.

The 'island' of the title is a pastoral dystopia, but a dystopia with a dif-
ference—or, rather, a dystopia with a *différance* (in, of course, the Derridean
sense), for this is a dystopia characterized by the free play of signifier and
signified. The key figure of 'Gilligan' enacts a dialectic of absence and pres-
ence. In his relations with the Skipper, the Millionaire, and the Professor,
Gilligan is the repressed, the excluded. The Other: He is the Id to the Skip-
per's Ego, the proletariat to the Millionaire's bourgeoisie, Caliban to the Pro-
fessor's Prospero. But the binarism of this duality is deconstructed by Gilli-
gan's relations with Ginger, the movie star. Here Gilligan himself is the
oppressor: Under the male gaze of Gilligan, Ginger becomes the Feminine-
as-Other, the interiorization of a 'self' that is wholly constituted by the lin-
guistic conventions of phallocentric desire (keeping in mind, of course, Saus-
sure's *langue/parole* distinction). That Ginger is identified as a 'movie star'
even in the technologically barren confines of the desert island foreshadows
Debord's concept of the 'society of the spectacle,' wherein events and 'indi-
viduals' are reduced to simulacra. Indeed, we find a stunningly prescient
example of what Baudrillard has called the 'depthlessness' of America in the
apparent 'stupidity' of Gilligan and, indeed, of the entire series.
 The eclipse of linearity effectuated by postmodernity, then, necessitates a
new approach to the creation of modes of liberatory/expressive praxis. The
monologic and repressive dominance of traditional 'texts' (i.e., books) has
been decentered by a dialogic discourse in which the 'texts' of popular cul-
ture have assumed their rightful place. This has enormous implications for
cultural and social theory. A journal like *Dissent*, instead of exploring the
question of whether socialism is really dead, would make a greater contri-
bution to postmodern discourse by exploring the question of whether Elvis
is really dead. This I hope to demonstrate in a future study. (Morton
1990:299)

Even those who might be unfamiliar with the relentlessly silly *Gilli-
gan's Island* cannot fail to recognize the sharply pointed humor of this pas-
sage. I will conclude this section by commenting on the obvious point of
Morton's clever parody: in order to be profound, it is neither necessary
nor sufficient to be opaque.

The Scientific Approach and Cultural Materialism

The logical errors and immoral implications of interpretive anthropol-
ogy stem from the paradigm's failure to embrace and apply the funda-
mental principles of rational inquiry embodied in the scientific approach
to knowledge. It should be remembered, however, that science is not a
royal road to truth, and even the consistent application of the scientific
method cannot guarantee the production of full and certain knowledge.
(Science, as we have seen, claims provisional certainty rather than

absolute certainty.) As a result, even those anthropological paradigms that do attempt to adhere consistently to the principles of scientific inquiry cannot always claim complete success in the pursuit of precise and reliable knowledge.

The paradigm of cultural materialism provides an instructive example. Although most commonly associated with Marvin Harris (1979), the paradigm's principal architect, cultural materialism is championed by many other anthropologists as well (see Murphy and Margolis 1995). Cultural materialism is a research strategy that seeks to explain the causes of the similarities and differences among the world's cultures. The goals and methods of cultural materialism have always aspired to be explicitly and thoroughly scientific (Harris 1968; 1979; 1996). According to the theoretical principles of cultural materialism, there is a universal pattern of sociocultural systems that consists of three components: *infrastructure, structure,* and *superstructure.*

The infrastructure is, in essence, the culture's technology of subsistence and reproduction; it "constitutes the interface between nature in the form of unalterable physical, chemical, biological, and psychological constraints on the one hand, and culture which is *Homo sapiens*'s primary means of optimizing health and well-being, on the other" (Harris 1994:68). The structure is the basic social organization of the culture; it consists of the ways the society is organized to produce, distribute, and consume goods and services at both the domestic and the political levels. The superstructure comprises the set of values and beliefs that add meaning to life by providing emotional, intellectual, and aesthetic satisfactions.

The fundamental theoretical principle of cultural materialism is the principle of *infrastructural determinism,* which holds that particular forms of infrastructure give rise to particular forms of structure, which in turn give rise to particular forms of superstructure. As Murphy and Margolis explain, however, the principle of infrastructural determinism is neither rigid nor simplistic:

> The cultural materialist model of society asserts that all three levels [infrastructure, structure, and superstructure] are in a continuous dynamic state and that there are significant and predictable relationships between them. The model suggests that changes in a society's infrastructure are primarily the result of changes in a human population's relationship to its environment. Moreover, cultural materialism holds that, over time, changes in a society's material base will lead to functionally compatible changes in its social and political institutions (structure) and in its secular and religious ideology (superstructure). (Murphy and Margolis 1995:2)

This assertion seems plausible on the surface; no sociocultural system of any sort could exist without living human beings, so the infrastructure, which is the means by which human beings ensure their survival, must in some important sense come first. In fact, cultural materialists have marshalled considerable evidence to substantiate the primacy of the infrastructure (see Harris 1979). Monotheistic religions, for example, are found only in societies with a state level of political economy, and states are found only in societies with agricultural or industrial-agricultural modes of production. The principle of infrastructural determinism appears to be true *in broad outline*, but that is precisely the problem with it: at its present stage of development, it can only tell us what is *generally* true, not what is *specifically* true. This limitation is one that cultural materialists like Murphy and Margolis recognize and admit:

> [Cultural materialism] never suggests that *all* changes in the system under *all* circumstances spring from alterations in the infrastructure. Nor does cultural materialism claim that the structure and superstructure are passive entities that do not influence the material base. Rather it proposes a probabilistic relationship between these three levels, while at the same time insisting that the *principal* forces of change reside in the material conditions of human existence. Thus, when we note changes in a society's structure or superstructure, we must first look to its infrastructure for our explanations because, according to cultural materialism, that is the most probable source of change.
>
> One final caveat is in order. While cultural materialism looks to the productive and reproductive modes of society in order to account for its structural and ideological components, there may be a time lag before ideologies or social institutions evolve that are compatible with changed material conditions. (Murphy and Margolis 1995:3)

This statement is unarguable, as anyone who is familiar with cultural processes can attest, but in one important sense it is also unsatisfying, because it lacks the degree of specificity that we have come to expect from scientific knowledge. Precisely *which* changes under precisely *what* circumstances spring from alterations in the infrastructure, and which stem from the structure and superstructure? If the relationships between the three levels are probabilistic, exactly what are the probabilities? What determines whether there will or will not be a time lag between an infrastructural change and a structural or superstructural accommodation? How long will the time lag be? If the length of time varies (as it apparently does), what factors account for the variability?

The crucial lack of specificity in the theoretical principles of cultural materialism is particularly apparent when compared to the theoretical

principles of the natural sciences. In physics, for example, the theoretical principles of aerodynamics are understood with great specificity: it is possible to determine the airworthiness and performance characteristics of a new aircraft design, even before the prototype is constructed, simply by applying the principles of aerodynamics in computer simulations. When and if cultural materialists achieve a comparable level of knowledge, they will be able to predict, with equal precision, the response of any particular sociocultural system to any hypothetical set of circumstances. At present, however, cultural materialism is incapable of generating such precise predictions.

Indeed, the anthropologist Tim O'Meara argues that the theoretical principles of cultural materialism necessarily limit the paradigm's ability to predict and explain human behavior. According to O'Meara (1997), cultural materialism is founded upon a fundamental logical error; the paradigm postulates that the "infrastructure" has casual power to shape the other elements of sociocultural systems, yet the "infrastructure" is simply an abstraction, a statistical generalization derived from recurrent patterns of behavior. Since the "infrastructure" is not an empirical entity with a tangible existence of its own, it cannot have any causal efficacy in the real world. While there are undeniable correlations between the patterns of behavior labeled as "infrastructure" and those labeled as "structure" or "superstructure," such "patterns of behavioral events," according to O'Meara (1997:406), "are not causal laws," but are instead simply "signposts pointing toward the causal properties of the behaving entities." O'Meara explains:

> Correlations among event types may help us predict future event types with some accuracy, but only if relevant conditions remain similar. Because of the vast number, specificity, and delicacy of psychological and other constituent mechanisms of humans, however, the corresponding number, specificity, and delicacy of relevant conditions is also vast. Only by learning the causal-mechanical properties of those mechanisms and the environmental conditions to which they are sensitive can we *explain* people's behavior in current circumstances or *predict* them in novel circumstances. (O'Meara 1997:406)

O'Meara's argument is subtle and complex, and it appears likely to engender considerable debate within anthropology. As of this writing, that debate has just begun (see Harris 1997b), and the eventual outcome is not at all clear. What does seem clear is that the principle of infrastructural determinism is imprecise and incomplete at best. It should be quickly noted, however, that cultural materialists are very much aware of this fact. Commenting on the demise of communism in the former Soviet

Union, for example, Marvin Harris (1992:300) admits that the long time lag between the Bolshevik Revolution in 1917 and the fall of communism in 1991 poses a problem for cultural materialism: "the evidence for concluding that the Soviet bloc's collapse is an example of the primacy of infrastructure is not as clear cut as I would like it to be."

Moreover, cultural materialists can hardly be faulted for having failed so far to produce a complete explanation of cultural causality. They are the ones, after all, who first defined such a goal, and they are the ones who admit that there is still work to do. Moreover, they are the ones who have consistently argued for a scientific approach to anthropological knowledge, and they are the ones who have invariably tried to state their arguments in clear, straightforward language. Cultural materialism is not the only scientific paradigm in anthropology, of course, and it is an open question whether it will be the dominant scientific paradigm in the future of the discipline. Whether the principle of infrastructural determinism is refined to become a theory of great precision, or whether it ultimately becomes a footnote in the history of anthropology, cultural materialists will still be able to claim a major contribution to the discipline: they demonstrated a commitment to the principles of rational inquiry at a time when many of their colleagues were advocating the abandonment of reason.

5

Conclusion: Science, Humanism, and the Future of Anthropology

I began this book with the observation that anthropology has been plagued since its inception by an unresolved identity crisis. The question at the heart of that crisis remains unanswered within the discipline today. Is anthropology a nomothetic science dedicated to describing and explaining the biocultural evolution of the human species (in the broadest senses of both terms), or is it a form of humanistic scholarship devoted to evoking and interpreting the cultural variability of the human species? Depending on which anthropologist you ask, the answer could be one or the other or both. That kind of fundamental ambiguity is unparalleled in the academic community. No discipline in either the natural sciences or the humanities would allow such extreme latitude in its definition of itself. Even the social sciences have less equivocal senses of their own identities than anthropology.

The Ambiguous Identity of Anthropology

The ambiguity of anthropological identity has long historical roots, of course. At the turn of the twentieth century, when the discipline was being established as an autonomous entity, anthropologists were already divided as to whether they wanted their field to emulate the humanities or the sciences. As the turn of the twenty-first century approaches, however, anthropology is no closer than ever to achieving consensus on this issue than it has ever been. If anything, the debate between humanistic anthropologists and their scientific colleagues is more acrimonious than it has ever been.

Anthropology has traditionally attempted to stake out a compromise position on this central issue by regarding itself as both the most scientific of the humanities and the most humanistic of the sciences. That

compromise has always looked peculiar to those outside anthropology, but today it looks increasingly precarious to those within the discipline. Contemporary anthropology is polarized by a bitter, divisive dispute that threatens to fragment the discipline into mutually antagonistic entities. Each of those entities would claim the label "anthropology" largely for itself, and each, to a large extent, would deny either the legitimacy or the utility of the other.

The Dangers of Ambiguity

The consequences of such fragmentation would be overwhelmingly deleterious. The discipline of anthropology is already handicapped by its ambiguous identity, both intellectually and politically. If its identity remains logically inconsistent, the discipline will face the very real threat of self-annihilation. Anthropology will find it increasingly difficult to justify its claim to a place within the university curriculum, just as it will find it increasingly difficult to justify its bid for research funding. At the beginning of this book, I quoted Brady (1991:5) to the effect that "there is [and always has been] more than one way to say anthropology." I submit that it is time for "anthropology" to mean one thing and one thing only.

Should "anthropology" mean what the scientists say it means, or should it mean what the humanists say it means? From everything that has been said to this point, it is obvious that my sympathies are entirely on the side of those anthropologists who adhere steadfastly to the principles of rational inquiry. I have no patience for any variety of epistemological relativism, which I regard as logically deficient and morally offensive. In my view, anthropology should be exclusively defined as the scientific study of the human species. That does not mean, however, that I would like to see anthropology defined as a scientific discipline *as opposed to* a humanistic one.

The reason is simple. True science and genuine humanism are not mutually incompatible. Interpretive anthropologists have argued that science and humanism are fundamentally opposed to one another, but interpretive anthropologists are mistaken, and the kind of humanism they advocate is a spurious one. Genuine humanism embraces the scientific approach rather than rejecting it. In fact, the fundamental principles of rational inquiry upon which science is based are both necessary and sufficient for a genuinely humanistic perspective, for reasons that I will explain shortly.

In this final chapter, I want to explore a definition of anthropology that combines the scientific and humanistic perspectives, and then I want to

consider the implications of that definition for the future of the discipline. I will argue that the phrases "scientific humanism" and "humanistic science" are both largely redundant. All genuine humanism incorporates the scientific perspective, and all legitimate science embraces humanistic values. We have already examined in some detail the true nature of legitimate science; I want to look now at the true nature of genuine humanism.

The Two Cultures Reconsidered

In a classic work entitled *The Two Cultures and the Scientific Revolution*, C. P. Snow (1959) identified the *humanistic* and *scientific* traditions as two distinct cultures within the academic world. In Snow's formulation, the humanistic culture consists of those disciplines, such as art, literature, and philosophy, whose scholarship is devoted to interpreting the meanings embodied in the products of human creativity; the scientific culture consists of those disciplines, such as physics, chemistry, and geology, whose research is devoted to discovering the laws inherent in the processes of natural phenomena. Snow argued that the humanistic and scientific cultures were fundamentally incommensurable and that members of the two cultures were virtually unable to communicate with each other. His argument has been widely influential. Richard Lee, for example, sees a direct application to anthropology:

> Anthropology is an apt example of a discipline that finds itself straddling the boundaries of C. P. Snow's two cultures. Within the discipline today there is a powerful current moving toward the view of anthropology as essentially a humanistic, even literary discipline, where truth, apart from the poetic variety, is unattainable. An equally strong current moves in the opposite direction, embracing the promise and moral authority of science and strengthening its commitment to improved techniques of data collection and measurement, coupled with more (not less) rigorous application of theory. (Lee 1992:33)

There is considerable cogency to this characterization of contemporary anthropology, as we have seen. Interpretive anthropology has explicitly emulated the model provided by literary criticism, and scientific anthropology has explicitly emulated the model provided by the natural sciences. Interpretive anthropologists and scientific anthropologists do in fact have a great deal of difficulty communicating with one another (Lett 1987:129–52). A strong case can be made for the existence of Snow's two cultures in anthropology, as Lee suggests.

There is the possibility of a more subtle analysis, however. Lewis Jones

argues that Snow's dichotomy oversimplifies the matter. It is clearly true that the humanities and the sciences constitute two readily distinguishable cultures, but the more meaningful distinction, Jones argues, lies elsewhere:

> The real gulf is not the gap between the arts and the sciences but the canyon between those who practice genuine scientific [i.e., rational] thinking (whether or not they have a scientific background) and everyone else, including many scientists and engineers highly trained in narrow specialties. (Jones 1989:57)

Reconciling Science and Humanism

Jones's point is that it is possible to be a member of the scientific culture and yet not adhere consistently to the fundamental principles of rational inquiry, just as it is possible to be a member of the humanistic culture and be consistently rational. (The eminent rocket scientist Wernher von Braun was an uncompromising creationist, for example, while the extraordinary literary artist Mark Twain was an unswerving skeptic.) Scientists and humanists are divided by their divergent interests and goals, but they need not be divided by divergent understandings of the fundamental nature of reality.

Moreover, a rational member of the humanistic culture would be able to communicate with a rational member of the scientific culture, because rationality would provide them with a common language and a common set of assumptions. Even though one might be interested in pursuing objective-emotive knowledge while the other might be interested in attaining objective-propositional knowledge, they would both be able to recognize the distinctiveness and the compatibility of their goals. The humanist and the scientist might regard each other's interests as tame, tedious, or even trivial, but neither would have to regard the other's interests as in any way threatening.

This line of thought leads to the possibility of a reconciliation between scientific and humanistic anthropologists, or at least to the possibility that they could coexist without antagonism. If scientific and humanistic anthropology were both committed to the consistent application of the fundamental principles of rational inquiry, there would be no possibility of dispute between the two approaches. The two sides could simply agree to pursue different but not incompatible interests. Scientific anthropologists would have no quarrel with interpretive anthropologists who wanted to evoke and interpret cultures as long as interpretive anthropologists

were consistently rational in their evocations and interpretations.

Scientific anthropologists do have a quarrel with interpretive anthropologists, however, because interpretive anthropologists are not consistently rational in their evocations and interpretations. Worse than that, of course, interpretive anthropologists explicitly reject the fundamental principles of rational inquiry upon which science is based. As we have seen, their rejection of science is founded upon a fallacious argument, since the interpretive critique of science is inevitably directed against scientism. Ironically, however, interpretive anthropology is not only antiscience, it is also antihumanism, despite the fact that it purports to be humanistic. An examination of the essential elements of humanism will reveal why this is true.

The True Philosophy of Humanism

As I mentioned briefly in chapter 1, the philosophy of *humanism* consists of an interrelated set of epistemological, ethical, and aesthetic principles, and the group of disciplines commonly referred to as the "humanities" are founded upon those humanistic assumptions. There is a basic point that is frequently missed in the anthropological debate about the humanistic and scientific approaches, however: the fundamental epistemological principles employed in the humanities are essentially identical to the fundamental epistemological principles employed in science. Reason lies at the heart of both humanism and science.

Literary criticism and other forms of humanistic analysis, for example, rely upon reason to evaluate the relative value of works of art. The standards of scholarship in the humanities require critics to be internally consistent in their arguments. Those standards also require critics to be comprehensive in their consideration of available evidence. Illogical analyses carry no more weight in the humanities than they do in the sciences. In the *production* of works of art, obviously, artists rely heavily upon intuition and imagination, but the *evaluation* of works of art necessarily relies upon reason. The situation is parallel in science, of course, where scientists employ intuition as the spark for discovery but rely upon the principles of verifiability and testability to validate knowledge.

There is a fundamental difference between the sciences and the humanities, certainly. The sciences, which seek to attain objective-propositional knowledge, are concerned primarily with factual judgments, whereas the humanities, which seek to attain objective-emotive knowledge, are concerned primarily with value judgments. Nevertheless, sound judgment in both cases requires the use of reason, and that is why there is considerable

overlap in the epistemological principles employed by the two approaches. Since objective-emotive statements (e.g., "symmetry is beautiful") are not falsifiable, the humanities do not necessarily require the rules of verifiability and testability to evaluate such statements. However, evaluating emotive statements often requires propositional knowledge, because factual premises generally underlie value judgments. The factual claim that Michelangelo's statue of David is symmetrical, for example, would be subject to the rules of verifiability and testability. Furthermore, it is essential in the humanities, just as it is in the sciences, to recognize the distinction between propositional and emotive statements and to employ the rules of logic in the evaluation of those statements.

For these reasons, the essential principles of rational inquiry are a *necessary* component of a genuinely humanistic approach. Remove the element of rationality from humanism and all that remains is mysticism. This is why O'Meara (1990:751) says that "anthropological approaches that eschew empirical science are not therefore humanistic" but are instead "metaphysic." The epistemological standards of scientific inquiry are also *sufficient* to inspire genuine humanism, because the consistent application of reason inevitably results in the distinctive set of ethical values that is characteristic of the humanistic approach.

A quick review of the essential tenets of humanism will reveal why this is so. The philosophy of humanism has a long and varied history that can be traced back more than twenty-five hundred years, but the contemporary version of that philosophy is ably summarized in a pair of twentieth-century documents: "Humanist Manifesto II," originally published in 1973, and "A Secular Humanist Declaration," originally published in 1980. The two documents were endorsed by more than two hundred noted intellectuals, including A. J. Ayer, Francis Crick, Raymond Firth, Sidney Hook, Ernest Nagel, Willard Quine, Andrei Sakharov, and B. F. Skinner; both documents are reprinted in a book by the American philosopher Paul Kurtz (1983) entitled *In Defense of Secular Humanism*. Among the essential tenets of humanism summarized in those two documents are the following seven principles, all paraphrased or quoted from Kurtz (1983: 15–19,41–43):

1. *The Value of Reason.* Humanists "are committed to the uses of the rational methods of inquiry, logic, and evidence in developing knowledge and testing claims to truth." Humanists are further committed to the proposition that "reason and science can make a major contribution to human knowledge" and that there is "no better substitute for the cultivation of human intelligence."

2. *The Value of Free Inquiry.* Humanists "oppose any tyranny" over the activity of the human mind, including "any efforts by ecclesiastical, political, ideological, or social institutions to shackle free thought." Humanists further affirm that "free inquiry requires that we tolerate diversity of opinion and that we respect the right of individuals to express their beliefs, however unpopular they may be, without social or legal prohibition or fear of sanctions."

3. *The Dignity of the Individual.* The "preciousness and dignity of the individual person is a central humanist value." Humanists "reject all religious, ideological, or moral codes that denigrate the individual, suppress freedom, dull intellect, [or] dehumanize personality." In addition, humanists "believe in maximum individual autonomy consonant with social responsibility."

4. *The Principle of Moral Equality.* Humanists contend that "the principle of moral equality must be furthered through elimination of all discrimination based upon race, religion, sex, age, or national origin." As a consequence, humanists endorse "equality of opportunity and recognition of talent and merit," and they "deplore racial, religious, ethnic, or class antagonisms."

5. *The Ideal of Freedom.* Humanists "consistently defend the ideal of freedom, not only freedom of conscience and belief from those ecclesiastical, political, and economic interests that seek to repress them, but genuine political liberty, democratic decision-making based upon majority rule, and respect for minority rights and the rule of law." Humanists support "the defense of basic human rights, including the right to protect life, liberty, and the pursuit of happiness." Humanists advocate individual freedom from both "religious control" and "jingoistic government control."

6. *The Value of Religious Skepticism.* Humanists "recognize the importance of religious experience" in the role it plays in giving "meaning to the lives of human beings," but humanists "deny that such experiences have anything to do with the supernatural." Instead, humanists "consider the universe to be a dynamic scene of natural forces that are most effectively understood by scientific inquiry." Humanists maintain that "men and women are free and are responsible for their own destinies and that they cannot look toward some transcendent Being for salvation."

7. *The Nature and Source of Ethics.* Humanists embrace the "philosophical

tradition that maintains that ethics is an autonomous field of inquiry, that ethical judgments can be formulated independently of revealed religion, and that human beings can cultivate practical reason and wisdom and, by its application, achieve lives of virtue and excellence." Humanists recognize "the central role of morality in human life," and they "believe in the central importance of the value of human happiness here and now." While humanists reject traditional forms of absolutist morality, they "maintain that objective [moral] standards emerge, and ethical values and principles may be discovered, in the course of ethical deliberation."

It should be obvious from this summary that interpretive anthropology is ultimately incompatible with the philosophical principles of humanism. While the interpretive approach endorses the ideals and principles of individual liberty, dignity, and equality, it rejects other essential elements of the humanistic program. The epistemological relativism of interpretive anthropology denies the preeminent value of reason and renders religious skepticism impossible, while the nihilism of the interpretive approach undermines the foundation of humanistic ethics. It should be equally obvious that scientific anthropology is entirely congruent with the epistemological and ethical principles of humanism.

Scientific anthropology is also entirely congruent with the aesthetic principles of humanism. There is nothing whatsoever in the epistemology or ethics of scientific anthropology that would preclude an informed appreciation of art, for example. Interpretive anthropologists hold no necessary advantage over their scientific colleagues in this area, despite interpretive anthropology's vaunted predilection for evocative writing. If anything, it could well be argued that scientific anthropologists have superior literary taste, since they are likely to prefer genuine literary artists over self-proclaimed literary anthropologists. Speaking for myself, I have never read a contemporary interpretive ethnography that I found to be remotely comparable to the literary works of Gabriel García Márquez, Mark Helprin, John Gardner, William Styron, John Fowles, Peter Mathiessen, or Bruce Chatwin. For that matter, I personally know of nothing in the interpretive oeuvre that has the evocative power of Charles Wagley's ethnographies or the lyrical poignancy of Loren Eiseley's essays.

There is considerable irony in the widespread misconception that an interest in humanistic studies marks one as imaginative, creative, and passionate, whereas an interest in scientific studies marks one as dull, mundane, and impersonal. In fact, the best scientists tend to be exceptionally imaginative, remarkably creative, and intensely passionate, not

only in their professional careers but in their personal lives as well. It is commonplace for accomplished scientists to cultivate an intimate appreciation of the arts, but it is much less common for artists to acquire an intimate knowledge of the sciences. Interpretive anthropologists criticize their scientific colleagues for their allegedly impersonal and unevocative writing, but few interpretive anthropologists exhibit any familiarity with either the methods or the findings of science. Most scientific anthropologists, on the other hand, are quite capable of appreciating evocative and stylish writing, and that is why most scientific anthropologists regard much interpretive writing as pretentious and obfuscatory.

In sum, science and humanism share essentially identical epistemological, ethical, and aesthetic principles and convictions. The phrase "scientific humanism" is largely redundant, since all humanism is, or should be, founded upon scientific knowledge. The phrase "humanistic science" is also largely redundant, since all science is, or should be, congruent with the ethics and aesthetics of humanism. The distinction between science and humanism that has been traditional in anthropology is artificial and misleading. Recognizing the fundamental complementarity of science and humanism results in a definition of anthropology that is far more productive.

The Definition of Anthropology

Anthropology is a *humanistic science* in every sense of the term. It is humanistic in the sense that its subject matter involves the whole of human phenomena, and it is humanistic in the sense that its epistemological, ethical, and aesthetic principles are entirely congruent with the philosophy of humanism. Anthropology is also humanistic in the sense that its interest in the cultural expressions of human creativity overlaps with the central focus of the humanities. Anthropology is necessarily a science, however, because the successful investigation of the anthropological field of inquiry demands a scientific approach.

Anthropology has always defined its domain of inquiry in the broadest possible terms. Among the scientific disciplines devoted to the study of human beings, anthropology is the only one that attempts to account for all human phenomena in all places at all times. The subject matter of anthropology is vast, but it includes, most importantly, the evolution of anthropoids, hominoids, and hominids; the origins and spread of *Homo sapiens*; the nature and origins of human language; the nature and origins of human consciousness; the evolution of human society and culture; the causes and consequences of human biological diversity; and the causes

and consequences of human cultural diversity (Harris 1997a:26).

Those various elements can be subsumed under a single succinct definition: *Anthropology is the scientific study of human evolution*. Since human evolution has been a distinctively *biocultural* phenomenon, the discipline of anthropology is necessarily divided into the subfields of archeology, ethnology, linguistics, and biological anthropology. Each subfield has an obvious contribution to make to the integrated study of human evolution, and each comprises a part of the whole that is anthropology. Interpretive anthropology, however, unjustifiably rejects this conception of anthropology. The interpretive approach incorrectly equates anthropology with ethnography, when in fact ethnography is simply a necessary but not sufficient component of ethnology, which in turn is a necessary but not sufficient component of anthropology.

Nevertheless, it is logically possible that there could be room for the interpretive approach within a humanistic science devoted to the study of human biocultural evolution. Given such a conception of anthropology, interpretive ethnographers would be able to evoke and interpret cultural variability and still call themselves anthropologists as long as they explicitly adhered to the scientific principles of rational inquiry. As I argued earlier, however, interpretive ethnographers are not likely to embrace an anthropology that defines itself as the scientific study of human biocultural evolution, even though doing so would allow them to pursue their research interests while coexisting peacefully with their anthropological colleagues.

The reason, of course, is that accepting such a definition of anthropology exposes the comparative triviality of their interests and activities. The interpretive approach has little or no possible contribution to make to our understanding of human evolution. Faced with the choice of either admitting the relative triviality of evocation and interpretation or denying the possibility of description and explanation, interpretive anthropologists will inevitably choose the latter. I also think it is unlikely that interpretive anthropologists will stop calling themselves anthropologists and start calling themselves novelists or journalists or anything else. After all, the identity of anthropology has always been ambiguous; neither humanists nor scientists can claim exclusive right to the label "anthropology" on the basis of historical precedent.

The Prospects for Anthropology

As a result, the threat to the integrity of anthropology is likely to continue. The discipline is likely to continue to be riven by contentious debate

from within, and it is likely to continue to be regarded with suspicion and skepticism from without. It is a dire prospect. If the epistemological and ethical errors of interpretive ethnographers are not corrected, anthropology as a whole will continue to suffer. Ethnologists, archeologists, linguists, and biological anthropologists will continue to be guilty by association with a paradigm that is irrational in its applications and immoral in its implications. The errors and excesses of the interpretive approach constitute an embarrassment and a hindrance to anthropology.

The interpretive approach should be rejected not simply for the negative reason that it is irrational, however, but for a positive reason as well. There is an overwhelmingly superior alternative that is far more intellectually attractive. At this moment in the history of the discipline, the scientific approach is producing a radical critique of traditional anthropological knowledge that has profound implications for the identity of the field. The scientific critique of anthropological knowledge, unlike the interpretive critique, is rational, substantive, and provocative. There is a compelling intellectual current moving through the discipline, and it is promising to sweep away the intellectual detritus of a century of eclectic theorizing. There is reason to be optimistic about the future of anthropology.

The Failure of Traditional Social Science

Ironically, a growing number of scientific anthropologists are coming to the same conclusion held by interpretive anthropologists: on the whole, traditional social science has been a conspicuous failure. It is ironic because the two groups have drawn that same conclusion from very different premises. While interpretive anthropologists argue that the epistemology of science is fundamentally flawed, scientific anthropologists argue that the epistemology of science has been insufficiently applied. As Harris (1991:83–84) puts it, "the problem is not that we have had too much of positivist social science but that we have had too little."

In any event, the conclusion is inescapable: traditional social science has failed to achieve the level of knowledge that it should have achieved by this point in its history. That failure is particularly apparent when the social sciences are compared to the natural sciences. In the pursuit of propositional knowledge, disciplines such as anthropology, economics, political science, psychology, and sociology have been substantially less successful than disciplines such as astronomy, biology, chemistry, geology, and physics. As Tooby and Cosmides (1992:19) observe, the natural scientific disciplines "have developed a robust combination of logical coherence, causal description, explanatory power, and testability, and

have become examples of how reliable and deeply satisfying human knowledge can become." The social sciences have failed to produce comparable levels of understanding in their domains of inquiry. Tooby and Cosmides (1992) argue persuasively that "the recent wave of antiscientific sentiment spreading through the social sciences draws much of its appeal from this endemic failure."

The fundamental reason for the relative inadequacy of the social sciences is their failure to achieve *conceptual integration*. Cosmides, Tooby, and Barkow explain the meaning of the phrase:

> Conceptual integration . . . refers to the principle that the various disciplines within the behavioral and social sciences should make themselves mutually consistent, and consistent with what is known in the natural sciences as well. The natural sciences are already mutually consistent. . . . Such is not the case in the behavioral and social sciences." (Cosmides, Tooby, and Barkow 1992:4)

Instead, disciplines such as anthropology, psychology, and sociology maintain distinct vocabularies and appeal to different explanatory principles. That is true, in fact, even within anthropology itself, which shelters multiple paradigms whose claims to knowledge are mutually contradictory. The different anthropological paradigms, like the various social sciences, are characterized by persistent boundary maintenance. In contrast, as Tooby and Cosmides (1992:19) point out, "disciplines such as astronomy, chemistry, physics, geology, and biology . . . are becoming integrated into an increasingly seamless system of interconnected knowledge and remain nominally separated more out of educational convenience and institutional inertia than because of any genuine ruptures in the underlying unity of the achieved knowledge."

In short, the natural sciences have enjoyed enormous success in their domains of inquiry because they have consistently and systematically applied the fundamental principles of rational inquiry, while the social sciences have been much less successful in their respective domains because they have neglected or even rejected the essential principles of science. "This disconnection from the rest of science," in the words of Tooby and Cosmides (1992:23), "has left a hole in the fabric of our organized knowledge of the world where the human sciences should be."

The Challenge for Anthropology

Filling the hole in our organized knowledge about humanity is the principal task facing anthropology today. The future of the discipline will

be determined by the manner in which anthropologists respond to that challenge. If they respond well, anthropologists will use the fundamental principles of rational inquiry to pursue the central questions of human origins, human nature, and the human condition. If they succeed in that effort, they will produce an integrated body of knowledge about the biological and cultural evolution of the human species that is both internally consistent and consistent with the knowledge produced by the natural sciences.

Biological anthropology, archeology, and linguistics have already taken significant strides in that direction, of course. The overall pattern of hominid evolution is emerging in increasingly sharp detail, thanks to biological anthropology, and the overall pattern of cultural evolution is even better known, thanks to archeology. Linguistics, which is building important links to neuroscience, is producing increasingly sophisticated models of the nature and origins of language (see Pinker 1994). On the other hand, cultural anthropology, which harbors the largest proportion of anti-scientific sentiment among the various subfields, continues to espouse incompatible conclusions and incoherent theories. Cultural anthropology has failed to achieve full conceptual integration with either the rest of anthropology or the natural sciences.

The Promise of Evolutionary Psychology

There are indications, however, that the situation may be changing. A number of anthropologists, relying exclusively upon the epistemological principles of science, have begun to question the traditional assumptions of cultural anthropology. The scientific critique of ethnographic knowledge has resulted in the debunking of several anthropological myths, including the myths of stress-free promiscuity among Samoan adolescents, of sex role reversals among the Tchambuli, of the Hopi concept of time, and of the Eskimo words for snow (Pinker 1994; D. Brown 1991; 1996).

To replace those myths, anthropologists are beginning to construct a coherent model of human nature that is consistent with both biological fact and the ethnographic record. One of the leading figures in that endeavor is Donald Brown, who poses a fundamental challenge to traditional anthropological knowledge in his important book *Human Universals*. As Brown (1991:6) explains, the study of human (i.e., cultural) universals has been long neglected in anthropology as a result of several specific anthropological assumptions which became established in the discipline in the early part of the twentieth century. Those assumptions include the notion

that culture is a distinct kind of phenomenon that cannot be accounted for in biological or psychological terms, the notion that human behavior is fundamentally determined by culture rather than any innate or instinctual predispositions, and the notion that culture is largely arbitrary.

Contemporary scientific research and analysis strongly suggest that each of these three fundamental assumptions is misleading. There appears instead to be a significant biological component to human culture and human behavior, and there is substantial evidence for the existence of a universal human psychology. The scientific study of human nature is currently being pursued under an evolutionary paradigm that is variously known as "evolutionary psychology" (Barkow, Cosmides, and Tooby 1992), "cognitive science" (Pinker 1994), and "Darwinian psychology" (Gray 1996). Unlike more familiar varieties of sociobiology, evolutionary psychology sees no connection between human genetic variation and human behavioral variation. Instead, it maintains that all humans share the same psychological frameworks. Nor does the paradigm assume that particular behaviors are genetically determined. "Natural selection does not select directly for behaviors," as Donald Brown (1991:83) observes; instead, "it selects for the psychological processes that (in conjunction with the environment) underlie behavior."

Evolutionary psychology posits that different cultures emerge from the application of a universal human psychology to different environments. Given that premise, there is the possibility of conceptual integration between evolutionary psychology, behavioral ecology, cultural ecology, and cultural materialism. The conceptual integration of those paradigms would foster the broader conceptual integration between cultural anthropology, biological anthropology, archeology, and linguistics (see Hawkes 1996; Netting 1996; Harris 1996).

In the introduction to a notable collection of articles gathered under the title *The Adapted Mind*, Cosmides, Tooby, and Barkow outline the fundamental assumptions of evolutionary psychology:

> The central premise of *The Adapted Mind* is that there is a universal human nature, but that this universality exists primarily at the level of evolved psychological mechanisms, not of expressed cultural behaviors. . . . A second premise is that these evolved psychological mechanisms are adaptations, constructed by natural selection over evolutionary time. A third assumption . . . is that the evolved structure of the human mind is adapted to the way of life of Pleistocene hunter-gatherers, and not necessarily to modern circumstances. (Cosmides, Tooby, and Barkow 1992:5)

Given these premises, the potential anthropological contribution to evo-

lutionary psychology is obvious. Ethnography provides the data base for identifying and testing extant universals, while biological anthropology and archeology provide the source of information about hominid evolution and human prehistory. Combining anthropology with neuroscience (a field at the juncture between biology and psychology) provides the framework for describing and explaining the evolution of human nature. Such a combination would promise a bright future for anthropology, as Cosmides, Tooby, and Barkow (1992:13) suggest: "If we, as behavioral and social scientists, change our customs and accept what mutual enrichment we can offer one another, we can be illuminated by the same engine of discovery that has made the natural sciences such a signal human achievement."

The Standard Social Science Model

Embracing evolutionary psychology entails abandoning a number of traditional anthropological assumptions. Recent scientific investigation, however, has revealed those assumptions to be false or misleading. The following list of erroneous anthropological premises is adapted from Donald Brown (1991:146):

1. Nature and culture are two distinct phenomenal realms, and neither can be explained in terms of the other.

2. Nature manifests itself in instinctive responses, whereas culture manifests itself in learned behaviors.

3. The human mind is essentially a blank slate or tabula rasa that has an enormous capacity to absorb culture.

4. Since culture is independent of nature, it is arbitrary and highly variable.

5. As a result of the arbitrary nature of culture and the tabula rasa quality of the human mind, human universals are few and insignificant.

These traditional anthropological postulates and a number of associated premises are widely shared in psychology and sociology as well. Tooby and Cosmides (1992:23) describe this interrelated set of assumptions and inferences as the "Standard Social Science Model," or SSSM, which they say "suffers from a series of major defects that make it a profoundly misleading framework." Those defects include a faulty analysis of the nature-nurture debate, which regards all human behavior as *either* biologically determined or culturally determined (ignoring the possibility

that behavior could be the result of the interplay of the two factors). The errors of the SSSM also include an illogical analysis of adult mental organization, which concludes that any feature of the mind not present at birth must have been acquired as a result of enculturation (ignoring the possibility that the features could have emerged as a result of maturation). Most important, as Tooby and Cosmides explain, the SSSM errs in requiring an untenable view of the human mind:

> A psychological architecture that consisted of nothing but equipotential, general-purpose, content-independent, or content-free mechanisms could not successfully perform the tasks that the human mind is known to perform or solve the adaptive problems humans evolved to solve—from seeing, to learning a language, to recognizing an emotional expression, to selecting a mate, to the many disparate activities aggregated under the term 'learning culture.' It cannot account for the behavior observed, and it is not a type of design that could have evolved. (Tooby and Cosmides 1992:34)

Indeed, evolutionary psychology argues persuasively that all of the fundamental assumptions of the SSSM are erroneous. The human mind is not a blank slate. Donald Brown (1991:144) identifies several compelling reasons to reject the tabula rasa view of the human mind: "Chomsky's analysis of how language is acquired, studies of the consequences of brain trauma, the discovery of brain cell specialization, the implications of attempts to construct artificial intelligence, and other lines of evidence all point to a human brain that is a very complex combination of specialized mechanisms." Thus human behavior cannot be wholly determined by culture, and culture itself cannot be entirely or even predominantly arbitrary.

Furthermore, human universals are numerous and highly significant. The existence of universals is compelling evidence for the existence of a universal human nature. Since "human universals provide vital clues to the nature of the human mind," as Donald Brown (1996:612) says, "an alliance of anthropology's comparative and evolutionary concerns with the various sciences concerned with the human mind could provide . . . deeper insight into the generation of culture." The recently revitalized study of human universals is contributing to a fundamental reformulation of anthropology. The insights that are emerging from the study of universals illustrate the value of a thoroughly scientific approach to the question of human nature.

Human Universals

Cultural anthropology is charged with documenting and explaining the similarities and differences among the peoples of the world, but cul-

tural anthropologists have paid far more attention to the differences than they have to the similarities. As a result, as Donald Brown (1996:609) observes, "the literature in anthropology that explicitly deals with universals is relatively slight," even though "anthropologists may and must rely upon universals to do their work." If there were no human universals, cultural anthropologists would not be able to understand or communicate with the people they study. In fact, however, there are hundreds of universals, and that is why ethnographers have little trouble understanding the people they study. Indeed, as Brown (1991:5) notes, "*nowhere* in the ethnographic literature is there *any* description of what real people really did that is not shot through with the signs of a universal human nature."

Many of the elements of that universal human nature are familiar and obvious. The extensive list suggested by Donald Brown (1991; 1996) includes the following: All humans use language as their principal medium of communication. Further, all languages have the same basic architecture. All languages are comprised of basic units of sound (phonemes) that are combined to form basic units of meaning (morphemes), and all languages arrange morphemes according to implicit rules of grammar (syntax) to produce understandable utterances. All people use paralinguistic tones and gestures to augment linguistic communication. All people classify each other in terms of status and role, and all people classify each other in terms of kinship. People everywhere employ a division of labor by age and sex. All people display emotion via universal facial expressions that elicit universal emotional responses. All people have aesthetic standards, just as all people have ethical standards. All people reckon time, understand logic, and think causally. People everywhere recognize the possibility of lying and cheating, and all people attempt to protect themselves from liars and cheaters.

The existence of these human universals has fundamental implications for anthropology, because they point to a universal human nature. In emphasizing cultural differences rather than cultural similarities, anthropology has contributed to a misleading image of human nature. In exaggerating "the importance of social and cultural conditioning," as Brown (1991:154) says, anthropologists "have, in effect, projected an image of humanity marked by little more than empty but programmable minds." The evidence refutes the assumption that the human mind is empty, however, and strongly supports the proposition that the human mind is a complex set of specific problem-solving mechanisms that evolved as adaptations to particular problems encountered during human evolution. If that proposition is true, the traditional anthropological approach to a

number of fundamental questions needs to be reevaluated.

Consider the question of gender roles, for example. Anthropology has traditionally maintained that gender roles are highly malleable, but a close examination of human universals reveals that gender roles are much less variable than the discipline has suggested (Brown 1991:108–10). In every culture in the world, for instance, sex is seen as a service provided by females to males. In every culture, men are more violently jealous than women. All over the world, men are aroused more quickly than women, and men in every culture are more aroused by visual stimuli than women. The average husband is universally older than his wife, and the average man is universally more aggressive than the average woman. In every culture in the world, nubility is seen as a central attribute of female attractiveness for men, and high status is seen as a central attribute of male attractiveness for women.

Anthropology has traditionally deemphasized these facts along with the other universal features of human experience. As a result, anthropology has failed to produce a cogent account of human nature. In its zeal to avoid biological reductionism, anthropology has frequently ignored the influence of biology on human behavior. Numerous errors have resulted. For example, Symons (1992:145) argues that "whenever a social scientist attributes something like the human male's sexual attraction to nubile females to cultural conditioning . . . he [or she] implicitly rejects a nativist conception of human nature and embraces an empiricist conception . . . [which has] essentially no chance of being correct."

According to evolutionary psychology, the critical variable underlying the universal differences between the sexes is the different reproductive roles played by men and women (Brown 1991:108–10; Symons 1992). Men can accomplish their reproductive goals through the simple act of insemination, whereas women must make a far greater investment in gestation and lactation if they hope to reproduce successfully. Therefore a woman would not maximize her reproduction by having more men inseminate her, but a man would maximize his reproduction by inseminating more women. Given these constraints, natural selection has acted to produce a number of "mental organs" adapted to maximizing reproductive success. Men who are violently jealous will compete with their fellows to limit access to female reproductive resources, thus increasing their chances of achieving paternity. Men who are attracted by nubility are more likely to inseminate healthy, fertile women. Women who are attracted by high status are more likely to choose men who can provide protection and resources for themselves and their offspring.

I am not suggesting that these hypotheses generated by the paradigm

of evolutionary psychology are necessarily and absolutely correct in every detail. They are provocative, certainly, and they may well be correct, but their real value lies in the fact that they constitute a coherent attempt to address a neglected issue. Human universals raise important questions about human nature that demand an integrated anthropological approach. I agree with Brown (1991:156) that it is "irresponsible to continue shunting these questions to the side, fraud to deny that they exist." It is intellectually irresponsible to ignore the questions raised by human universals not only because those issues lie at the heart of the anthropological enterprise but also because anthropology has been guilty of promulgating misinformation about those very questions. Brown (1991:154) suggests that anthropologists have long had a disreputable motive for exaggerating the differences among the world's cultures: "The more those differences can be shown to exist, and the more they can be thought to reflect purely social and cultural dynamics, the more sociocultural anthropologists (or sociologists) can justify their role in the world of intellect and practical human affairs and thus get their salaries paid, their lectures attended, their research funded, and their essays read."

The sociocultural anthropologists who have been most responsible for exaggerating the differences between cultures, of course, have been interpretive anthropologists. The central premise of interpretive anthropology, after all, is that cultures are incommensurable with one another. Scientific anthropologists have demonstrated that premise to be false by identifying extensive similarities among all human cultures. To address properly the questions posed by human universals, cultural anthropology must abandon the epistemological relativism of interpretive anthropology and embrace the essential principles of rational inquiry. It must further abandon the erroneous assumptions of the Standard Social Science Model and embrace the evolutionary perspective of biological anthropology and archeology. In a phrase, cultural anthropology must be conceptually integrated with the rest of the scientific community.

Conceptual Integration and the Future of Anthropology

Tooby and Cosmides (1992:47) observe that "the single most far-reaching consequence of the Standard Social Science Model has been to intellectually divorce the social sciences from the natural sciences, with the result that they cannot speak to each other about much of substance." It would be self-destructive for anthropology to continue to isolate itself from the scientific pursuit of knowledge. The overwhelming advantages of joining the community of genuinely scientific disciplines are readily

apparent. It is not necessary to look outside anthropology to appreciate the unparalleled opportunities for success afforded by the scientific approach. As Clark (1993:824) remarks, "paleoanthropology is advancing with new vigor as a result of the input from diverse natural sciences and the close collaboration that has developed between physical anthropology, molecular biology, and archeology."

Indeed, all three subfields of biological anthropology, archeology, and linguistics are "advancing with new vigor," and the reason for their success is obvious. With minor exceptions, all three subdisciplines adhere steadfastly to the fundamental principles of scientific inquiry. Cultural anthropology cannot be said to be advancing with comparable vigor, however, and the reason for its failure is obvious. Cultural anthropology is crippled by the virus of irrationality. Until that virus is eliminated, conceptual integration with other fields of scientific knowledge will be impossible, and intellectual progress will be problematic.

I have attempted in this book to outline the essential rules of rational inquiry upon which science is based. I have attempted as well to illustrate the intellectual and moral value of the scientific approach and to identify the errors and dangers of the interpretive perspective. In the final analysis, I have attempted to articulate a rationale for the conceptual integration of all anthropological subfields with the successful disciplines of the natural sciences. I am convinced that the future well-being of anthropology depends upon that conceptual integration. In conclusion, let me echo a sentiment first expressed by the philosopher of science Karl Popper (1963:337): "believing as I do in social science, I can only look with apprehension upon social pseudo-science."

References

Abel, Reuben. 1976. *Man Is the Measure: A Cordial Invitation to the Central Problems of Philosophy.* New York: Free Press.

Appell, G. N. 1989. "Facts, Fiction, Fads, and Follies: But Where Is the Evidence?" *American Anthropologist* 91(1):195–98.

Applebaum, Herbert, ed. 1987. *Perspectives in Cultural Anthropology.* Albany: State University of New York Press.

Ashley, Kathleen M. 1990. *Victor Turner and the Construction of Cultural Criticism: Between Literature and Anthropology.* Bloomington: Indiana University Press.

Atkinson, Paul. 1992. *Understanding Ethnographic Texts.* Newbury Park, Calif.: Sage Publications.

Barkow, Jerome H., Leda Cosmides, and John Tooby, eds. 1992. *The Adapted Mind: Evolutionary Psychology and the Generation of Culture.* New York: Oxford University Press.

Benedict, Ruth. 1934. *Patterns of Culture.* Boston: Houghton Mifflin.

———. 1948. "Anthropology and the Humanities." *American Anthropologist* 50:585–93.

Bernard, H. Russell. 1994. "Methods Belong to All of Us." Pp. 168–79 in *Assessing Cultural Anthropology,* ed. Robert Borofsky. New York: McGraw-Hill.

———. 1995. *Research Methods in Cultural Anthropology: Qualitative and Quantitative Approaches.* 2d ed. Walnut Creek, Calif.: Altamira Press.

Binford, Lewis. 1962. "Archaeology as Anthropology." *American Antiquity* 28:217–25.

———. 1981. *Bones: Ancient Men and Modern Myths.* New York: Academic Press.

———. 1986. "In Pursuit of the Future." Pp. 459–79 in *American Archaeology Past and Future: A Celebration of the Society for American Archaeology 1935–1985,* ed. David J. Meltzer, Don D. Fowler, and Jeremy A. Sabloff. Washington, D.C.: Smithsonian Institution Press.

———. 1989. *Debating Archaeology.* San Diego: Academic Press.

Birth, Kevin K. 1990. "Reading and the Righting of Writing Ethnographies." *American Ethnologist* 17:549–57.

Bohannon, Paul, and Mark Glazer, eds. 1973. *High Points in Anthropology.* New York: Alfred A. Knopf.

Boon, James A. 1982. *Other Tribes, Other Scribes: Symbolic Anthropology in the Comparative Study of Cultures, Histories, Religions, and Texts*. Cambridge: Cambridge University Press.

Boston, Robert. 1994. "Is Bigfoot an Endangered Species?" Review of *Big Footprints: A Scientific Inquiry into the Reality of Sasquatch* by Grover S. Krantz. *Skeptical Inquirer* 18(5):528–31.

Brady, Ivan, ed. 1991. *Anthropological Poetics*. Savage, Md.: Rowman & Littlefield.

Brown, Donald E. 1991. *Human Universals*. Philadelphia: Temple University Press.

———. 1996. "Human Universals." Pp. 607–13 in *Encyclopedia of Cultural Anthropology*, ed. David Levinson and Melvin Ember. New York: Henry Holt.

Brown, Michael F. 1996. "On Resisting Resistance." *American Anthropologist* 98(4):729–35.

Bruner, Edward M. 1986a. "Experience and Its Expressions." Pp. 3–30 in *The Anthropology of Experience*, ed. Victor W. Turner and Edward M. Bruner. Urbana: University of Illinois Press.

———. 1986b. "Ethnography as Narrative." Pp. 139–55 in *The Anthropology of Experience*, ed. Victor W. Turner and Edward M. Bruner. Urbana: University of Illinois Press.

Carneiro, Robert L. 1995. "Godzilla Meets New Age Anthropology: Facing the Post-Modernist Challenge to a Science of Culture." *Europa* 1:3–21.

Carrithers, Michael. 1990. "Is Anthropology Art or Science?" *Current Anthropology* 31(3):263–82.

Cerroni-Long, E. L. 1996. "Human Science." *Anthropology Newsletter* 37(1):52,50.

Clark, J. Desmond. 1993 "Distinguished Lecture: Coming into Focus." *American Anthropologist* 95(4):823–38.

Clifford, James. 1986. "Introduction: Partial Truths." Pp. 1–26 in *Writing Culture: The Poetics and Politics of Ethnography*, ed. James Clifford and George E. Marcus. Berkeley and Los Angeles: University of California Press.

———. 1988. *The Predicament of Culture: Twentieth-Century Ethnography, Literature, and Art*. Cambridge: Harvard University Press.

———. 1989. "Comment on 'Ethnography Without Tears' by Paul A. Roth." *Current Anthropology* 30(5):561–63.

Cosmides, Leda, John Tooby, and Jerome H. Barkow. 1992. "Introduction: Evolutionary Psychology and Conceptual Integration." Pp. 3–15 in *The Adapted Mind: Evolutionary Psychology and the Generation of Culture*, ed. Jerome H. Barkow, Leda Cosmides, and John Tooby. New York: Oxford University Press.

Crapanzano, Vincent. 1992. *Hermes' Dilemma and Hamlet's Desire: On the Epistemology of Interpretation*. Cambridge: Harvard University Press.

Cunningham, Frank. 1973. *Objectivity in Social Science*. Toronto: University of Toronto Press.

D'Andrade, Roy G. 1995. "What *Do* You Think You're Doing?" *Anthropology Newsletter* 36(7):1, 4.

Dennett, Michael R. 1989. "Evidence for Bigfoot? An Investigation of the Mill Creek 'Sasquatch Prints.'" *Skeptical Inquirer* 13(3):264–72.

———. 1994. "Bigfoot Evidence: Are These Tracks Real?" *Skeptical Inquirer* 18(5): 498–508.

Derrida, Jacques. 1976. *Of Grammatology.* Baltimore: Johns Hopkins University Press.

———. 1978. *Writing and Difference.* Chicago: University of Chicago Press.

Doglin, Janet L., David S. Kemnitzer, and David M. Schneider, eds. 1977. *Symbolic Anthropology.* New York: Columbia University Press.

Dumont, Jean-Paul. 1992. *The Headman and I: Ambiguity and Ambivalence in the Fieldworking Experience.* Prospect Heights, Ill.: Waveland Press.

Evans-Pritchard, E. E. 1965. *Theories of Primitive Religion.* London: Oxford University Press.

Fluehr-Lobban, Carolyn, ed. 1991. *Ethics and the Profession of Anthropology: Dialogue for a New Era.* Philadelphia: University of Pennsylvania Press.

Foucault, Michel. 1976. *The Archaeology of Knowledge.* New York: Harper & Row.

Frankel, Charles. 1955. *The Case for Modern Man.* New York: Harper.

Gardner, Martin. 1988. *The New Age: Notes of a Fringe Watcher.* Buffalo, N.Y.: Prometheus Books.

Geertz, Clifford. 1973. *The Interpretation of Cultures.* New York: Basic Books.

———. 1979. "From the Native's Point of View: On the Nature of Anthropological Understanding." Pp. 225–41 in *Interpretive Social Science: A Reader,* ed. Paul Rabinow and William M. Sullivan. Berkeley and Los Angeles: University of California Press.

———. 1983. *Local Knowledge: Further Essays in Interpretive Anthropology.* New York: Basic Books.

———. 1984. "Distinguished Lecture: Anti Anti-Relativism." *American Anthropologist* 86(2):263–78.

———. 1986. "Making Experience, Authoring Selves." Pp. 373–80 in *The Anthropology of Experience,* ed. Victor W. Turner and Edward M. Bruner. Urbana: University of Illinois Press.

———. 1988. *Works and Lives: The Anthropologist as Author.* Stanford, Calif.: Stanford University Press.

———. 1990. "Comment on 'Is Anthropology Art or Science?' by Michael Carrithers." *Current Anthropology* 31(3):274.

———. 1994. "The Uses of Diversity." Pp. 454–67 in *Assessing Cultural Anthropology,* ed. Robert Borofsky. New York: McGraw-Hill.

Gellner, Ernest. 1988. "The Stakes in Anthropology." *American Scholar* 57:17–30.

Gray, J. Patrick. 1996. "Sociobiology." Pp. 1212–19 in *Encyclopedia of Cultural Anthropology,* ed. David Levinson and Melvin Ember. New York: Henry Holt.

Handler, Richard. 1991. "An Interview with Clifford Geertz." *Current Anthropology* 32(5):603–13.

Harris, Marvin. 1968. *The Rise of Anthropological Theory.* New York: T. Y. Crowell.

———. 1979. *Cultural Materialism: The Struggle for A Science of Culture.* New York: Random House.

———. 1991. "Anthropology: Ships That Crash in the Night." Pp. 70–114 in *Perspectives on Behavioral Science: The Colorado Lectures,* ed. Richard Jessor. Boulder, Colo.: Westview Press.

———. 1992. "Distinguished Lecture: Anthropology and the Theoretical and Paradigmatic Significance of the Collapse of Soviet and East European Communism." *American Anthropologist* 94(2):295–305.

———. 1994. "Cultural Materialism Is Alive and Well and Won't Go Away until Something Better Comes Along." Pp. 62–76 in *Assessing Anthropology,* ed. Robert Borofsky. New York: McGraw-Hill.

———. 1995a. "Comment on 'Objectivity and Militancy: A Debate' by Roy D'Andrade and Nancy Scheper-Hughes." *Current Anthropology* 36(3):423–24.

———. 1995b. "Anthropology and Postmodernism." Pp. 62–77 in *Science, Materialism, and the Study of Culture,* ed. Martin F. Murphy and Maxine L. Margolis. Gainesville: University Presses of Florida.

———. 1996. "Cultural Materialism." Pp. 277–81 in *Encyclopedia of Cultural Anthropology,* ed. David Levinson and Melvin Ember. New York: Henry Holt.

———. 1997a. "Anthropology Needs Holism; Holism Needs Anthropology." Pp. 22–28 in *The Teaching of Anthropology: Problems, Issues, and Decisions,* ed. Conrad Philip Kottak, Jane J. White, Richard H. Furlow, and Patricia C. Rice. Mountain View, Calif.: Mayfield.

———. 1997b. "Comment on 'Causation and the Struggle for a Science of Culture' by Tim O'Meara." *Current Anthropology* 38(3):410–18.

Hawkes, Kristen. 1996. "Behavioral Ecology." Pp. 121–25 in *Encyclopedia of Cultural Anthropology,* ed. David Levinson and Melvin Ember. New York: Henry Holt.

Headland, Thomas, Kenneth Pike, and Marvin Harris, eds. 1990. *Emics and Etics: The Insider/Outsider Debate.* Newbury Park, Calif.: Sage Publications.

Hempel, Carl G. 1965. *Aspects of Scientific Explanation and Other Essays in the Philosophy of Science.* New York: Free Press.

Herrnstein, Richard J., and Charles Murray. 1994. *The Bell Curve: Intelligence and Class Structure in American Life.* New York: Free Press.

Hodder, Ian. 1982a. *The Present Past.* New York: Pica Press.

———. 1986. *Reading the Past: Current Approaches to Interpretation in Archaeology.* Cambridge: Cambridge University Press.

Hodder, Ian, ed. 1982b. *Symbolic and Structural Archaeology.* Cambridge: Cambridge University Press.

———. 1987. *The Archaeology of Contextual Meanings.* Cambridge: Cambridge University Press.

Jackson, Michael. 1989. *Paths toward a Clearing: Radical Empiricism and Ethnographic Inquiry.* Bloomington: Indiana University Press.

Jarvie, Ian. 1988. "Comment on 'Rhetoric and the Authority of Ethnography: Postmodernism and the Social Reproduction of Texts' by P. Steven Sangren." *Current Anthropology* 29(3):427–29.

Johannsen, Agneta M. 1992. "Applied Anthropology and Post-Modernist Ethnography." *Human Organization* 51(1):71–81.

Johnson, Allen. 1995. "Explanation and Ground Truth: The Place of Cultural Materialism in Scientific Anthropology." Pp. 7–20 in *Science, Materialism, and the Study of Culture,* ed. Martin F. Murphy and Maxine L. Margolis. Gainesville: University Presses of Florida.

Jones, Lewis. 1989. "The Two Cultures: A Resurrection." *Skeptical Inquirer* 14(1):57–64.

Keesing, Roger M. 1987. "Anthropology as Interpretive Quest." *Current Anthropology* 28(2):161–76.

Krantz, Grover S. 1992. *Big Footprints: A Scientific Inquiry into the Reality of Sasquatch.* Boulder, Colo.: Johnson Books.

Kroeber, Alfred L. 1920. "Review of *Primitive Society.*" *American Anthropologist* 22: 377–81.

———. 1935. "History and Science in Anthropology." *American Anthropologist* 37: 539–69.

———. 1948. *Anthropology.* New York: Harcourt, Brace.

Kuhn, Thomas. 1970. *The Structure of Scientific Revolutions.* 2d ed. Chicago: University of Chicago Press.

Kuper, Adam. 1989. "Editorial." *Current Anthropology* 30(3):266.

Kurtz, Paul. 1983. *In Defense of Secular Humanism.* Buffalo, N.Y.: Prometheus Books.

———. 1986. *The Transcendental Temptation: A Critique of Religion and the Paranormal.* Buffalo, N.Y.: Prometheus Books.

Lakatos, Imre. 1970. "Falsification and the Methodology of Scientific Research Programmes." Pp. 91–196 in *Criticism and the Growth of Knowledge,* ed. Imre Lakatos and Alan Musgrave. Aberdeen: Cambridge University Press.

Lastrucci, Carlo L. 1963. *The Scientific Approach: Basic Principles of the Scientific Method.* Cambridge, Mass.: Schenkman.

Lee, Richard B. 1992. "Art, Science, or Politics? The Crisis in Hunter-Gatherer Studies." *American Anthropologist* 94(1):31–54.

Lett, James. 1987. *The Human Enterprise: A Critical Introduction to Anthropological Theory.* Boulder, Colo.: Westview Press.

———. 1990. "Emics and Etics: Notes on the Epistemology of Anthropology." Pp. 127–42 in *Emics and Etics: The Insider/Outsider Debate,* ed. Thomas Headland, Kenneth Pike, and Marvin Harris. Newbury Park, Calif.: Sage Publications.

———. 1991a. "A Field Guide to Critical Thinking." Pp. 31–39 in *The Hundredth Monkey and Other Paradigms of the Paranormal*, ed. Kendrick Frazier. Buffalo, N.Y.: Prometheus Books.

———. 1991b. "Interpretive Anthropology, Metaphysics, and the Paranormal." *Journal of Anthropological Research* 47(3):305–29.

———. 1992. "The Persistent Popularity of the Paranormal." *Skeptical Inquirer* 16(4):381–88.

———. 1996a. "Emic/Etic Distinctions." Pp. 382–83 in *Encyclopedia of Cultural Anthropology*, ed. David Levinson and Martin Ember. New York: Henry Holt.

———. 1996b. "Scientific Anthropology." Pp. 1141–48 in *Encyclopedia of Cultural Anthropology*, ed. David Levinson and Martin Ember. New York: Henry Holt.

———. 1997. "Science, Religion, and Anthropology." Pp. 103–20 in *Anthropology of Religion: A Handbook*, ed. Stephen D. Glazier. Westport, Conn.: Greenwood Press.

Luhrmann, T. M. 1989. *Persuasions of the Witch's Craft: Ritual Magic in Contemporary England*. Cambridge: Harvard University Press.

Magnarella, Paul J. 1993. *Human Materialism: A Model of Sociocultural Systems and a Strategy for Analysis*. Gainesville: University Press of Florida.

Manganaro, Marc, ed. 1990. *Modernist Anthropology: From Fieldwork to Text*. Princeton: Princeton University Press.

Marcus, George E. 1988. "The Constructive Uses of Deconstruction in the Ethnographic Study of Notable American Families." *Anthropology Quarterly* 61:3–16.

Marcus, George E., and Dick Cushman. 1982. "Ethnographies as Texts." *Annual Review of Anthropology* 11:25–69.

Marcus, George E., and Michael M. J. Fischer. 1986. *Anthropology as Cultural Critique: An Experimental Moment in the Human Sciences*. Chicago: University of Chicago Press.

Maugham, W. Somerset. 1938. *The Summing Up*. Garden City, N.Y.: International Collectors Library.

Mead, Margaret. 1977. "An Anthropological Approach to Different Types of Communication and the Importance of Differences in Human Temperaments." Pp. 47–50 in *Extrasensory Ecology: Parapsychology and Anthropology*, ed. Joseph K. Long. Metuchen, N.J.: Scarecrow Press.

Morton, Brian. 1990. "How Not to Write for *Dissent*." *Dissent* (Summer):299.

Murdock, George Peter. 1980. *Theories of Illness: A World Survey*. Pittsburgh: University of Pittsburgh Press.

Murphy, Martin F., and Maxine L. Margolis, eds. 1995. *Science, Materialism, and the Study of Culture*. Gainesville: University Presses of Florida.

Nagel, Ernest. 1961. *The Structure of Science*. New York: Harcourt, Brace, & World.

Naroll, Raoul, and Ronald Cohen, eds. 1970. *A Handbook of Method in Cultural Anthropology*. New York: Columbia University Press.

Netting, Robert McC. 1996. "Cultural Ecology." Pp. 267–71 in *Encyclopedia of Cultural Anthropology*, ed. David Levinson and Melvin Ember. New York: Henry Holt.

Nissam-Sabat, Charles. 1987. "On Clifford Geertz and His Anti-Anti-Relativism." *American Anthropologist* 89(4):935–39.

Norbeck, Edward. 1974. *Religion in Human Life: Anthropological Views*. New York: Holt, Rinehart, & Winston.

O'Meara, Tim. 1989. "Anthropology as Empirical Science." *American Anthropologist* 91(2):354–69.

———. 1990. "Anthropology as Metaphysics: Reply to Shore." *American Anthropologist* 92(3):751–53.

———. 1995. "Comment on 'Objectivity and Militancy: A Debate' by Roy D'Andrade and Nancy Scheper-Hughes." *Current Anthropology* 36(3):427–28.

———. 1997. "Causation and the Struggle for a Science of Culture." *Current Anthropology* 38(3):399–418.

Pandian, Jacob. 1985. *Anthropology and the Western Tradition: Toward an Authentic Anthropology*. Prospect Heights, Ill.: Waveland Press.

Pelto, Pertti J., and Gretel H. Pelto. 1978. *Anthropological Research: The Structure of Inquiry*. 2d ed. New York: Cambridge University Press.

Pinker, Steven. 1994. *The Language Instinct*. New York: William Morrow.

Polanyi, Michael. 1962. *Personal Knowledge: Towards a Post-Critical Philosophy*. Chicago: University of Chicago Press.

Popper, Karl R. 1959. *The Logic of Scientific Discovery*. London: Hutchinson.

———. 1963. *Conjectures and Refutations: The Growth of Scientific Knowledge*. New York: Basic Books.

Rabinow, Paul. 1986. "Representations Are Social Facts: Modernity and Post-Modernity in Anthropology." Pp. 234–61 in *Writing Culture: The Poetics and Politics of Ethnography*, ed. James Clifford and George E. Marcus. Berkeley and Los Angeles: University of California Press.

Rabinow, Paul, and William M. Sullivan. 1979. "The Interpretive Turn: Emergence of an Approach." Pp. 1–21 *Interpretive Social Science: A Reader*, ed. Paul Rabinow and William M. Sullivan. Berkeley and Los Angeles: University of California Press.

Redfield, Robert. 1953. "Relations of Anthropology to the Social Sciences and to the Humanities." Pp. 728–38 in *Anthropology Today*, ed. Alfred L. Kroeber. Chicago: University of Chicago Press.

Redman, Charles L. 1991. "Distinguished Lecture in Archeology: In Defense of the Seventies—The Adolescence of New Archeology." *American Anthropologist* 93(2):295–307.

Reyna, S. P. 1994. "Literary Anthropology and the Case against Science." *Man* 29:555–81.

Roscoe, Paul B. 1995. "The Perils of 'Positivism' in Cultural Anthropology." *American Anthropologist* 97(3):492–504.

Roth, Paul A. 1989. "Ethnography Without Tears." *Current Anthropology* 30(5):555–69.

Salzman, Philip Carl. 1994. "The Lone Stranger in the Heart of Darkness." Pp. 29–38 in *Assessing Cultural Anthropology*, ed. Robert Borofsky. New York: McGraw-Hill.

Sangren, P. Steven. 1988. "Rhetoric and the Authority of Ethnography: 'Postmodernism' and the Social Reproduction of Texts." *Current Anthropology* 29(3):405–35.

Schneider, David M. 1965. "Kinship and Biology." In *Aspects of the Analysis of Family Structure*, ed. Ansley J. Coale, Marion J. Levy, and S. S. Tomkins. Princeton: Princeton University Press.

Scholte, Bob. 1974. "Toward a Reflexive and Critical Anthropology." Pp. 430–57 in *Reinventing Anthropology*, ed. Dell Hymes. New York: Vintage Books.

———. 1984. "On Geertz's Interpretive Theoretical Program." *Current Anthropology* 25(4):540–42.

Service, Elman R. 1985. *A Century of Controversy: Ethnological Issues from 1860 to 1960*. Orlando, Fla.: Academic Press.

Shankman, Paul. 1984. "The Thick and the Thin: On the Interpretive Theoretical Program of Clifford Geertz." *Current Anthropology* 25:261–79.

Shanks, Michael, and Christopher Tilley. 1987. *Social Theory and Archaeology*. Albuquerque: University of New Mexico Press.

Shore, Bradd. 1990. "Anthropology as Anthropology: Reply to O'Meara." *American Anthropologist* 92(3):748–51.

Shweder, Richard A. 1991. *Thinking through Cultures: Expeditions in Cultural Psychology*. Cambridge: Harvard University Press.

———. 1996. "The View from Manywheres." *Anthropology Newsletter* 37(9):1,4–5.

Siegel, Harvey. 1987. *Relativism Refuted: A Critique of Contemporary Epistemological Relativism*. Dordrecht: D. Reidel.

Snow, C. P. 1959. *The Two Cultures and the Scientific Revolution*. New York: Cambridge University Press.

Spaulding, Albert C. 1988. "Distinguished Lecture: Archeology and Anthropology." *American Anthropologist* 90(2):263–71.

Sperber, Dan. 1985. *On Anthropological Knowledge: Three Essays*. Cambridge: Cambridge University Press.

Spiro, Melford E. 1986. "Cultural Relativism and the Future of Anthropology." *Cultural Anthropology* 1:259–86.

———. 1992. *Anthropological Other or Burmese Brother? Studies in Cultural Analysis*. New Brunswick: Transaction Publishers.

Stoller, Paul. 1986. "The Reconstruction of Ethnography." Pp. 51–74 in *Discourse and the Social Life of Meaning*, ed. Phyllis Pease Chock and June R. Wyman. Washington, D.C.: Smithsonian Institution Press.

———. 1989. *The Taste of Ethnographic Things: The Senses in Anthropology*. Philadelphia: University of Pennsylvania Press.

Symons, Donald. 1992. "On the Use and Misuse of Darwinism in the Study of Human Behavior." Pp. 137–62 in *The Adapted Mind: Evolutionary Psychology and the Generation of Culture*, ed. Jerome H. Barkow, Leda Cosmides, and John Tooby. New York: Oxford University Press.

Szasz, Thomas. 1961. *The Myth of Mental Illness: Foundations of a Theory of Personal Conduct*. New York: Hoeber-Harper.

———. 1973. *The Age of Madness: The History of Involuntary Mental Hospitalization*. Garden City, N.Y.: Anchor Books.

———. 1984. *The Therapeutic State: Psychiatry in the Mirror of Current Events*. Buffalo, N.Y.: Prometheus Books.

———. 1987. *Insanity: The Idea and Its Consequences*. New York: Wiley.

Tilley, Christopher, ed. 1990. *Reading Material Culture: Structuralism, Hermeneutics and Post-Structuralism*. Oxford: Basil Blackwell.

Tooby, John, and Leda Cosmides. 1992. "The Psychological Foundations of Culture." Pp. 19–136 in *The Adapted Mind: Evolutionary Psychology and the Generation of Culture*, ed. Jerome H. Barkow, Leda Cosmides, and John Tooby. New York: Oxford University Press.

Trigger, Bruce G. 1991. "Distinguished Lecture in Archeology: Constraint and Freedom—A New Synthesis for Archeological Explanation." *American Anthropologist* 93(3):551–69.

Turner, Victor. 1974. *Dramas, Fields, and Metaphors*. Ithaca, N.Y.: Cornell University Press.

Tyler, Stephen A. 1984. "The Poetic Turn in Postmodern Anthropology: The Poetry of Paul Friedrich." *American Anthropologist* 86(2):328–36.

———. 1986a. "Post-Modern Anthropology." Pp. 23–49 in *Discourse and the Social Life of Meaning*, ed. Phyllis Pease Chock and June R. Wyman. Washington, D.C.: Smithsonian Institution Press.

———. 1986b. "Post-Modern Ethnography: From Document of the Occult to Occult Document." Pp. 122–40 in *Writing Culture: The Poetics and Politics of Ethnography*, ed. James Clifford and George E. Marcus. Berkeley and Los Angeles: University of California Press.

Wagley, Charles. 1977. *Welcome of Tears: The Tapirapé Indians of Central Brazil*. New York: Oxford University Press.

Wallace, Anthony F. C. 1966. *Religion: An Anthropological View*. New York: Random House.

Watson, Patty Jo, and Michael Fotiadis. 1990. "The Razor's Edge: Symbolic-Structuralist Archeology and the Expansion of Archeological Inference." *American Anthropologist* 92(3):613–29.

Watson, Richard A. 1991. "What the New Archaeology Has Accomplished." *Current Anthropology* 32(3):275–91.

White, Leslie. 1949. *The Science of Culture*. New York: Grove Press.

Wilk, Stan. 1991. *Humanistic Anthropology*. Knoxville: University of Tennessee Press.

Winch, Peter. 1958. *The Idea of A Social Science and Its Relation to Philosophy*. London: Routledge & Paul.

Wolf, Eric. 1964. *Anthropology*. Englewood Cliffs, N.J.: Prentice-Hall.

Index

a posteriori statements, 24. *See also* propositional statements

a priori statements, 23, 53. *See also* propositional statements

Abel, Reuben, 22, 43, 87

Adapted Mind, The (Cosmides, Tooby, and Barkow), 126

aerodynamics, 111

aesthetics, xiii, 2–4, 56, 104, 109, 120–21

agriculture, 61

Allah, 35–36

American Anthropological Association, 23, 25, 94

analytic proposition, 23, 25, 45. *See also* propositional statements

anthropoid, 121

anthropological theory. *See* theory

anthropology, xi–xiv, 1, 18, 21, 34, 54; ambiguous identity of, 113–15; definition of, 121–22; prospects for, 122–23. *See also* biological anthropology; cultural anthropology; interpretive anthropology; scientific anthropology

Appell, G. N., 82, 92, 98

archeology, 10–12, 34, 122–23, 125–26, 131–32

argument: contrapositive, 59; deductive, 62–63; definition of, 57; dilemmatic, 59; hypothetical, 59; inductive, 63; modus ponens, 58–59, 62, 69; modus tollens, 59; sound, 61; valid, 59–61. *See also* logic

artificial intelligence, 128

astronomy, 123–24

Atkinson, Paul, 91

Ayer, A. J., 118

Barkow, Jerome, 124, 126–27

behavioral ecology, 126

Bell Curve, The (Heernstein and Murray), 72

Benedict, Ruth, 1

Bernard, H. Russell, xi, 47, 80, 84

Bigfoot. *See* Sasquatch

Big Footprints (Krantz), 72–76, 79

Binford, Lewis, 11

biological anthropology, 30, 34, 75, 122–23, 125–26, 131–32

biological reductionism, 130

biology, 54, 123–24

Birth, Kevin, 12, 105

Boas, Franz, 6, 26–27, 72

Bossburg (Washington), 74

Brady, Ivan, 114

brain, 49, 128

Brown, Donald, 125–30

Bruner, Edward, 13

California, 74

Candide (Voltaire), 106

Carneiro, Robert, 91, 95, 103–4, 106–7

Carrithers, Michael, 5

causality, 3, 83, 111–12

Cerroni-Long, E. L., 86, 105

chemistry, 54, 113, 123–24

Chomsky, Noam, 128

Christians, 53–54

civilizations, ancient, 68

clairvoyance, 67

Clark, Desmond, 132

Clifford, James, 12, 14–15

cockfighting, 7

cognitive science, 126. *See also* evolutionary psychology

About the Author

James Lett has taught anthropology and philosophy at the University of Florida, Florida Atlantic University, Barry University, and the Florida Institute of Technology. He is presently professor of Anthropology and chair of the Department of Social Sciences at Indian River Community College in Fort Pierce, Florida, where he has taught anthropology and geography since 1986. Born in Germany in 1955, he was raised in France and Pakistan, among other places, and educated at the College of William and Mary (B.A., 1977) and the University of Florida (Ph.D., 1983). He has conducted ethnographic research on tourism in the British Virgin Islands and on the mass media in the United States. He is the author of *The Human Enterprise* and a contributor to several other books on anthropological theory, including *Science, Knowledge, and Belief, Encyclopedia of Cultural Anthropology, Anthropology of Religion, Emics and Etics, Hosts and Guests,* and *Media Anthropology.*